Echoes

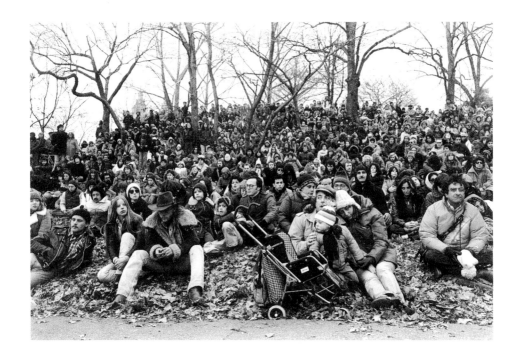

Lina Bertucci. *Silent Vigil (Central Park, 8 December 1980).* 1980.

Echoes

Contemporary Art at the Age of Endless Conclusions

Edited by Francesco Bonami

THE MONACELLI PRESS

First published in the United States of America in 1996 by
The Monacelli Press, Inc.,
10 East 92nd Street, New York, New York 10128.

Library of Congress Cataloging-in-Publication Data
Echoes : contemporary art at the age of endless conclusions / edited by Francesco Bonami ; essays by Francesco Bonami . . . [et al].
p. cm.
ISBN 1-885254-36-9
1. Postmodernism. 2. Art, Modern—20th century. 3. Art and society—History—20th century. I. Bonami, Francesco.
N6494.P66E28 1996
709'.045—dc20 96-24487

Printed and bound in Hong Kong

Designed by Mathew Forrester

Cover illustration: *Silent Vigil*, Lina Bertucci

Contents

This book is dedicated to
those who listen and to
those who answer.

Acknowledgments

The echo created by the seventy-two artists in this book allowed me to conceive of this project. Thanks to all of them, my vision of reality has been invaluably enlightened.

Jen Budney, Jeff Rian, Keith Seward, Mark Van de Walle, and Neville Wakefield gave me the opportunity to look, from different vistas, on the panorama of contemporary art and culture, where the individual defines his or her borders. Beyond these borders we cannot find an alternative to art that is as powerful a tool of transformation. I feel that we all share the idea that art gives to many people a wide spectrum of choices, while the world is changing more and more into a binary system of "yes" and "no." For their trust and patience in following the project I am very grateful.

My gratitude for the enthusiasm and trust that Gianfranco Monacelli granted to my original idea deserves much more space than these few lines. Matthew Forrester, who designed this book, has been a major force in the life of *Echoes*.

A special thanks to Cathryn Drake for her editing skills. I am also grateful to all at The Monacelli Press, who with their hard work helped me to realize this first editorial effort. Thank you.

Francesco Bonami

Echoes

The Road Around (or, A Long Good-bye)

Francesco Bonami

Among the Mayans of Guatemala an "echo" is the last stage of the life cycle. It is a person who hears, intuits, and responds to the community. The "echoes" in our contemporary culture are the artists who listen to the sounds and transformations of society.

Who is listening to the sounds of our community? Certainly not the millions of faceless surfers who crowd the electronic highways day after day in the utmost silence—no smiles or grimaces to help each other—who just hang around in that nonplace, trying to figure out to whom our debt for this life has to be paid. There are no more echoes to those sounds that come from afar. We live elbow to elbow, but we do not realize it: our skin has disappeared into the air of cipher messages.

The space that art takes in this world is so small that it can be easily overlooked; its yearly audience is roughly the same as that of one hour on America Online. An artist today is as useful to the world economy as a blacksmith, or as a gas station attendant will be in the year 2200. Yet a society that lets its echoes go silently by is a society doomed to disappear, doomed to be dispersed into the hypercommunication that is gnawing on the last few bones of a century of endless conclusions. Endless conclusions, or a chain of endless beginnings in an expandable time frame on the flat surface of a small screen. The depth of time is finished—kaput. Its finish is Nosferatu's curse, an abyss of time. And each artist lives on the surface of a shallow but murky ocean, where the bottom remains infinitely hidden.

Yet art can be seen as a powerful tool in the hands of a bunch of helpless, utopic individuals who, like myself, are seeking a freedom that could return to us an identity, as we cross the road of two millennia in a volatile climate of PIN and 1-800 numbers. Art today

11

is the only center of the human spiral that starts in your own bedroom and moves through your home, down the stairs, into the street, toward the city, around your country and beyond its borders into a world condensed around its diameter. And from this world, which is living out its own consumption, art can always go back inside the bedroom, where everything is possible.

Art at the end of this millennium is the sign of liberation in which each of us has free access, freedom of judgment, freedom to do and make, freedom to like or dislike, and freedom to run away or stand forever in one place, where giving up understanding is allowed. How many banalities are committed in the name of art, to serve a transformation rather than this fragmented and fishy "progress," which is merely devoted to updating our own uncommunicability?

The goal of this book is to bring together ideas that reflect the complexity of the weave formed by images and words. A fabric of meanings loomed by a continuous system of exchanges with no clear hierarchies, it creates a system similar to the *kularing,* in use at the beginning of the century in the Trobriand islands of Papua New Guinea. This system consisted of a floating market that moved from one island to another, in which goods were exchanged constantly year after year for decades, until the round of the thousand islands was concluded and some of the goods had come back to their former owners enriched by time and usage, with an added spiritual dimension. Art, with its ideas, visions, and production, is a kind of contemporary *kularing,* much more able to maintain an endless relationship with the Other than with a constantly changing economic context.

The images in this book travel through its pages, crossing over and through the words to create new and unpredictable cycles of thought and associations. The artworks are not commented upon and the texts are not comments: they grow one on top of another in total dependence, still soaked with subliminal freedom. Words spring from the images, and images bloom from the words. Each image becomes at once a sign and a sound. The essays help to slow down the flux of images, just as the images help the reader to avoid an automatic perception of a written reality.

To structure a book without hierarchies is, in a way, the ultimate attempt to question the realm of captions in which we are trapped. Text and art echo each other; and where their two waves meet, a certain ephemeral meaning of our contemporary reality is disclosed. Grouping together five writers and more than sixty artists' visions is a way to underline the importance of diversity in a fragmented world—the importance of accepting a certain level of uncommunicability in order to accept the responsibility of each identity on the threshold of a delirious ending.

With the collapse of the Soviet bloc and the opening of contemporary art to undisclosed and barely known creative realities, the Western front melted under the warmth of the multicultural electric heater. Soon the contemporary art world realized that much of the fascination of the unknown was simply a result of our ignorance. After consuming the roughness of Eastern novelties so quickly, we had to confront the fact that contemporary art was merely the product of the combined three pillars of Western society: capitalism, Judeo-Christian religion, and the philosophical system of the Age of Enlightenment. Elsewhere, in international surveys, what we embraced so demagogically proceeded toward a definition of a contemporary language, as much as the economic systems were updating their structure to a new free-market dimension. Doomed by its own sophisticated perfection, Western art could not confront its Eastern counterpart without expressing the development of a neo-imperialistic culture. The indulgence of hedonism, politically correct or not, meant facing the gap between a society of hyperconsumption and one in awe of working appliances and the taste of fresh bananas. This gap was not aesthetic, but rather one of basic life experiences. Contemporary art was getting closer to the toll booth.

Yet art remains everywhere one of the strongest possibilities for the establishment of new relationships within the cultural and social forces of a society, on the condition that it maintains its ideas of diversity, of distance and different time zones; fights homogenizing style and consumer trends; and butts heads with the established rules of entertainment and profit. At the end of an age of winners, art speaks the chilling last words of the loser that knows it will soon be speaking first. This is not an evangelic vision, but rather a perspective into a world that must accept the idea of a meeting point where rich and poor will come together to share the next leg of civilization.

It would be preposterous to presume that this book can symbolize such a point of sharing. Nevertheless, I presume that in the back of the authors' minds there were thoughts of building some kind of bridge over the void that has been created by the unconsidered progress of our society, forgetful of any quality beyond our own immediate needs and desires. The artists that contributed to this book are "echoes" of an age of constant transformation within a landscape of information that is piled as dunes in a vast desert, always different and always alike. Their works function as points of reference outside of the visual nightmare of trashy high definition. These artists reflect a generation that is determined, after the deafening noise of the 1980s, to listen again to the sound of brakes on the railway of uncivilized development.

This generation goes back to that Monday evening in December 1980 when the roots of the 1990s began—the night John Lennon had no time to turn to see who was calling his

name. The flash that took his life took also the perspectives and hopes of a whole generation. In a sacrificial rite, an unknown person in a black raincoat stepped out of the dark and entered the absurdity of History, dragging down with him all the idealism and dreams of an age. The day after, on a Central Park hill in front of the Dakota building, a crowd gathered together to celebrate the last, hushed echo before the emptiness of the next decade. The 1980s were a long moment of denial for a young generation suddenly aged under the burden of piled-up defeats, pushed into an egocentric hurricane that held in its eye the dreadful calm of a devastating plague. It was on that very hill in front of the Dakota that the 1990s began to germinate. Now these artists can redesign the map of the future along their own paths, where once a web of roads got tangled.

For one long decade, contemporary culture and its arts tried to forget the depth of its wounds, playing off the economic surface of appearance. This was a decade that produced a limbo of projects—a senseless time mesmerized by the glitter of the moment and the explosive panacea of success, breathless from the choking hug of a social elite. It was only with the falling of the Berlin Wall and the crumbling of the stuffed Soviet dream that Western culture was forced to redefine its own direction and reason for existing. The project finally got back on its feet again, rejoining the spirit lost that night of December 1980.

But that fierce spirit of the 1970s is no longer anchored to the ground of the same reality. Like the shipwrecked people on Delacroix's raft, the models of these years travel clinging to the wreck of the Western system, floating adrift on the wave of its own irrefutable success. The planet has gradually been Westernized; but paradoxically through the homogeneous distribution of production modes—both economic and creative—the gap between different cultures has widened, setting free the most violent traumas, as the rings of a stone thrown in the water might come back to the shore transformed into threatening waves.

Differences among people are exacerbating the deception of a "balance" created by the consumption of the same goods and the same wrongful manipulations, such as that morbid ideal of a global communication created by the Internet. Through the infamous Web, the world deludes itself that it is getting smaller and cozier; whereas, on the contrary, the Web is merely, softly completing the destruction of the multiculturalism that has been so unrealistically practiced and so rarely achieved. Each voice, each face, each smell and sound will disappear slowly from our memory on the flat screen of the computer owned (soon) by every family in the world.

That is why art, with its ancient and paleo-cyber physicality, appears to be the only tool capable of protecting time and space in their original states and original dimensions, and the only place where our diversity will be allowed to grow and transform itself. In its

seemingly utter uselessness, art is on the verge of becoming the updated version of the machine gun that so many embraced at the end of the 1960s in the childish hope that it could serve a purpose. Today being an artist means being able to transform one's own project with the possibility of creating a traumatic change in the sclerotic relations that rule the life of the individual.

The electronic highways are expanding aggressively in the undefined landscape of the future. Under their pillars contemporary art is crossing the narrow paths of a reality quite concrete, because it is protected by the unique identity of each person. The intangible web of hypercommunication is faced by the uncertainty of art—the weavings of art may seem obscure, yet they are clear enough to produce an enlightening and irreversible experience in the individual. More and more, global relationships created by contemporary technology are working to hide the sclerosis of conviviality, of the immediate exchange, of a pure and simple look on the reality of things.

In a virtual democracy without real freedom, 28,800 bps is the tremendous speed of loneliness. If one day this immaterial Alexandrian library of optic fibers should collapse into a huge cyberstake, not only would all of our knowledge disappear but together with it our only identity would burn down, which has been built up day after day through invisible, compressed, and artificial devices. In the void of our memory our eyes would burn and the normal space of our daily life would be unbearable. We are running away from the center, leaving no trail of bread crumbs to guide us back to our original source.

The works of the contemporary artists appearing in *Echoes* function as those bread crumbs, taking us back to the roots from which our thoughts have departed. The earth is going through an incoherent expansion while contemporary art is defending the spiral of existence from its very small center, projecting it into the rest of the reachable world. Keeping the point of this spiral together allows each of us to get back to the meaning of our life, toward the creative element that nature granted us at birth.

If we look at art as a minor player in a system of profit and entertainment, we will not see any sense in those works of art that we encounter by chance. We will continue to avoid the many challenges that contemporary artists confront us with. If, on the other hand, we become aware of art as a microsystem, as a kind of totally independent ecology of behaviors, then we will realize to what great extent this system can preserve the freedom of a whole society from those dangerous distortions and threats that deprive individuals of autonomy from the voracious means of production and consumption. We agree, then, with the French philosopher Paul Virilio, who believes that art is a form of liberating resistance. Yet the contemporary artist is dragged away from her or his project by the sirens of profitable

accomplishments. Resistance is a difficult practice today, but those who succeed in it achieve a status even higher than that of the shaman; they become "echoes," figures in stillness listening to the voices of their communities, seeking answers to the meaning of existence.

Listening carefully, you may hear that the echo produces in the audience a deep reaction, quite opposite to that of "interaction," where the role of the viewer is altered. What is generally called "interactivity" is deception, forcing those to act who wish only to witness the event of representation. Being "interactive" means to accept the loss of our identity and our role, and to give up the total freedom of observation and meditation.

Every ritual follows an exact structure in which different actions work together. The ceremony is not at all interactive because, for example, the priest does not ask the participant to exchange experiences. What the priest does during the rite is to offer each person an opportunity to have his or her own unique, enlightening experience.

Art is an evergreen temptation to offer an experimental chance at new perceptions related to every square foot of our interior selves. At the moment, contemporary art is producing minimal rituals that hope to free yet transform the viewer. These rituals are not only of a spiritual and sublime nature, but are charged with social and political content that can fully succeed only once the works' formal functions halt the gaze of the witness for just that one instant longer, creating a deeper intellectual engagement. If this formal (and apparently superficial) capacity is missing, the participant is rejected and the artist has most likely failed, after too hurriedly asking the viewer to cross the diaphragm that creates the two identities, author and witness.

Artistic experience at the end of this millennium is becoming more and more complex, one of difficult balance and right scale. It is walking a tightrope with no safety net of "whys" below. At times it is tempting to dive into the global broth, where all of us are boiling and eating the same ideas, but this is a childish wish and a dangerous extremism that leads to the loss of all personal responsibility. In this dream of ecumenical upheaval, we forget that witnessing is a quiet, creative act. We forget that developing an independent judgment, a confrontation with the opposition, is the very making of culture that eventually leads us to shared epiphanic occasions.

The true witness, the one who faces the artwork, open and ready to serve as the right recipient, is also the ultimate beneficiary of the creative meaning of existence, which is otherwise consumed day by day into the flux of the point of no return. Indeed, what Gustave Flaubert feared most was the slow, irresistible journey of routine, daily things toward their final unsuccess. His fear is negated today by the continual technological revolutions that allow for new and broader hopes. Everything is obsolete and discontinued as soon as it is no

longer an idea; to achieve our goal is quite impossible because the goal itself is updated and pushed further away as soon as it is clearly established. We live an eternal tomorrow, which is the real damnation of our social culture. In this tomorrow, art is 100% pure rust, stuck to its own tiny present. The experience of this art cannot be pushed further away, because once you see it you basically get it; it is a project that rarely can be transformed into a real product.

Contemporary art is the fantastic package of enlightening ideas—it is what people look at, sell, and buy. We have no choice but to unwrap the package and achieve our ultimate necessity: surprise. It is through surprise that reaction rises to the levels of reality: to pleasure and disgust, indifference and misunderstanding, sadness and happiness, stupidity or ignorance; to violence, peace, love, and fantasy; to loneliness or comradeship. We must choose between the idea of living now, full-time, or living tomorrow, in an overflowing future where fewer choices will be available and very little room left for us.

The echoes of these artists offer a dated but most powerful alternative. Contemporary art is now perhaps the only concrete "server" of our society. A server that instead of disappearing with our words into a vague universe penetrates deep down into the center of meaning, into the endless diversity of the world. I titled this introduction "The Road Around," which may seem ironic for a book that tries to cross by foot the flow of languages dividing two millennia. The road goes around and not ahead, faithfully believing that the circular language of contemporary art still contains the information for achieving a new cultural revolution, one that could balance the technological earthquake that threatens—any minute now—to shake us.

Of course, we cannot avoid looking at the huge cracks forming in the spirits of millions of individuals obliged to give up all personal talents not related to the function of sophisticated electronic instruments. These are cracks that will sooner or later collapse the entire structure of our beliefs and the very idea of individuality that we used to apply to ourselves. Yet those artists who stay and listen, and whose patience this book should make an example, will keep sending back the echoes of their thoughts, clear and long. Hopefully, if we listen carefully, we will get used to the trembling of the transformation taking place underground. Like the people of the island of Stromboli, near Sicily, we will adjust to the constant and useless eruptions of the great volcano of endless progress, and the ocean, pure and clear, will become our only engaging perspective.

Many civilizations have been wiped away in the name of progress. Ours could be next. Because the trails that brought us to this stage of development have been mostly abandoned and overgrown, it is sometimes hard to understand just how we arrived at this point in our

history. Art may be the only universal creation of civilization that has been able to survive the acid rains of mechanic, nuclear, and electronic technology. Granted, it has survived through its own dazzling feats of transformation, perversion, or deception, but it has never disappeared, maintaining, arguably, a kind of *ante litteram* globality. The art that we call "contemporary" is more a residue of what art has been at many particular points of civilization. Yet its trails are the clearest of all, which means that each individual has always taken good care of his or her own creative energy, in order to protect the art that it produced. Thus the idea of art has been saved from the kind of erasure that has already canceled out entire cultures.

Today the message that art sends out is quite feeble—and hard to defend—but in the mirror of the past this message comes back reversed. The undying role of human imagination is projected outside the silver glass, with its unpredictable power of transformation and improvement. If so many artists today can reach a stage of "echoes," it means that a society still exists capable of sending forth at least as many sounds to express at least as many questions: a society that hides, behind its violence, a germ of true justice. We live by the constant responses of a technology that does not know any doubt, when all art is doubt—a question within other questions, like a Russian nesting doll of self-containing inquiries.

It is in our endless listening to the meaning and uncertainty of our contemporary identity that we will eventually discover to whom the debt for all our vision must be paid.

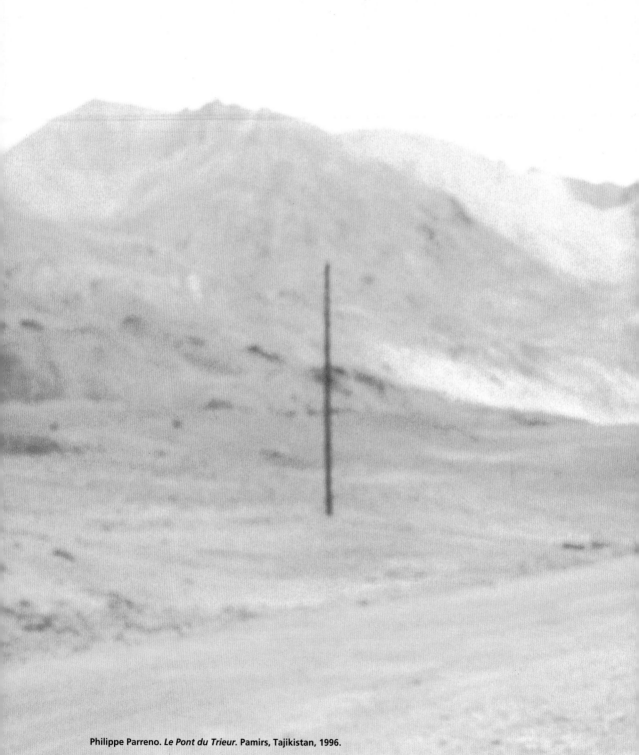

Philippe Parreno. *Le Pont du Trieur.* Pamirs, Tajikistan, 1996.

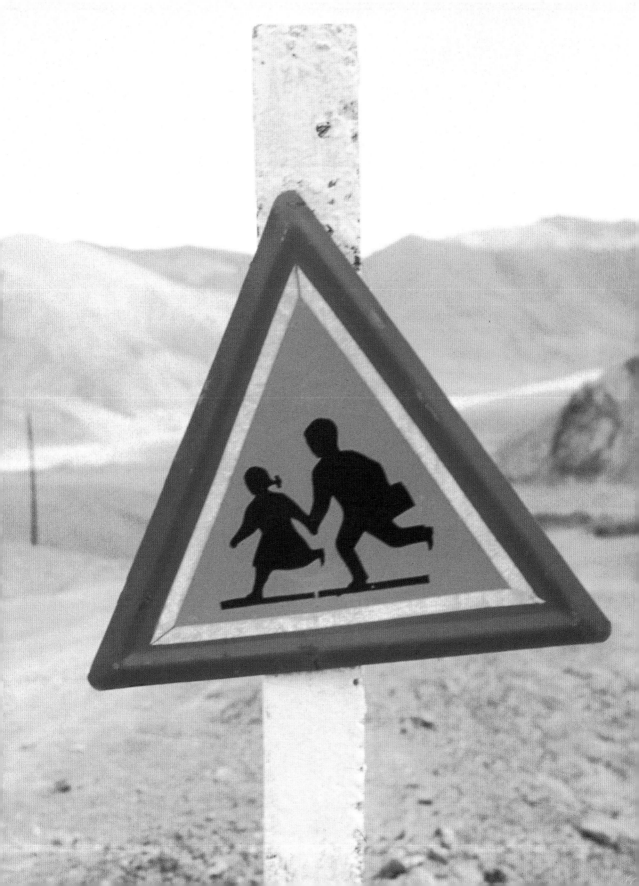

The Generation Game

Jeffrey Rian

Throughout the 1980s words like *postmodern*, *appropriation*, and *reproduction*, and prefixes like *neo-* and *re-* were used to describe art. Painters "appropriated" styles and images, sculptors used found objects, the term *re-photography* was applied to a "pictures generation"[1] of artists who "used" photography as an ingredient in their art. "Neogeometers" imbued older styles with new meaning. Many were represented by a gallery named after the movies, Metro Pictures. Their art evoked memories and resonances in which the styles, objects, or pictures they used became like playing cards in an artistic game of memory, most of which had been seen and half-remembered from the mass media and from art reproductions. They were also after a "look," one that they had seen in magazines, at the movies, and on television, which would serve as part of the atmospheric "feel" as well as aesthetic "frame" of their art.

Such neologisms also communicated something about the way artists were using images, materials, and media, and how they were seeing and using them differently than they had been in the recent past, such as in pop art. The language was different from Clive Bell's "significant form" or Clement Greenberg's "formalism" (in which art is a self-contained form of expression), and Michael Fried's "objecthood." Modernists treated art as a specialized form of communication, with its own language and manner of representation. Postmodernists used everyday images as a part of their "palette." They looked to modernism to explain their similarities and differences, defining themselves by its rules and using its language as a springboard for their "neo-" definitions. Their primary precursors were Marcel Duchamp, an early transgressor of artistic form, and Andy Warhol, who brought the media and popular imagery into art.

In a 1949 roundtable conference on aesthetics in San Francisco, Duchamp used the term *aesthetic echo* to describe an artwork's capacity to be reborn at another time by another set of viewers. He said that a work of art is independent of the artist, and that an "aesthetic echo" could be felt by new spectators, who may see it differently.[2]

In the 1980s similar echoes were occurring across media in different styles, in relation to the past itself, and in relation to the evolution in the electronic media and their evident effects on art. Echoes were also being felt across time, particularly in relationship to America's golden decade, the 1950s. The influence of television, rock 'n' roll, and later, Xerox and computer technology, was instrumental in the creation of terms such as *appropriation* and *rephotography*, as well as a shift in artistic orientation from avant-gardism to something that came to be a kind of contemporary anthropology.

Duchamp's "echo" also involves "taste," in which a sensuous feeling is created in a "dominating onlooker who dictates what he [or she] likes and dislikes." To submit to art's aesthetic echo, he suggested, is like being in love. Submitting to its pleasures involves a "mysterious constraint" in which a viewer not only participates but is a necessary part.[3]

Eight years later, at a Houston conference on "The Creative Act," Duchamp described artists as "mediumistic beings in a labyrinth beyond time and space."[4] He said that artistic decisions are intuitive, that artists are not entirely conscious of the creative act and its effects, and that posterity often decides this by other various decisions, including something like an "aesthetic echo."

Also at the 1957 Houston conference were Rudolph Arnheim and William Seitz, among others, and again, Gregory Bateson, who shared many of Duchamp's ideas. Bateson particularly was a proponent of the idea that art is a form of creative play. He said that artistic images are not about the image, because the image is a mere vehicle in the expression of something else. This something else is creativity, which, he stated, is not only "perception," but the "subject matter of art."[5]

Being a systems thinker, Bateson considered art's relationship to an artist as something like an egg's relationship to a chicken: "the artist is the picture's way of getting itself painted."[6] This related to Duchamp's idea that artists are "mediumistic beings" who use physical media like paintbrushes or chisels—and nowadays, video cameras—to express something about the world, and that they are also psychological mediums who convey messages about the environment at large. The artwork, as such, is the result of the relationship between artist and cultural environment: the agar in which art evolves and through which creativity is reflected. In this relationship internal communications are set up between what artists intuit and what they make, and between artist and audience. Their intuitions con-

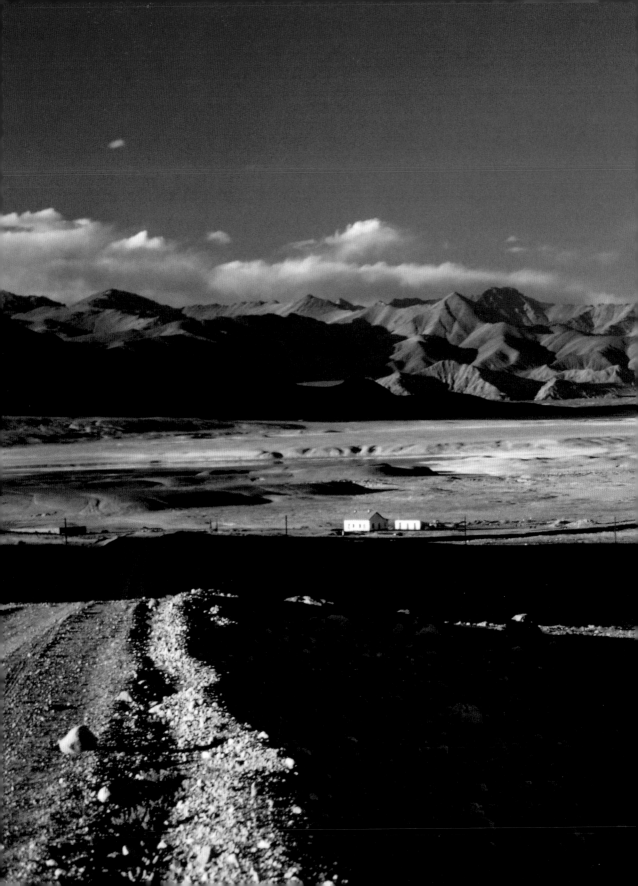

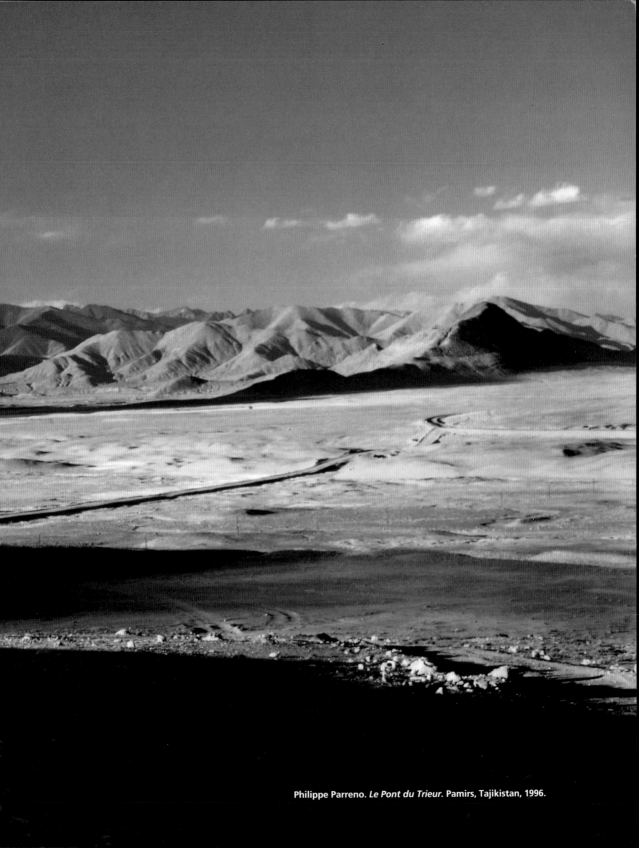

Philippe Parreno. *Le Pont du Trieur.* Pamirs, Tajikistan, 1996.

stitute conceptions. Conceptions are fertilized in the interaction of idea and materials. Revisions and calibrations compromise an artwork's birth. Yet, as Bateson noted, the part of our mind that consciously understands an artwork is very different from the unconscious that began its creation.

"The created image is conscious," Bateson said, "but the act is beyond description."[7] This may be because, as Duchamp suggested, art is enigmatic, like falling in love. Yet it carries a strong "aesthetic echo," an obscure mirror of some alluring Other through which we try to find ourselves.

Bateson called the "aesthetic echo" of the modern world a form of "aesthesia," a sensory perception, which very often is a "nostalgia for an unchanging world, or the aesthetics of trying to resist that change."[8] He described art as a search for unity, and a quest for grace and integration, such as the innocent grace of animals, which humans mask by deceit. The concept of the Fall, for example, is tantamount to an increase in awareness, the creation of beauty, and a fall into creative perception. Religion and art, as such, were once our means of recovering grace and integration.

In the modern world, artistic perception also involves a sensory remove or an attitude of "disinterestedness," which Lord Shaftesbury (1671–1715) and the Cambridge Platonists maintained was an inborn understanding of beauty and also an innate moral sense in people. This manner of contemplation evolved into "aesthetic distance," for which the appreciation of beauty is disengaged in a contemplative attitude or state of mind for which we are aware of an object itself yet detached from it. This is love at a remove: a state of mind in which one is visually absorbed but not physically concerned. It is entirely modern, because we are psychologically aware of the relationship between an object to that which it symbolizes. Form and substance are separate entities. In traditional societies minds "totalize" their thoughts and perceptions, according to Levi-Strauss (*The Savage Mind*), and image and idea are one by way of analogy. Analogies, in turn, are conveyed by "*adequate symbolism* and an adaptation of superior principles to human necessities."[9] Therefore, "the eagle or lion, for example, is not so much a symbol of image of the Sun as it *is* the Sun in a likeness. . . . [And to] have lost the art of thinking in images is precisely to have lost the proper linguistic of metaphysics and to have descended to the verbal logic of 'philosophy.'"[10] In other words, this is the Fall into "aesthetic distance" from which "aesthetic echoes" evolve.

Although we understand the distinctions between an object and what it symbolizes, no artist can guarantee to transport us there by the willful creation. As Duchamp suggested to Bateson, "no artist can say he is a genius and will create a masterpiece. It will create itself if there is the context for it. The work is independent of the artist."

Bateson: [Then] doesn't the work of art exist before it is made?

Duchamp: Yes, it has to be pulled out . . . but a work can run away with itself. It's a kind of race between the artist and the work.[11]

Here again the artist is medium, like Michelangelo chipping away at rock to reveal what lay intrinsically within it. The artist's calibrations act like a governor maintaining equilibrium so that, like an engine, it does not self-destruct or become overpurposive or simply illustrative. Calibrations also involve intuition and restraint. What preexisted were the codes by which art is made—in ancient times an *ur*-mythos informed the coding; later métiers and styles of representation created codes, later still artists began to excavate the mysteries and ambiguities of unconscious process and social patterning. Today they use the media as packagers of codes that can be reused and played back.

Bateson described artistic communication as "an approximate synonym of pattern, redundancy, information, and 'restraint,'" all of which are essential attributes in communication and of which art is a form of communication that is "internally patterned and itself part of a larger pattern."[12] To Bateson these larger patterns include the universe, as well as cultures or parts of cultures. But "[h]ow do you discuss emotion," he asks, "without destroying its life?" His answer was that conscious understanding is different from the unconscious process involved in creating art. And the "code whereby perceived objects or persons (or supernaturals) are transformed into [art] is a source of information about the artist and his culture."[13]

Bateson constructed much of his systems-based epistemology on the Theory of Logical Types adumbrated by Russell and Whitehead in *Principia Mathematica*, which states that classes of things cannot be members of their own class, the class being of a different "logical type." He adapted this concept to Alfred Korzybski's idea in *Science and Sanity* that maps are distinguished from territories—"a message, of whatever kind, does not consist of those objects which it denotes ('The word *cat* cannot scratch us')"[14]—and applied it to evolution, schizophrenia, and art, specifically how art conveys messages about the human quest for grace and integration.

Both Bateson (1904–1980) and Duchamp (1887–1968) would leave their marks. Bateson's few books would (unfortunately) be variously classified under Ecology or New Age, never quite finding bookstore categories to fit his systems thinking. Yet his kind of thinking was instrumental in a culture that by midcentury—the era of the teenager (*Catcher in the Rye*, 1951) and the first commercial computer (UNIVAC, 1951)—was evolving under the forces of electronics and would reach an evolutionary cusp in the late 1980s.

Duchamp would become the demiurge of a brand of art called appropriation, which was based on re-presentation. He was a questioner of classifications, particularly those of art and its métiers. His influence increased in the 1980s, when conventional practices had been all but abandoned by the descendants of an avant-garde tradition, which suggests that an "aesthetic echo" had occurred for him as well, largely because his ideas had gained new meaning in this period.

During the 1980s Duchamp's artists heard an "aesthetic echo" in themselves through mass media, for which they would become its mediums, reinterpreting what they and a coterie of critics were calling cultural signs and signifiers. Their art echoed the past as if the past itself had become an art form and was largely about technological transitions and social differentiation.

Duchamp and Warhol established models for artists to use differentiated patterns to communicate relationships between smaller and larger patterns. In the 1980s these patterns expanded into larger media, and the larger media were incorporated into art. More than anything, however, the postwar period was a time of transition, perhaps as significant as that from the Middle Ages to the Renaissance, in which modernism began to look like an endgame and in which slower media like books and painterly arts were being engulfed by faster electronic media. In this environment a new art would evolve, most of which was based on a youth-oriented culture, which would have little to do with handmade art and much to do with magazines and film-related media, and include disembodied voices called "talking heads"—voices more powerful than anything a romantic like Arthur Symons or a formalist like James Joyce could ever have imagined. Something deep and ambiguous and rich was occurring, something that infiltrated every aspect of life as we had come to know it.

Coming of age during this era required an adjustment of habits and perceptions, both conscious and unconscious. Life changed; art changed. Teenagers became a force, a social entity in the economy. Entertainment and service industries replaced bulk industry. Electronics changed perceptions. What we know and how we express ourselves—our sensory lives—changed. We feel different, act different, and think different than ever before. Yet we are the same engines of creation that we have been for fifty millennia.

Sunset on the Golden Decade

The American century's golden decade was the 1950s, when its self-image and its icons rose to international prominence. Television, entertainers like Elvis and Marilyn, advertising, gargantuan aerodynamic cars, Progress ("our most important product," as Ronald Reagan, host

of *General Electric Theater*, told Americans weekly) created not only a different world (*Welt*) but a different *Weltanschauung*. The children of the 1950s were the first television generation, the first rock 'n' rollers, and the recipients of an unprecedented postwar largesse.

In the 1950s our parents' utopia was represented in magazines like *Reader's Digest, The Saturday Evening Post, Better Homes and Gardens*, and in portable worlds like the Sears catalog. These were "perfect worlds," forms of representation, crafted and designed by adults to validate a world that was theirs by earned right and now alive in economic potential. These "perfect worlds" represented everything American—the social attitudes, racial separateness, and unprecedented power to shop. However, a new generation was coming of age and learning the ropes of adulthood in a way unlike ever before. They would read magazines called *Mad* and *Seventeen* and customize the adult world, turning cars into "hot rods," inventing hairdos like the pompadour and New Yorker, and influencing styles of dress, such as capri pants and fat-soled loafers called "bombers." They would become a new social entity, a new voice in a changing and increasingly technological society.

The word *teenager* entered the language in the gin-and-jazz 1920s, but before the late 1940s, it was used primarily as an adjective. In the fifteen years following the Second World War, the population of the United States grew by forty percent, the largest group being the children born during those years, with the teenaged population doubling between 1950 and 1976, growing to 34 million. Teenagers generated a separate reality with their private argot including words like *cool, chick, far out, loser, weirdo, beat, drip, square, drag*. They would inspire new genres in film, literature, and music, and earn as well the term *juvenile delinquent*.[15] The age itself imagined this new group. What evolved was a collective voice in a transition between industrial and electronic cultures, and between a "goods"-producing and a service-oriented economy. The year 1956 was the Year of the Teenager—a phenomenon usually reserved for something new.[16] That same year Elvis's first hit, "Heartbreak Hotel," was released, and Allen Ginsberg published *Howl and Other Poems*.

One idea fostered during the postwar period was to focus on domestic revitalization with the same intensity that the country had focused on the war effort. Bearers of the Depression attempted to rekindle the myth of a chicken in every pot, a TV in every home, a car for every driver, and a college education for every (white) American child. In the 1950s, not only did the freeway and superhighway transform America's cities and landscape in its futuristic vision, but education flourished. Outside schools, however, various media began to play against each other, creating dissonances between the way teachers taught and how children experienced life through the media, resulting in a rupture between book-learning and the images about which they were entirely self-taught.

As teens entered late adolescence the entertainment arts came to represent their utopia, presenting a world with another reality even more radiant than that of *Reader's Digest, The Saturday Evening Post,* or the Sears and Montgomery Ward catalogs. Shows such as *The Adventures of Ozzie and Harriet, Leave It to Beaver, American Bandstand,* and *The Mickey Mouse Club* played the parent's reality against the child's. Ozzie Nelson never worked. The dancers on *American Bandstand* were real Philadelphia teenagers, as were the Burbank, California, Mouseketeers. Reality blurred, and entertainment seemed a way to escape the responsibilities of adulthood as fostered by parents and schools. It was then, and it still is. The psychic residual effects of television and entertainment radiated throughout America, and TV bohemians like Ozzie Nelson and Maynard G. Krebs influenced a suspension of agreement in the transition between teenagehood and adulthood, which for many children of the 1950s would, in the years to come, extend until middle age: if you were lucky enough to transit yourself into the arts and entertainment media, you could effectively avoid that heinous concept that made Maynard cringe—*work.*

The arts became an alluring lifestyle. Television and entertainment imbued the word *art* with career potential. Universities were filling up with students, many of whom studied art as an alternative lifestyle as well as a career. Many played in garage bands, in which musical education was of no importance. Simultaneously, the art world would expand its métiers to include the media and its ubiquitous images.

The prevailing contemporary art, however, was abstract expressionism and European modernism—the avant-garde and the tradition of the new. But abstract expressionism was by and large philosophical and nature-based; it was made by a generation born before World War I, and its themes revolved around the nineteenth century's fascination with Attic Greece, philosophical questions of Being and the Absolute, as well as the psychological intensity of Nietzsche, Freud, and Joyce. Nietzsche's *Ubermensch* was adult to the core. Freud's psychology was based on parent-child relations; it emphasized maturity. Abstract expressionists also abhorred anything decorative in art. They felt that unlocking the unconscious would be their better guide. Conferences such as the two attended by Bateson and Duchamp discussed the ontological nature of art, its creative and formal aspects. Aesthetics and philosophy were vital issues to artists, despite Barnett Newman's dictum that aesthetics is to an artist what ornithology is to a bird. Artists were serious, even in their playfulness.

By the time of Robert Rauschenberg, Jasper Johns, and the Beat poets, nearly all of whom were born in the late 1920s, artists and writers would begin to draw upon social and environmental changes. They would look back to the playful high jinks of the dadaists and surrealists, to the Roaring Twenties, the pre-Depression years in which they were born. They

listened to fast jazz (bebop) and were caught up in the throes of a postwar differentiation. Through them we would hear the first inklings of a different type of art and even a different variety of *Ubermensch*—one that could invoke the night and the electric intensity of rock 'n' roll. The Beat generation's mix of jazz and Zen would look at life from the purview of an outsider with no real interest in square jobs or going straight (television trivialized this attitude in the character of Maynard G. Krebs). Their artistic play struck the very heartstrings of people younger than themselves.

To parents who had grown up with war and its demands for instant maturity, Elvis Dionysus struck fear in their hearts. He ran counter to their utopian modernism. Yet for those (of us) in the threshold, conflicting messages were constantly being sent, because the media enshrined and fed upon youth, and teachers and parents told us to ignore the media and to grow up. But they could not fight their distracting influence. More energy was generated in dens and rec rooms and backseats than in any classroom. No one was prepared for this; only recently have the media been addressed in classrooms, and their images and advertising's twisted rhetoric taught alongside books. This was not the case then, nor even fifteen years ago.

By the mid-1960s, the members of the first television generation were in their late teens and early twenties. They would rebel against a cruel and useless Vietnam War, as well as the American myth fostered by dark-suited politicians and admen. Their rebelling, however, arose from their own privileges, and the conflicting messages of their parents' postwar politics and communist paranoia. Their reactions suggested that the American myth, the war, and communist paranoia were all a ruse. And they were justified.

Because the majority of recipients of postwar largesse were also white, their privilege made them different from their revolutionary counterparts of the civil rights movement and Migrant Workers Union. And liberal as they thought themselves, they hardly comprised a downtrodden leftist core, nor did they embody the discontent of the Cuban proletariat upon whom they modeled their improvised revolution at home. Yet this group, raised in peace and lulled by television, was the engine of the radical Left. They influenced an end to the Vietnam War, supported minority causes and civil rights, and planted the seeds of today's multiculturalism. They recognized the impossibility of the utopia they had been fed. And separately and together alternative groups revolted against the social patterns that they felt compelled to change, although they never quite found succor with each other or among themselves.

Revolution then was nothing like it is today, which emanates from an angry, radically conservative and religious Right. It did, however, reflect a change in perceptions, many of

which arose among a new body politic that came to prominence in the 1950s and which extended adolescence—that nebulous evolutionary period between childhood and maturity—by focusing the world on teenagers.

Like the 1950s, the 1960s also added to our vocabulary, giving us *hippie, psychedelic, acid, tripping, flower power, electric Kool-Aid* (for an acid-laced soft drink). Young people dressed in motley outfits like Pre-Raphaelites or dazed prophets. They sought the inner visions of mystics and crazies. They took tabs of blotter acid or peyote buttons to access electric inner visions. Naturalism blended with electronics. And from this psychedelic vista would evolve today's interests in natural food and in more aesthetic lifestyles.

By the late 1970s the hippies had cut their hair, stopped taking acid (many rediscovered cocaine, long considered nonaddictive, which became the new drug of choice), and started entering the work force. The economic power of the 1950s had been dissipated in Lyndon Johnson's "guns and butter" policy. The country was trying to recuperate from an OPEC oil embargo, which resulted from the Yom Kippur War of 1973—as well as recover from a costly war in Vietnam.

Simultaneously, electronic technology was beginning to replace the electromechanical wonders of the 1950s and 1960s. IBM Selectras, mimeographs, transistor radios, and gas guzzlers were replaced by personal computers, Sony Walkmans, and Japanese-made compact cars. Where parents in the 1950s moved to suburbs and built malls and fast-food chains and superhighways, America's industry-based economy was shifting to a service-based economy, a large part of which was the packaging and processing of lifestyle. All of this, however, was made possible by the epic growth and industry-styled education of the 1950s; it created the shift in professions from producers to those such as lawyering, consulting, designing, waiting tables, bartending, or working in fast-food chains. Resource production went abroad (fewer of us were willing to work in mines and mills). And much of our disinterest was due to postwar parental largesse.

The 1950s would not end, however. The golden decade would be brought back in souvenir fashion during the Reagan administration, when the baby-boomers (a group defined in 1978)[17] were entering middle age—now no easy task considering the fact that entertainment was geared for people between the ages of sixteen and twenty-two, mostly males. But in many ways the 1980s echoed the dreams and purposes of the 1950s, for between an epic surge in the Dow Jones in August 1982 and the stock market crash of October 1987, it would seem like the 1950s had returned.

Instrumental in the epic growth of the 1980s was the election of Ronald Reagan, who slept until nearly nine o'clock on the day of his inauguration, 20 January 1981. Departing

president Jimmy Carter had not slept that night. He had called President-elect Reagan at 7:00 A.M. to announce the imminent release of the hostages in Iran, but Reagan's aides would not wake him. Carter had hoped to announce the hostages' release in the final hours of his tenure, but he never would. Reagan became president at noon, and the first plane of hostages to leave Iran took off at 12:35 P.M.[18]

Many of the television generation, now reaching professional maturity, helped to elect the avuncular representative of their parents' generation. Ironically, he was just the sort of slick-toned, commie-bashing authority figure they had spent the late 1960s rebelling against. But it was a nostalgic time. A kind of devolved revolutionary spirit had set in that looked longingly at the safe, happy, conservative 1950s as the font of its self-identity.

The country as a whole dreamed of reaping the same harvests that the golden decade had inspired. But in 1981 interest rates were around 21% and the country was in a period of stagflation (economic stagnation with inflation), which had been rising almost steadily since 1973. In fact, with the exception of Texas (which would end the decade in shambles), America was in recession.

To curb inflation the incoming laissez-faire president fostered a different economic policy, much of which was based on a doodle that Arthur B. Laffer drew on a cocktail napkin in 1974. The Laffer Curve suggested that the optimum ratio between taxes and revenues occurred on the low end of the tax scale; therefore, tax cuts would stimulate what was called a supply-side, or "trickle down" economy (i.e., money falls like manna from the rich—many of whom giddily watched their money market accounts steadily increase).

Reagan paved the way for "trickle down" by easing the rules of government, authorizing deregulation and privatization—practices that went hand in hand with his economic policy. He also had a calming, almost soporific influence. And while lulling us to sleep he relaxed controls, which also made life easier on himself, especially since a March 1981 gunshot wound had left him more injured and incapacitated than the nation was led to believe. This relaxation of rules had the opposite effect on business—not surprising, considering the fact that his firing all of the striking air-traffic controllers helped to signal a Darwinian awakening in the business community. His rhetoric was based on the idea that profit is a god-given right, which helped to fuel an unprecedented increase in commercial trading, creating, in addition, a veritable explosion in the number of lawyers, consultants, brokers.

Other pivotal characters of the 1980s were Ivan Boesky and Michael Milken. Milken was the archetype of an '80s overachiever and was instrumental in initiating a creative form of investment that took advantage of corporate debt—virtually a kind of profit made from fool's gold. Abetted by computer trading, the constant movement of paper money gen-

erated unprecedented profit for those servicing the movement.

An obsessive student and an inveterate loner, Milken graduated Phi Beta Kappa from Berkeley in 1968. Never interested in the rumblings occurring in his own generation, he earned an MBA from the Wharton School of Business, and soon after could be seen wearing a leather aviator's cap under a miner's lamp on the predawn bus from Cherry Hill, New Jersey, to work at a bond brokerage house called Drexel Firestone, pouring over financial reports, scouring the nation for hidden profits. He exemplified the newly coined term *workaholic*, and soon discovered that potentially sound companies that were unable to raise capital to finance growth were candidates for corporate takeovers. Their debt could be used as tax write-offs, parts sold off and depreciated, and the most profitable parts retained, merged, or sold. He used his own brokerage firm's resources to underwrite a presumably high-yield bond, called a "junk" bond (which because of a company's debt could be bought at a low price). The risk was great, but a careful investor could turn a small investment into large profit by selling shares to hostile takeover dealers.

Milken helped to reshape the financial world, becoming the "junk bond king" and symbolic leader of a growing phalanx of corporate "raiders" who, during the Reagan years, tallied more than two trillion dollars in trades—beginning with a record high in the Dow Jones Index in August 1982 and lasting until October 1987.[19] By the mid-1980s an MBA was the preferred university degree, with graduates from the better schools starting out at $80,000 a year and using corporations like playing cards in high-stakes games of chance. Not only small companies were targeted but also large ones such as R. H. Macy, Walt Disney, and Gulf Corporation.

The rationale for corporate takeovers was that inefficient corporations could be made more efficient by restructuring them; and Milken and Boesky were credited with boosting the financial market during a time when real resource production was in steep decline. Enormous profits were made in "green-mailing" (buying blocks of a company's stock so that the company has to buy them back at inflated prices), "mergers" (transferring companies' resources to one surviving company), and "leveraging" (LBOs, or leveraged buyouts, using borrowed money to buy controlling interest in a company). However, not only did it restructure corporate America (already stressed by its sagging industrial base) but it added to the country's debt, and by 1985 America had become a debtor nation, and the Great American Debtscape had become both a burden and a shadowy resource.

One thing the 1980s proved was that American business is astonishingly inventive, for not only did the entertainment industry begin to flourish, but Wall Streeters discovered a way to create profit from debt—and America's service-based economy, which evolved

from agriculture, mining, and manufacturing, expanded in the fields of communication, public relations, wholesale and retail trades, finance, insurance, real estate, government, entertainment, and food services. By 1990 about three-quarters of U.S. employment was service related. Ultimately, however, the fruits of the Reagan administration's deregulation policies were the crash of October 1987 and the Savings & Loan debacle, both of which created a tsunamilike shock wave and an economic slump that radiated into every sector of society. And by early 1990 the sun had set completely on the American century and its most glowing decade.

Those five years gave us one final burst of '50s radiance before the reality of a new age would set in. This sunset also was willed into being, not only by the aging postwar patriarchy but by the children who had rebelled against it and who nonetheless longed for it. For in rebellion, they wanted to retain many of the traits bestowed upon us in the 1950s. This is a common attribute of generational change, for succeeding generations naturally follow the rules by which they have been educated.

During the 1980s advancements in electronics and the entertainment arts mirrored the often troubling social, environmental, and political changes that were occurring at a breakneck pace. Innovations and highlights included the first compact discs (1983), CNN (1980), MTV (1981), glasnost and perestroika (1985), van Gogh's *Irises* sold for $53 million (1987), Solidarity and the crumbling Berlin Wall (1989). Social stresses were John Lennon's assassination and Love Canal (1980), the coining of the acronym "AIDS" (1982), the discovery of an irreversible greenhouse effect (1983), the deteriorating ozone layer and Chernobyl nuclear disaster (1986), the Wall Street crash and Savings & Loan collapse (1987), the oil spill by the Exxon Valdez (1989). We learned new terms such as *MS-DOS, HIV, drive-by shooting, serial killer, crack cocaine, down-and-dirty, gridlock, ethnic cleansing, hate speech, channel-surfing, workaholic, repetitive stress injury, computer virus, fax modem, morphing, information superhighway, cyberpunk.* The divorce rate increased, the two-income family became a way of life, and credit cards nearly replaced savings accounts. Not only did the cold war terminate, but America's position as leader in bulk industry also dissipated. And we would become more political and acerbic as the events of the 1980s devolved and our nostalgia for the 1950s evaporated.

Where business flourished on a reutilization of industry, art successes were phenomenal as well, with the art world functioning as a counterenvironment to the successes of the larger environments of business and entertainment. Artists exploited the past for its styles. People dressed smartly in nostalgically designed ready-to-wear by Ralph Lauren and in stark minimalist designs from Agnes B. and Comme des Garçons (mostly variations of black); they

used the word *project* to add importance to sideline activities and to give art activities a sense of professionalism. Indeed, perhaps they waxed success and potential if only to attract them.

Art World as Other World

Art reflects the environment in which it is made, echoing in its condensed facets and symbolic traces the ethos and outlook of an age and its people. Through art, unconscious processes can be elicited, and some of the values and wonders of a people can be discovered. But what this environment comprises and composes, like agar in a culture medium, is as elusive as water to a fish, for as we alter it, it alters us.

Environments are aggregates of conditions, elements, artifacts, and social milieus that extend from conscious process and seep into habitude, utility, and forgetfulness. They are everything known and consigned to our self-giving, befitting the very shape of our survival and perpetuity. Human environments are unknown by Nature yet wholly subsume her. They are also symbolic, like our fulfillments in awards, diplomas, licenses, and sacraments, the way we process our senses, the way we speak, how we accoutre ourselves. They become more explicit if you pull a muscle, break a leg, or move to a foreign country, or if one environment, say television, overtakes others, like radio and theater, both of which were reformatted by television until TV producers began to differentiate television from earlier media.

Art reflects the elusiveness of symbolic environments algebraically, with variables and unknowns representing metaphorically the larger environment. Based on their intuitions, artists create messages that audiences have to decode. But as Bateson noted, it is not only the codes of representation that are the subject of art but the creation of codes themselves. For example, artists and critics created the word *appropriation* to describe a new art. Yet something else in the environment created the atmosphere that engendered it. Artists' "codes" expressed the larger codes that they intuited from the environment.

Language is the most primary of human coding systems, and the most elusive, for the sources of language are unknown, yet it has evolved and externalized from utterances into visible codes that came to emanate their own hardened-seeming dimension. From speech to hieroglyphs, manuscript writing, printing, neon signs, preferences agglutinated and accrued, and in that process the characteristics of what and how we know ourselves are shaped and reshaped, determined and redetermined. Art is both a subset of language and a parallel system by which artists transform feelings into forms that may or may not have linguistic affinities.

Since the first inklings of writing we have "descended into the verbal logic of philos-

ophy" as Ananda K. Coomaraswamy wrote in his essay, "Primitive Mentality."[20] This Fall into self-consciousness was made possible by writing, from which philosophy, literature, and science evolved. The history of literacy versus the mythopoesis of orality has been explored by Milman Parry, Alfred Lord, and H. J. Chaytor, among others. Their revelations, beginning in the late 1920s, particularly those concerning the cliché-based structure of oral tales, helped scholars to understand the biases of literacy and orality. For example, oral cultures live by the clichés and puns that literati abhor. Clichés are needed for memorizing the oral "encyclopedia," for all knowledge is shared in the minds and memories of a preliterate culture. However, the printed texts of a literate culture, as Walter Ong noted, "are not real words, but coded symbols whereby a properly informed human being can evoke in his or her consciousness real words, in actual or imagined sounds."[21] Within the printed word orality still resides. Beginning in the late 1950s Marshall McLuhan (particularly in *The Gutenberg Galaxy*) and Ong, among others, examined the effects of electronic technology on literacy. They suggested that the effects of electronics on writing were as profound as the effects of writing on orality, or the printing press on the technologizing of language. These changes influenced art.

Technology had already been described nearly a century before as influencing our knowledge and perceptions. In 1872 Samuel Butler published *Erewhon*, an anagram for nowhere, in which he described humans as the reproductive organs for making more machines. In other words, we perpetuate a mechanical world out of habitual dependency, meaning that the technology we create to assist us in turn influences us.

In Butler's century science and industry flourished. It would create what Alfred North Whitehead called "the invention of invention." Darwin positioned Man at the top of a biological heap that rose up in violent bursts from the infusorian, and survived by will and what Jean-Baptiste Lamarck called the inheritance of acquired characteristics. Robber barons took this idea to heart in Manifest Destiny: California was America's by right. (Andrew Carnegie's own contract with America was based on land the government gave away to make a railroad. Using his steel monopoly, he made inferior tracks so that he could replace them. He amassed an enormous fortune and an unprecedented art collection.) In that century, the Protestant marriage of the bible and capitalism, of God and business, also was born, and would be born again in the 1980s, when God and business were not only spoken of in Reagan's politics but by overstimulated evangelists with direct lines to viewers' PIN numbers.

Art, too, would become liberated from its classical confines and struggle like Darwin to find its own roots and self-identity. Color, form, and abstraction were examined by impressionists, cubists, and constructivists. The inner landscape was explored by symbolists,

van Gogh, Redon, Gauguin, and later by surrealists; chance and play, by dadaists. The sounds and images of industry and electricity entered into art with futurist Luigi Russolo's *The Art of Noise* (1913), Mondrian's gridscapes, and Prokofiev's *Pas d'Acier* (*Dance of Steel*, 1929). In the early 1920s Satie would prefigure Muzak in his *musique d'ameublement*, as well as Philip Glass's minimalist repetitive and synthetic music. And since then electricity has increased, generating a low-decibel atmospheric hum for which music and Sony Walkmans may act as a kind of anchor or counterenvironment to the noise around us.[22]

By the 1950s innovation and invention had become our tradition. The métiers of painting and sculpture had become genres, subsets of art, academic pastimes bordering on kitsch. Artists were expected to explore possibilities but not necessarily to develop a traditional technique. They could work with and use such métiers to develop a style, borrowing from conventions, combining them with photographs and everyday materials. Art's borders expanded; its definitions, loose as they were, became more elusive. Photography, film, television, and magazine images were brought into art history.

A "poststudio" art proliferated in the late 1960s and 1970s in performance, conceptual, earthworks, environmental, and Fluxus art, which was generated by artists bred on dada, action painting, Beat poetry, and exploratory art. But in schools art by a slightly younger generation was still studio-oriented, partly because university curricula were based on the career-oriented specialism that proliferated after the war, which fostered the idea that a personal style could evolve into a career in art. They taught "exploration," but art departments often hired teachers based on a specialty, which meant that "realism" was taught by the in-house realist and abstraction by an "abstract" specialist. Painting and sculpture soon became "on the job," or context-specific métiers, which meant that traditional métiers were not ends in themselves. Images and styles came to be used conceptually, combined and juxtaposed to suggest associations and memories, or what Baudelaire called "correspondences." And unlike the performance, conceptual, and situationist artists of the 1970s, the next generation incorporated the "look" of the mass media into their media-based art. They did this by "appropriating" images and presenting and combining them in various ways.

In *Orality and Literacy* Ong used the term *secondary orality* to describe electronic-based culture. He was referring to the orality of telephones, television, and radios, and to the fact that writing was a support medium for these other media and, more significantly, that "postliterates" were beginning to think differently. He wrote: "Secondary orality is both remarkably like and remarkably unlike primary orality. Like primary orality, secondary orality has generated a strong group sense, for listening to spoken words forms hearers into a group, a true audience, just as reading written or printed texts turns individuals in on themselves. . . . Unlike

members of a primary oral culture, who are turned outward because they have had little occasion to turn inward, we are turned outward because we have turned inward."[23] In terms of images, recognitions also are affected by information increase. And one of the results appears to be what systems thinkers call pattern recognition.

In oral cultures, pattern was applied to things as an ordering principle. For example, in the ancient quadrivium, a blend of arithmetic, geometry, music, and astronomy, number and pattern were applied to geometrical patterns and their divisibility. The golden mean, or golden section, was an architectural unit that was based on the body—the foot to navel and navel to top of head being the basic patterned relationship of A is to B as B is to A + B— also an angle of 63 degrees. Architects through the Middle Ages based their constructions on this geometrically patterned system of measurement. Moreover, as a part of the seven liberal arts, the quadrivium was applied to the pattern of knowing things in the world, while the trivium, grammar, rhetoric, and logic or dialectic, provided the means of oral expression.[24]

This pattern of knowing survived in some form until the nineteenth century, when rhetoric was abandoned in education. There are some carryovers that remain, such as the oral defense of one's dissertation, which come out of ancient dialectic and disputative education. Our understanding of these ancient systems was more clearly revealed when writing started to be affected by larger communication systems, such as newspapers, the telegraph and railroad, and electricity, during a time when the West was expanding its margins across the globe. Our stretching of communication boundaries would bring cultures closer together only to reveal our differences.

Patterns today are common occurrences in all of our "fast" media. Knowledge has become transformed by repetitive increase in the "environment." We see things before we learn anything about them; familiarity has replaced in-depth knowing: kangaroos, Inuits, Joyce's *Ulysses*, Prince Charles's affairs are ambient to the environment and tell us varieties of things, none of which might suit a specialist's knowing. Still, such "free-floating" patterns become knowable in a way that is unlike the way teachers inculcated knowledge. These differences also have created dissonances in the organization of facts that literacy and a literate education relied upon. Moreover, mixed messages are being sent between the two, and through the mass media a diversity of patterns in culture, race, and ethnicity have become more explicit: history has come to be seen as an expression of imperialism and progress, authors as encoders of contexts, contexts the containers of events, and so on.

Bateson defined information as a "difference that makes a difference." Living in a world of information overload, in which redundancies create noise—and *noia*—can eventuate in varieties of paranoia. As a result, recognizing symmetries, samenesses, and differences are a

necessity but also a stress factor. Sensory experience provides tactile sensing, which enables us to piece together differences and similarities through pattern recognitions. These are not the same as analysis, isolation, and linearity, which are the mainstays of literacy, but we can use literacy to support our understanding of patterns.

Patterns are also the evidence of deeper meanings and resonances that are being expressed. And pattern recognition allows us to penetrate those levels of meaning, or different "logical types," to use Bateson's understanding of pattern. Already we are learning to read such patterns as children do—outside institutions. What evolve slower are the processes of learning to learn about these patterns. Art, however, is one way to approach an understanding.

In art, patterns are recognized and reprocessed in style and content. Picasso invented patterns for simple subjects—still lifes, portraits, landscapes—which a disgruntled critic called "cubism." Mostly Picasso applied a style that he (and Braque) created to everyday subjects. Yet an underlying idea of the cubist style was its shattering of the picture plane and the one-point Renaissance perspective. It also suggested film's use of montage, the simultaneity of modern life, and particularly the modern world's fracturing of margins and centers in the newspaper's simultaneous presentation of the world's regions on a single page. A man reading a newspaper, even Picasso himself, would not necessarily be conscious of these similarities. Yet time reveals larger patterns, and changes in thinking as expressed in media such as books and electronics can reveal other pattern relationships.

In the context of a newspaper, for example, lies our preference for distance and our removed relationship to things like art and language. For if we were truly emotionally involved in our language and in the images we show in newspapers, we could not read or see them without feeling horror and revulsion. Like our art, we are detached from the sensory world of our forefathers for whom Homer's "winged words" were events in which one was emotionally involved and totally immersed. Yet we see this in retrospect. And just as Plato wrote in *Phaedrus* (275) that writing destroys memory, he could only say that because he could write. From our own vantage we conceive different patterns and perspectives. Words like *appropriation* say something about electronics and its effects on how we experience what is private and what is public.

Artists operate like probes, searching for means and materials to communicate feelings or ideas. They echo their environment and seek ways to step outside it in order to discover different perceptions about it. Generally they attempt to unify and encompass; often they seek a different order of understanding, which is engendered by some kind of recognition they have intuited and are attempting to communicate. Artists process their intuitions, and suggest relationships analogically, and we interpret them with the hope of understanding

things more deeply, or at another level of abstraction.

Cubism was conservative in content but radical in form and style. Later abstraction-ists expanded space and time. Clyfford Still compressed the rugged American landscape, us-ing a palette knife to create a tactile surface. Barnett Newman sought the absolute, such as the burst of creation in a single vertical line on a monochrome ground. Jackson Pollock danced his surfaces, and in a painting like *Autumn Rhythm* conveyed the color of landscape as well as the calculated steps of a Martha Graham dance. These artists were extending modernism and the sensory perceptions opened up by science and technology. Their art was literate-based and teleologically oriented. It was founded on reductionism and specialism. The language of art also became condensed like that of mathematics, specialized in its focusing of thought into image. It was Warhol, however, who played a pattern in electronic media against a pattern in art, summoning advertising's exhaustive redundancy and the repetitiveness of an iconographic art.

In traditional iconography, images and representations are fixed according to con-ventions, with objects standing for something else by a resemblance. "The parts of an icon," according to Coomaraswamy, "are not organically related, for it is not contemplated that they should function biologically, but ideally related; they being the required component parts of a given type of activity stated in terms of the visible and tangible medium."[25] Warhol's im-ages were both human and supernatural. Marilyn and Elvis rose to supernatural status by way of a tacit cultural agreement. No one really created them, but like symbols, signs, and street slang, their status was conferred through repetition. This conferral was unconscious, even though the publicist's intention was purposeful. Their celebrity status was generated in and by the media, but a tacit public conferral validated it. They became famous for be-ing famous. Warhol, however, was ambivalent about his subjects and more interested in sub-suming them into his art. Yet on a broader level he created an art based on patterns that were created by people through the media. It looked not back to the art of the ages but at pat-terns in society and the media. And it looked through the eyes of a younger mentality.

By the late 1960s Warhol had become a modern Rubens, recording in industrial fashion America's golden decade. His art was made in a place called the Factory, his subjects were celebrities, car crashes, electric chairs, drawings of front pages of newspapers. Everything could be easily produced using a camera and large silk screens. He also employed advertis-ing's greatest ploy: putting on the audience, wearing them, giving them what they wanted, playing back in a redundant feedback loop the images they talked about most frequently. Warhol's environment included television, magazines, rock 'n' roll. He presented himself as a virtual screen—a yes-man, sounding board, and social chameleon, cool as a noncommittal

rock 'n' roller suspicious of his interlocutor while being accommodating, always agreeing, always alluring, always presenting a different facet, always ambiguous in his seeming directness.

This is also an iconic aspect of art, for icons never say an explicit "no." Instead, they present "yes" as an inclusive pattern. To be excluded from the pattern, such as Christianity, is to embody the "no," for which no explicit negative marker is necessary. To explain the idea of iconic communications, Bateson uses the example of how a small and a large dog would enact a mock fight. They enact "yes," sniffing and growling, in order *not* to fight. He also suggested that the small dog would know something that the larger dog does not know, simply from their differences. This relationship is similar to that between artists and nonartists, from whom, through a spiritual wound or some form of "outsider" knowledge, art often arises.

By the 1980s the two most salient references in American art were Warhol and Duchamp. Warhol exemplified the successful transition from the everyday to the transcendental, which included the metaphysics of money and entertainment. He communicated something about the power of the media to influence the creation of iconographic images. Duchamp represented the intellectual side of art's metaphysics: the use of found objects as a way to transform meaning. He was not necessarily saying that a urinal is art, but that mass production was encroaching upon the handmade.

What distinguishes the everyday artifact from the artistic one, however, is its purpose; and the artist's intention is, as Bateson suggested, an integration of unconscious and conscious processes. Duchamp was also interested in the creative process as much as the artifact. By appending his signature he made the Readymade unique, but in no way did he challenge the forces of mass production. Warhol enlisted the aid of industry when he autographed a soup can. He also learned something from rock 'n' roll and the mass media, and found celebrity for himself in the perennial play of art.

Learning through Electricity

By the early 1980s postmodernism had already begun to be discussed in literature in the works of John Barth, Jorge Luis Borges, Italo Calvino, William Gass, John Hawkes, the French Oulipo writers George Perec and Nathalie Sarraute, among others, and in the vernacular and commercially styled architecture of Michael Graves, Robert A. M. Stern, and Robert Venturi. But the word itself had not yet become commonly used. Yet the styles and motifs of literature and architecture had become subjects themselves for writers to experiment within language and form. Once artists began to crossbreed studio art with vernacular and commercial images, *postmodernism* was applied as a blanket expression to the work of those who

had grown up with television, fast advertising, fast film, and fast magazines, and who incorporated into their art the "aesthetic echo" of slides, reproductions, and magazine images they had grown up with.

Jack Goldstein, Sherrie Levine, Robert Longo, Richard Prince, David Salle, Cindy Sherman, and so on, are all children of the 1950s who "scavenged" (as it was called early on) images and styles, and reused them in a manner that reflected the environment in which they were raised. Using discrete objects and images, they elicited a resonant mnemonic echo, or an "aura," to borrow from Walter Benjamin, a key figure in 1980s critical "discourse" who first suggested that the "reproduction" itself was instrumental in art, although potentially destructive to artistic originality. But postmodernists were using the "aura" as an "echo" to convey "semiotic" resonances, meaning that the style had an implicit quotient, like a tarot card, which could be released and interpreted in a manifold of ways, depending on the "theory," or theoretical methodology one chooses to see it from.

Images evolve in meaning, too. For example, the photograph of a smokestack, which might have represented work and progress to Depression-bred parents, came to represent pollution and waste. This change in perspective, which evolved in the revolutionary 1960s, had also become a stock-in-trade to the "pictures generation." One could echo in different directions, across moieties, and crossbreed styles to unlock codes beneath codes.

Compared to their immediate precursors of the 1960s and 1970s, particularly conceptual and performance artists, the "pictures generation" was not only image-oriented but also more conservative. Here the two generations were at cross-purposes: artists of the late 1960s and 1970s wanted to get away from and even destroy the gallery system, while the younger artists made a post-pop genre of art that was media-based, take-home, designer-related, and magazine-slick. And this new art was taken home in unprecedented quantities.

By treating painting, sculpture, photography as genres of art, or as established forms, the way a writer can write police or sci-fi books, artists could explore and manipulate categories of form and style, and neither claim an avant-garde affiliation nor deny their own testing of boundaries, for the boundaries they were testing had changed. Pictures and words were used together. Books were played against pictures. (Contemporary book covers are remarkably similar to '80s art. This use of images treats books as subsets of faster media such as film, television, and magazines; indeed books are packaged in images.) In doing so, postmodernists also looked back at pop art as its avatar. As Richard Prince once noted, "everybody I know is a Pop artist."[26]

Many used gallery walls like the pages of a magazine. In the late 1960s and early 1970s Vito Acconci turned walls into 3-D pages to enact interior monologues.[27] For '80s artists

the gallery "look" blended a magazine's slickness with potpourri combinations of things. They echoed '50s modernism as it had been updated in sleek, airy postmodern architecture. Like new wave music, art was revisionist but more aestheticized in its look. Galleries beamed the '80s lifestyle of money and success with their minimalist interiors (i.e., high modernism aesthetically designed and reappointed). Postmodernists also revealed their transitional status between literate and electronic cultures in their blending of styles, yet it was a period that looked back nostalgically at unmediated literacy's sunset years. Ralph Lauren founded his fashion empire on Gatsbyesque styling. He exemplified yuppie culture—a blend of youth and money. His collections were based on styles—such as safari, New England— or on cleaned-up thrift shop couture. Yet he lived a clinical, postmodern lifestyle; his own home was a bastion of minimal modernism, entirely unadorned, like an '80s gallery.[28]

The photographic contingent of the pictures generation used photography as a part of their palette. Cindy Sherman photographed herself in the guise of an actress in a film still; she used film stills as a genre of picture-making. Sherrie Levine rephotographed Walker Evans photographs and repainted Fernand Léger watercolors; for her the modern style had become a souvenir art form. Richard Prince rephotographed advertising pictures, cropping the text as he photographed them, sometimes grouping them in a slide sheet to make a large "gang," as he called them. Magazines had become our cultural encyclopedia, wherein different subgroups were played back as cultural tokens—"sampled" as we now call it. Allan McCollum cast black-and-white, hydrocal pictures, called "surrogates," which he hung salon style, sometimes in clusters of hundreds. Here salon styling made sculptural, generic images as tactile objects. Jack Goldstein airbrushed a Disney-like nightscape in a sinister graphic style. He also revealed the dark side of sentimentality: the perceived turned into an object by the perceiver. This, too, was the dark side of telemetric attraction: entertainment will disappoint and depress if one is too drawn into it. Louise Lawler traced the passage of a Frank Stella painting in different photographs, to use one example, and dressed a room to look like a slick magazine layout. Her installations were often like 3-D texts. In this example, provenance is an extension of personal style, and art is a commodity and a symbol of power. This reproduction-oriented art also was polymorphously sleek, big, exaggerated, vividly colored (often using Cibachrome), and dramatic in stylistic effect.[29]

Hiam Steinbach placed found objects on highly crafted wedge-shaped supports that were reminiscent of a Judd box. He had the supports constructed in wood with matte-colored Formica skins. The objects he collected (often kitsch) were intended to elicit social and/or political commentary, as well as to create an imagistic juxtaposition that was often poetic. Jeff Koons venerated the 1950s homemaker's icon, the vacuum cleaner, putting one or more

in neon-lit Plexiglas cases, and testing the borders of kitsch and mass production, treating them as icons and invoking a "commodity" game much in the manner of a Warholian stockbroker, his rhetoric more like sales pitch than artistic suggestion.

An artist did not have to be a "pictures" artist to be considered a postmodernist. For example, Mike Kelley made comedic art out of teenage disappointment. In performances, videos, and installations he questioned authority and maturity through a wry, adolescent-seeming complaint, surrounding it all with American junk kitsch and tatterdemalion gewgaws. One of his subjects involves the dissonant messages passed between authority figures and the media. He also reminds us that behind every funny man lies a grudge.

Painters who actually painted—relying on draftsmanship, representation, and color modulations—were often lacking in the painterly skills they consciously aped, although they were stylistically fresh. Julian Schnabel and David Salle fugued seemingly arbitrary images and styles. Salle's paintings featured backgrounds of dark-washed women in lascivious poses, over which a surface of images was decorously limned. Often he enlisted other painters in his work. Salle also revamped Rosenquist and Picabia; and his bric-a-brac style also allowed him to incorporate the mistake, which was not possible in an even-toned Rosenquist, for example. Schnabel borrowed from pop art and action painting, intending to outsize the two through sheer force of will and ego. He mixed kitsch and, occasionally, elegance. Eric Fischl painted soap-operatic pictures of adolescent sexual alienation. His was an art based on TV culture and on painting fictions. David Reed relied on trick manipulation of color and surface. His was a special effects art, in which the effect prepossesses the artifact, as if preconceived and then done over again like cars in different colors and sizes. Donald Sultan used industrial tar to paint clichés of lemons and flowers—a nostalgia for brute industry, rekindling a macho sentimentality, and a search for Warholian iconography in everyday objects.

In Germany Georg Baselitz, Georg Immendorf, Anselm Keifer, and Markus Lupertz addressed their own history and enhanced modern styles. In Italy Sandro Chia, Francesco Clemente, and Enzio Cucchi—the "three Cs," as they were called—portrayed literary scenes, personal narratives, and classical images. European artists were more classically trained, with their academic institutions still adhering to a master-student system. What clearly distinguished American from European artists was a profound difference in their relationships to the mass media. European teens began to show the effects of exposure to electronic media (and the international tribalism for which electronics is truly capable) later than did their American counterparts, because media consumption was state controlled (with the exception of Italy, which now offers as many as two hundred cable channels).

The look of American postmodern art borrowed as much of its styles and attitudes from

the media and rock 'n' roll as it did from the avant-garde. And it thrived in the business-oriented environment set up by one of the most laissez-faire of all administrations, whose entire outlook was rooted in the 1950s, whose resources existed more on paper than in stone, and whose minions were raised on rock 'n' roll. (Remember Lee Atwater, master of the negative campaign, sideline blues guitarist—a postmodernist after all.) The art world's attitudes and look also reflected the fashion world's curious blend of sensitivity and hostility, and, of course, its trendiness. Yet the art world was made more complicated by its success, and by the success seekers, some of whom bought with the eagerness of tulip buyers in seventeenth-century Holland (trading a farm for one Turkish bulb, which a noble had first imported and which awakened a perverse passion). For a brief couple of years, the East Village became a bargain basement of art; however, the more resilient galleries eventually moved to SoHo, which became the epicenter of the art scene by the late 1980s.

Also during the 1980s, critical "theory," mostly imported from France, had become a branch of knowledge that used art as a prop for theoretical and political discourses. Contemporary theory suggested that an artwork could be interpreted according to feminist, psychological, or political "readings." Its language clung to avant-garde notions of "resistance," "critique," "cultural permission," "cultural difference." American critics promulgated these ideas, and American artists, using their homebred engineering mentality, applied it to art.

Theory was also born in the late 1950s, particularly in the writing of Roland Barthes; but it reached an eerie fruition in the 1980s, when more of his books in translation were imported and seemed to speak directly to the dissonances occurring between literacy and the media. Critical theory replaced simple aesthetic theories on creativity or descriptions of art. America also had become a focus as the society that created the media "spectacle," and the Americanization of the world was seen to rise out of its proliferation of media and media iconography. American media, therefore, represented a new imperialism. Artists exploited these ideas, since one of art's purposes, as the avant-garde taught us, was to criticize culture. Yet the media simultaneously opened up our understanding of one another while consuming our pasts in making us similar.

Not long after the crash of October 1987 a political atmosphere was ignited in the art world. Soon branded "politically correct," it proliferated in the late 1980s and stared squarely at issues of difference. It brought the problems of gender, sexual preference, and multiculturalism to the surface. It lasted until the 1993 Whitney Biennial, where it was shown with such screeching surfeit that artists themselves began to cringe. Nevertheless, it continued in the younger generation of artists, but without the rancor.

Yet politically motivated art was bred in university education, which churned out artists

of a different sort from abstract expressionists, conceptualists, and performance artists. Many were taught by late-1960s-educated professors who had been influenced by a post-1968 "discourse," and the social and artistic manipulation of cultural signs. In this intense atmosphere art seemed to switch brain hemispheres. Artists began to focus on problems in culture as well as in art. Artists combined, for example, minimalism and social commentary (Peter Halley's "cell" paintings, for example). They depicted the politics of gender and racial difference (such as the work of Renee Green), and feminist art proliferated to proclaim its own status (Sue Williams, for example). Charles Ray created an art of eerie juxtapositions founded in scientific possibility—the heaviest cube in the world, a family all the same size, a Goliath stewardess. Mark Dion made an anthropological art based on the relationship between capitalist centers and their usurpation of the margins. (Indonesia is now a source for the West's raw materials, and is in an economic boom, based on our consumption of their now-dwindling resources.) Peter Fend used satellite photos in his paranoid political art, much of which was made possible by the Freedom of Information Act.

The tenor of the times dictated interest in feminism, sexual preference, and multiculturalism, in a conscious use of politics in art. But by the early 1990s postmodernism, the "pictures generation," and a spate of politically correct art had run their courses, as generational movements do, and younger artists, inured to television and the media, were turning to a more personal kind of art and a different relationship to the mass media. They continued to make political art, but they also tested boundaries and offered revelations based on a psychology of the self, suitable to the psychologizing age and its burgeoning passion for self-help. But the aesthetic of the work was more personal and everyday.

Perhaps it was easier to make art when the rules were clear and subject matter was outside oneself, such as in traditional or religious art—or even media-based art. After all, that which we seemingly know best, namely ourselves, is the most difficult to describe. But a self-help culture, or a so-called "culture of complaint," may also suggest something in regard to the world; and if artists are, indeed, mediumistic beings, they are saying something about the way they are perceiving the environment.

The Sensory Life of a Television Baby

Where children of the 1950s were the first to be naturalized in an electronic environment, the Generation X, as Douglas Coupland called those born after 1965 in his novel of that name, were truly born to it. These are electronic culture's first pure natives, for learning things by adaptation and being born to them are different, certainly from the perspective of

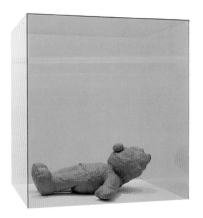

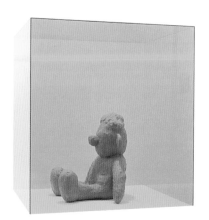

Michael J. Grey. *Proto (A). Proto (B). Proto (C). Proto (D).* 1993.

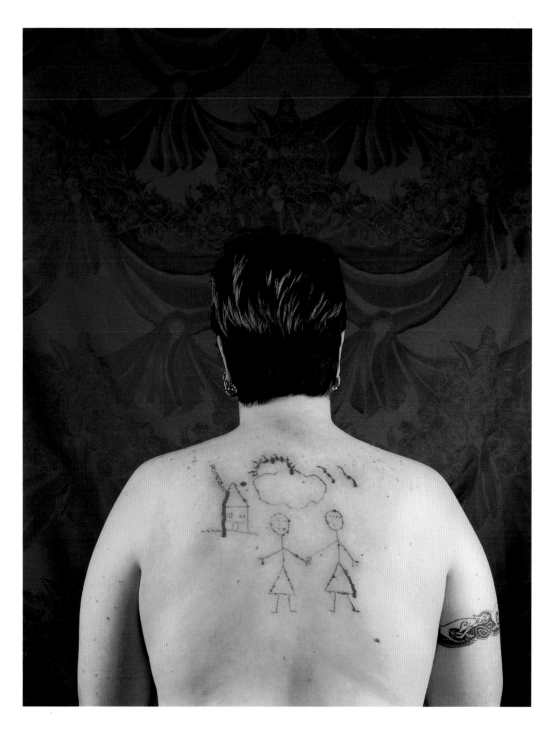

Catherine Opie. *Self-Portrait.* 1993.

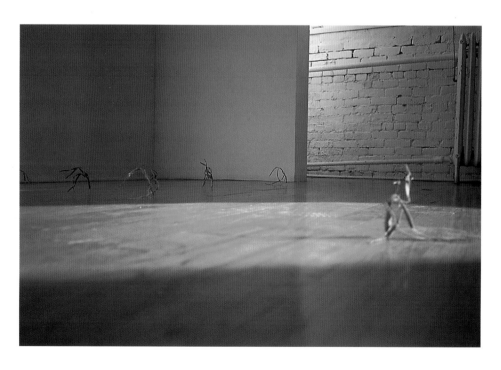

Above and opposite: **Eva Marisaldi.** *Vegetare (To Vegetate).* **1994.**

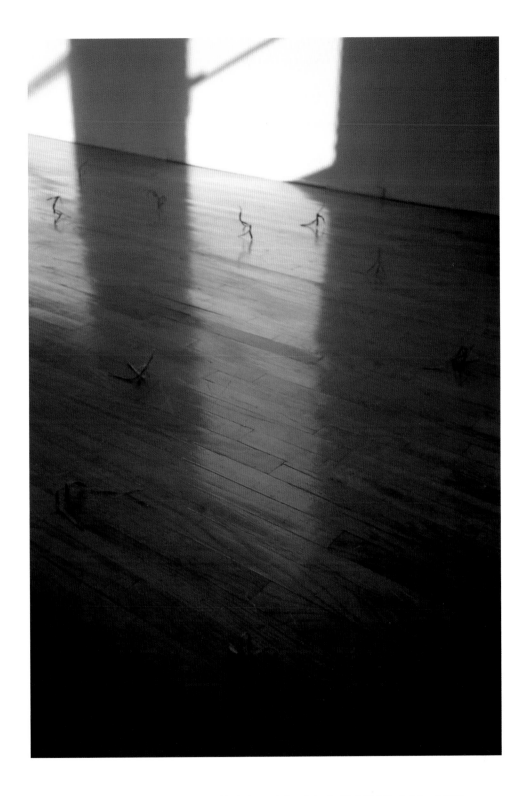

Following pages: **Noritoshi Hirakawa.** *Miran Fukuda, 31, 2:30 P.M., October 6 1994,*
Tokyo Tai-ikukan, Shibuya-ku, Tokyo. **1994.**

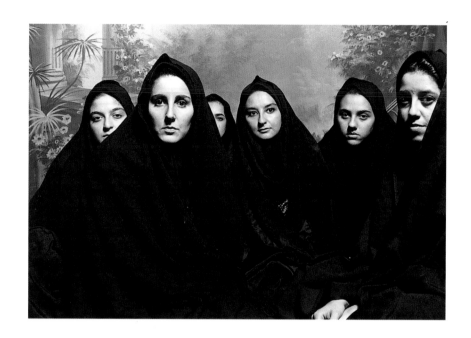

Above and opposite: **Shirin Neshat.** *Women of Allah.* **1996.**

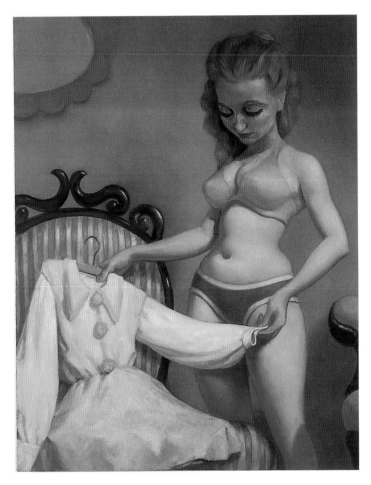

John Currin. *Girl with a Dress.* 1995.

Heimo Zobernig. *(l to r) untitled.* 1995.

James Casebere. *Asylum.* 1994.

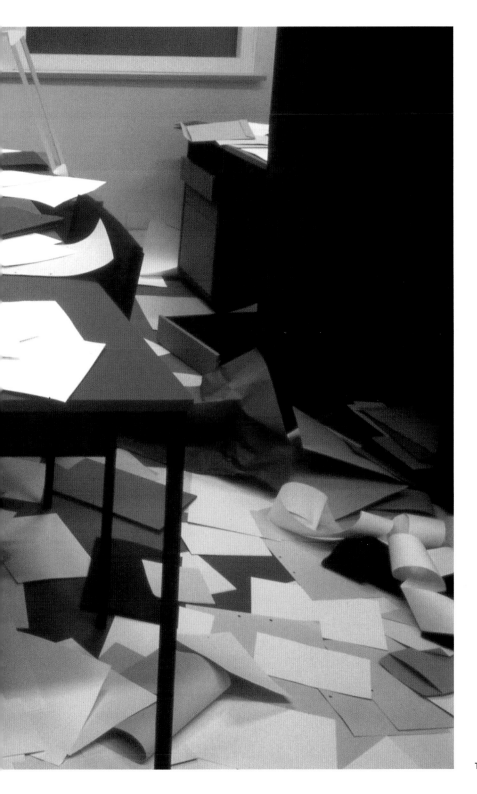

Thomas Demand. *Office.* 1995.

habits and sensory programming.

We are all born in tactility. Babies feel with blind fingers to find mother's milk. They put things in their mouths to get a taste of life. They learn life first through their senses. The senses also evolve in a kind of sequence, from the tactile to the auditory and the visual, or from the generalizing senses of taste, touch, and hearing to the specific one of sight. But as we approach adolescence the order of procedure reverses. As one moves up the sensory scale one moves closer to abstraction, and down the scale, closer to the stimulus. Jean Piaget noted in his studies of child development that at around age ten or eleven we begin to generalize, to think in abstractions, and to visualize those generalities. From a sensory perspective, this represents an increase in visual perception. Vision becomes important once we become familiar with the know-how of being human, which is tactile. Essentially, we erect a world on a tactile base.[30]

With touch there is intimacy but no definition, whereas with sight there is definition but no intimacy. The generic senses are also easily confused, and less defined, whereas hearing and sight are not so easily confused. For example, a bump inside your mouth feels enormous with your tongue but looks small in a mirror. Yet touch and sight operate together, as in our speaking of common sense, or *sensus communus*, which is the translation of one sense into another. These ideas are conveyed in language as well. For example, we speak of "rubbing someone the wrong way" or "grasping at straws," which are low-level sensory metaphors to convey a higher level of abstraction. Aristotle's classifying of the senses from touch to sight, from low definition to high definition, also involves the same scalar increase in sensory and emotional values, the will being a function of the eye, and the strongest human emotion.

Touch also registers intervals, not the connections between things. Sight enables us to gradate things. Sight isolates but it also connects. Eyes see but cannot weigh. With touch we feel things like interiority. To the blind the entire world is sudden.

Technological evolutions also influence the processing of the senses: if you are born into a culture without writing your sensory life is more intimate, it involves immersion more than concentration. In an oral culture the generic and audile senses are enhanced. Sound is a process sense; something is going on. As a result, preliterates live in a highly charged sensory environment that is not ordered by a higher level of abstraction in which one makes abstract generalities. Trobriand islanders, for example, make no connection between a yam seedling, a ripe yam, and a rotten yam. They use entirely different words to describe each state of being, because they do not make "generalizing" connections.[31] Their world is dominated by intervals and discontinuities for which rituals are a means to create order. Causes are attributed to gods and ancestors. Superstition abounds. Without an external

means (such as writing) to order their world, they never attain the ability to generalize and to make abstractions as we do today with writing and our obsession with classification. In literate cultures, at about age eleven, or Piaget's third stage in child evolution, children begin to make generalities that convey higher levels of abstraction. Literacy itself fosters this sensory bias. From literacy we also evolve aesthetic distance and the isolation of species of communication into art and language.

A child born into the electronic age learns his or her way into the world under the influence of disembodied voices and images, piecing together a world in collage patterns that absorb "everywheres" and "everywhens" into a cacophonous present. In the 1950s teachers and parents ordered the world as they were accustomed, before electronics. With electronics, our sensory life is processed differently, and the relationship of touch to sight is made more complicated because of the abundance of unrelated sounds and images.

In this regard Baudelaire's "correspondences" have a tactile as well as a visual connection, because images collide and abut each other without gradation. At some level of understanding visual images stimulate minds at a lower level of abstraction and are played against each other preverbally and without generalizing connections. This may influence the processing of language and the processing of higher levels of abstraction as children get older. It may register in the way people express themselves in gestures and fragmented utterances (especially in expressions such as "You know, like," or varieties of argot). It may suggest a form of image-related communication in which images are used as clichés, or received images, that are unaccompanied by linguistic explanation. For artists, for whom art-making is a late adolescent development (unlike mathematics or chess-playing or music, which involve tactile skills that very young children can master), visual development is a key issue. (Even styles of dress express a level of abstraction that begins at Piaget's third-stage development, in early adolescence.) Experiencing free-floating and unanalyzed images, which are integrated as tactile experiences, may offer a level of familiarity, or low-level stimulus, which might make Generation-Xers more adept at playing one against another, certainly as they get older. (This was already occurring with the pictures generation of the 1980s.) In this way they can engender varieties of memory.

In the processing of the senses there are both similarities and differences between preliterate orality and the secondary oral world of television, radios, telephones, and film. The dominant features of the oral world are a strong sound orientation (language exciting the ear), involvement not detachment, repetition, artistic formality, and social conservatism.[32] Electronic or secondary orality involves total sensory immersion and constant repetition of images, in which one is emotionally as well as aesthetically detached.

In the past, art was anonymous and collective rather than personal; it was formulaic and pieced together from known patterns, such as the attributes of first ancestors, or the four-quartered structure of the cosmos, which was based on the limbs of the body and its twelve major joints (as in our months, apostles, inches in a foot), with six on a side (shoulder, elbow, wrist, hip, knee, ankle), the spine being a scale or ladder from the lower genital world to the upper world of mind or heaven. These patterns, as anthropologists have discovered, comprise an *ur*-mythos, a universal theme that is remarkably similar across the globe. Traditional people thought by analogy, using a kind of metaphor in which an image actually stood for its referent: the eye of the needle conveys the "'thread-spirit' (sutratman) by which the Sun connects all things to himself and fastens them; he is the primordial embroiderer and tailor, by whom the tissue of the universe, to which our garments are analogous, is woven on living thread."[33] Sewing, as such, contained a higher level of abstraction that was expressed in an everyday activity. A higher level of abstraction could only be applied by literates. Nevertheless, the pattern through which the sewer fabricates textiles is based on a cultural concept that was born in conferral and seeps into habit, most of which is unconscious and is implemented by action, not preconceived thought. Artifacts were made according to the rules passed down through time, and the past was preserved at all costs.

Vestiges of our traditional heritage can be found in fairy tales and children's games like hopscotch (a rebirthing game of climbing—or dancing—from earth to heaven, which traces back to ancient rituals and continues to be maintained by children, who are as conservative as any preliterate). Later the practices of making became métiers, and traditional patterns were corrupted as real representation replaced formal analogy. Later still, métiers were abandoned and the subject of art moved directly toward unconscious processes. Yet pattern-making continues to be our guiding force. Similarly, ancient orality was nothing like electronic orality, simply because the latter is supported by writing, which is eye-oriented, detached, nonrepetitive, personal, private, original, and analytical. And yet we continue to process life through our senses.

As literacy evolved, so did pinpoint perspective, naturalism (and its spin-offs in history painting's time-line linearity), landscape's gradated perspectives, the still life's isolation of specific articles used for specific purposes. With literacy our sensory life evolved, as did alternative sensory biases. Phallic icons were replaced by pictorial art. Generic or proximity senses were generally considered taboo by Western civilization, because Christian morality led us to treat tactile pleasures as sinful, which, in turn, influenced the desexualization of art and a processing of life in which sexual control is required in a society in which we are instruments of labor.[34]

One-point perspective flourished during the age of print but began to come apart with early modernists who evolved a new art in response to the stultifying power of photography and the expansion of the communications environment. Artists went inside. Symbolists like van Gogh, Gauguin, and Redon explored interior landscapes, as did the poet Gerard Manley Hopkins, both formally, with his "sprung rhythm," and conceptually, with his "inscapes." Modern artists cobbled together a new art, tactually.

A constituent of abstract art is its tactile, ungradated, and pieced-together quality, much like cartoons. Late modernists refined modern art and surrounded their work in crisp white walls and slick frames. Such framing increased the visual preference of modernism's tactility. This was similar to the process of refinement and generalization in children: it is a move up the sensory scale from the tactile to the visual, from the generic to the specific.

Artists of the electronic world piece together art as they feel and perceive it (much of which has a cartoonlike tactility rather than easy visual gradation), formulating a different kind of art—one that may or may not be refined or museum-oriented, like the art of the 1980s, as its early retrospectives indicated. Where cubists and impressionists pieced together simple, everyday images, postmodernists brought modernism to an intellectually higher level of abstraction, for which more complicated theories were needed to describe the way images and styles were used as tokens of memory. The excesses of the 1980s evolved into a more personal use of fast images and fast media.

Thanks in part to the October 1987 stock-market crash and the crippled art market, it is tempting to describe the political art that emerged and segued into body-oriented, multicultural, and polymorphously sex-related art as an extension of the late 1960s and early 1970s. But this suggests that generations move forward by looking through self-similar rearview mirrors: the 1980s redid the 1950s, the 1990s redid the late 1960s. This also suggests that younger generations follow the cliché of looking back to grandparents, not parents. But in this faster-moving world, artistic "grandparents" are less than ten years prior.

The X generation is said to adhere to no particular philosophy except perhaps a kind of resigned nihilism similar to that first engendered by punk rock in the late 1970s, and given voice by groups like the Clash and the Sex Pistols. Yet they are also affected by a lack of definition in the culture at large and by mixed messages from parents and the media, at least in America. But if they opt for a postpunk attitude (also called "grunge," *grungy* being a word coined in the 1960s, possibly mixing *grime* and *sludge*), they venerate a different kind of homemade world from their forebears, one ruled by electronics, computers, and global entertainment, much of which can be home produced. Their Dionysian recovery in body decoration, polymorphous sexual expression, in "scatter" art and body-related art, in bands

like Nirvana, Hole, and L7, in diaristic and sex-related art, is different from that of '70s artists (Acconci, Burden, Smithson), all of whom were educated under the aegis of unmediated literacy. The younger generation looks back to the early 1970s through the lens of late-1970s punk. These affinities are aesthetic, however, because attitudes differ. Generation-Xers are more female-, homosexual-, and multiculturally oriented; they cross more boundaries, at least in youth. They seek respect rather than rebellion. They are turned off by parents acting like teenagers and are more savvy about the media's overstimulated communications. The test, of course, will be when their experiment lasts through their middle years. (In spite of all the attempts at racial integration in the late 1960s, racial boundaries hardened again in the 1980s and rebellion all but evaporated.)

The 1980s' set of values has also been rejected, particularly for its penchant for installed perfection and its attachment to modernism and its cherished avant-gardism. The new generation is exploring the technical possibilities of the ubiquitous personal computer and video recorder. Many are interested in simpler and more personal forms of expression. Photographers like Jack Pierson and Wolfgang Tillmans take low-tech photographs that tow the line between art and fashion—the former coming from art, now gravitating toward fashion; the latter coming from fashion, now more involved in art. Their subject matter is themselves and those they are close to, not the media or the images transmitted by them.

Some artists are installation-oriented. Rirkrit Tiravanija makes a personal installation art that combines a "poststudio" style with his Thai heritage. Art Club 2000 works by committee, using commodity culture as a palette from which they evolve a group-related art wherein they are themselves pictured. Andrea Zittel has made her entire Greenpoint, Brooklyn, house into an artwork. She has designed personal clothes and conceived a uniform of the future (which she means to be humanistic, not fascistic). Her art is market-oriented, but made private. The late Felix Gonzalez-Torres consciously mimicked Robert Smithson, using candy or objects to evoke another world from the one Smithson drew upon. He created a fey atmosphere, yet one that emanated a private form of politics for a grossly public world in which eyewitnessing had taken the place of "Miss Lonely Hearts" columns and privacy had gone public with television confession.

Generation-Xers use electronic equipment as tools of self-expression, much the way drawers and painters use pencils and brushes. They also are well aware of the pitfalls and false illusions of such tools—even though gadget electronics have taken over the world, compelling them to accoutre their rooms with VCRs and home DJ equipment. Their art reflects the music of P. J. Harvey, Hole, Liz Phair, L7, Blues Explosion. They "sample" styles freely and sing about themselves, sometimes as if that self is not entirely their own. John

Spencer of Boss Hogg and Blues Explosion, for example, recalls both the Big Bopper and Mick Jagger; his music is fraught with clichés, combining funk and rock motifs, and constant tempo changes. Yet it is original not only in his "sampling" of styles, but in his focus on other selves. Female singers no longer ape the boys. Their avatar is Patti Smith. But it is neither new wave nor punk, nor is it a "neo" version of an earlier style—which is to say they do not "appropriate" or "re-use," for the simple reason that they do not think of it that way. There is also a hallucinatory connection to the late 1960s in things like "rave" parties and techno music and its various genres—hard-core, jungle, ambient—which provide hallucinogenic spaces in which to lose oneself with other self-similars. The music is generic, however, and like baroque music it is composed of clichés, strung together by a DJ. Originality is not an issue in style. What is original is the content and the personalized aesthetic.

The artist's primary tools are electronic, and everything is treated as image, even text, particularly in "zines" and in popular magazines like *Raygun*. Television is a natural but not overwhelming presence, electronics and special effects are personal. Advertising is still a profound influence, because it saturates their art and continues to be the most overstimulated element in electronic culture. Yet it may be better understood for its exaggerated focus and manipulations of traits because its language is taught in schools and people are inured to its form of hyperbole. Another of their issues, however, is distribution rather than production, because technology is now home-based. Here they move outside advertising, using an electronic underground, and connect through small publications and electronic mail.

Nevertheless, advertisers know more about people as a group than psychologists ever did, simply because they stick to samplings and surveys. Market researchers have mastered rhetoric and using the audience. They use iconic communications in which *yes* means *no*. This is not iconic art, however. Ads are designed to attract attention, and are contoured to fit the audience and elicit desire, whereas art is contoured to probe and question our desire and get the audience to see itself. In the 1980s, advertising was borrowed by artists like Richard Prince as a source for subcultural codes. Contemporary artists understand this intimately and play back the code beneath the representations. Their expression is more tribal and looks to send its own messages.

Sometimes an image of the body is used like a vehicle of a self, as if bodies are not entirely self-possessed. Body art, silicone implants, aesthetic surgery, tattooing, and participation in tribes and gangs are forms of social expression. They are also unconscious and reveal deeper feelings about the self, about what is public and what is private, and about the larger communications context.

Sixties "nonartists" like Acconci, Burden, and Smithson, as well as movements like Fluxus, are venerated. But in the 1960s art was crossbred with performance. Fluxus was a kind of free-range art influenced by John Cage's music of chance and indeterminacy. It was a literate-based art of improvisation, and quite unlike anything a 1990s Fluxiste with a punk agenda might attempt. Acconci was a writer who turned two-dimensional expression into performance and who saw the gallery as the obvious place to perform a 3-D "page." Smithson, also a writer, chose the earth itself as his material. He made an ephemeral, almost shamanistic art, putting mirrors in the landscape and bringing the site-related stuff of quarries and slag heaps back to the "nonsite" of a gallery. His landscapes were essentially industrial wastelands or remote areas such as salt flats, which he used to look into prehistoric time while envisioning a sci-fi future. Burden was a stuntman who used himself as object in eliciting a surrogate self for a document-viewing audience. His was a body in social space. For these artists, documents had become art. Together, they broadened art and artistic perceptions.

But these were artists fundamentally expanding the thresholds of avant-garde art, whereas the younger artists are unaffected by such formal boundaries and are more immersed in the unknown and in an ambivalent artistic environment. They are deeply immersed in electronics and explore the parameters of a self coping with the forces of disembodied voices and increased noise. In this environment, identity is shaped by extrafamilial influences, which not only arise from a compromised family structure but are reflected in the proliferation of tribes and gangs, which themselves reflect a need among younger people to establish social unity as well as differentiation from their parents and the mixed messages they receive from the media and those in authority.

A form of social ambivalence is exemplified in the work of Matthew Barney. For his first exhibition at the Barbara Gladstone gallery in 1991, he filled the space with clinical-looking sports gear and Vaseline sculptures. He strung pitons up and across the gallery walls and ceiling, climbing in drag for a video, which he showed in a walk-in refrigerator downstairs. It was expensive and ambitious, and extremely male but sexually ambivalent. The opening thronged with visitors. Outside a gang of gay motorcyclists proclaimed him their own. But that was not necessarily the case, for his ambition went well beyond his own cloudy sexual identity. Two years later he made a grand-scaled video called *Cremaster* (a word, according to Barney, that refers to the muscles controlling the height of testicles). His video is a ritualistic performance whose running theme is a pregenital mythology—like Adam, from whom Eve was formed, or most bisexual/asexual creation myths in which a first ancestor embodies both sexes. It combines homoeroticism with sports' machismo. It is fraught with questions of presexual identity and the fundamental problem of sexual stability. Implied in his

male-oriented art, however, are questions of cultural rules and sexual orientation.

Stylistically, Barney is a crossover artist, marking a kind of threshold between the 1980s and 1990s. This is evident in his pristine installations, his ambition, and his Beuys-like yuppie mythology—premed at Yale, ex–Calvin Klein model, creator of ambiguous art, embodying ambiguous genius. Yet he is emerging as a strong influence among younger artists such as Michael Joo, who has evolved a different take than that of Barney. Joo's installations and video performances are Oriental-Occidental and body-related, with Zen-like affinities of immersion and out-of-body transcendence.

Another crossover artist is the English Damien Hirst, who shows a strong affinity toward the '80s generation, echoing works from Gerhard Richter to Jeff Koons's basketball tanks. In *The Practical Impossibility of Death in the Mind of Someone Living* (1991), Hirst had a Koons-like fish tank constructed which held a stuffed shark, a symbol of violent longevity and constant renewal. It had the eeriness of the movie *Silence of the Lambs,* as one critic wrote, and emanated wariness and caution, as if the unknown were both within and without. Hirst's art is also highly political in content and diversified in materials. He uses late-80's–early-90's framing devices—vitrines and cabinets—in which he installs animal skulls, biological specimens, an office table and chair. His art is clinical and reflects our era's obsession with death, particularly the death of the sexual revolution following the proliferation of AIDS. Hirst also looks at death matter-of-factly from an aesthetic viewpoint, the way a doctor might if he were an artist (like Dr. Frankenstein using body parts to construct an alternative mythology).

Among a newer phalanx of artists is the Italian Maurizio Cattelan. His performance-based style recalls the 1970s insofar as you never know what to expect. For example, in his Aperto room at the 1993 Venice Biennale he rented space to a perfume company. In another work he performed a prisoner's escape trick the night before the opening, never returning. And he sponsored a table soccer (Foozball) team composed entirely of Senegalese players. In this piece he called upon two of Italy's—and the world's—most salient themes: racism and sports. He organized a competition with art critics at a twenty-two-place table he had built. In other works he has invoked the delicate parent-child relationship of gallerist and artist, turning the table by getting the gallerist to play the entertainer and fool. In one exhibition he had his gallerist, a self-professed sexaholic, wear a penis-shaped bunny costume as part of his installation. Here he got the dealer to wear his id, focusing attention on the gallerist as performer and artist as director.

For most artists, however, the work is smaller than the aggressive and hyperbolic art of the 1980s. It does not project a gargantuan self, as did that of Julian Schnabel, among

that of others who have gravitated toward Hollywood filmmaking (Clark, Longo, Salle). Nor is it preoccupied with the aesthetic of success, as was the work of many '80s artists who constructed a downtown Manhattan café society and who decked themselves in fashions by Agnes B., Comme des Garçon, Yohji Yamamoto. The new artists reject this, as well as abstract expressionism's preferred couture. "Levis are dead," some techno habitués proclaim. Their own tribal brands are "in." And where '70s expression was gallery related, literate-based, and avant-garde, artists of the 1990s are totally immersed in electronic culture; their recognitions moved on from reflecting its imagery back to self-expression involving a personal aesthetic.

Ambiguities and Transitions

Ambiguity is one of art's most intriguing attributes. In oral or traditional cultures, distinctions between reality and myth are unclear; one never knows what is real and what is myth. Religious art revealed and concealed its mysteries. Literacy put history and myth in place, with its rules and use of evidence. Compared to traditional art, literate culture made private what was public to the native: land, information, and even ideas. What was private to natives was made public: their art and their sacred rites. Our own history is more obscure—we see it for its prejudices. We do not subscribe to the same prescriptions. History opens up; perceptions widen. Literacy evolved as well under the influence of larger media. These media are now part of our minds, and our thoughts operate through them. An electronic environment reshapes the communications context, and we draw upon larger patterns and recognitions. Changes in media have changed our perception of history.

Duchamp's "aesthetic echo" and definition of the artist as a "mediumistic being caught in a labyrinth beyond time and space" was his way of talking about the ambiguity of art and its constantly evolving processes—Heraclitus's ever-the-same, ever-changing river in which nothing occurs twice. The river endures. Art's sameness within the evolving contexts of language and technology underlies artists' quests for grace and integration.

Bateson described art as "an exercise in communicating about the species of unconsciousness . . . it is a sort of play behavior whose function is, amongst other things, to practice and make more perfect communication of this kind."[35]

As artists practice their craft, and as the process transfers from conscious thought or purpose to unconscious habit, they become less aware of what they are doing. The act of creation, however, is the revelation of such complex ambiguities. To Bateson art combined aspects of dream and purpose, and its "corrective nature," he noted, is an aid to life, because

"rationality unaided by such phenomena as art, religion, dream, and the like, is necessarily pathogenic and destructive of life."[36]

Art, he suggested, depends on internal relations, within which are "self-correction, repeated testing and listening, correcting and editing."[37] It requires restraint, otherwise it will run away with itself, or become overpurposive, as a lot of art did in the late 1980s and early 1990s. "The appreciation of a work of art is a form of recognition, perhaps a recognition of the self," which requires effort.[38] Like language, art is a system for generating "redundancy, pattern, and meaning."[39] Redundancy and repetition form patterns within which lie patterns of meaning, like the redundancies in advertising that reflect shared experiences, which become the basis of communications. Once we understand these criteria, what the artist is trying to convey can be determined, as well as its truth or its falsity, its usefulness as an aid to life or its self-deception. The problem of self-deception, which arises in art based on aesthetics, style, and self-expression, involves an abstract sense of removal that could not even have been imagined by a traditional artist for whom words like *disinterestedness* and *contemplation* have no meaning.

In the 1950s artists started to reveal changes in subject matter, especially in its focus on youth and media. In the 1980s these changes were perceived to have more historical and personal significance—as history had been engulfed by the media. Art in the 1980s also evolved its own arcane and complicated language. It required a special introduction, whereas entertainment needs no such introduction. Yet in art, "the effort precedes the reward rather than being spooned out."[40] Art's relationship to the mass media was perhaps something like Wordsworth's attraction to nature. He wrote about nature in London pubs, from the capital of the industrial world. Nature had become an art form during the Industrial Revolution; potted plants entered homes. For Wordsworth, industrialization had made nature explicit. For postmodernists, the subject was modernism and the media. In an electronic world, the images that animate it make styles explicit while outdating them.

In the environmental context of the 1990s art is in a curious state of evolution. Art forms, particularly profitable ones such as cinema, television, and music, are largely youth-oriented, yet the society at large complains about youth and about youth's complaints. Gallery art is small by comparison and private in a way that large media are not. Artists compete for space amid these distractions. Meanwhile critics have turned their interests toward pop culture, fashion, music, film. Magazines like *Artforum*, once bastions of avant-garde art, are examining popular culture. The language of the magazine has become friendlier.

These changes also reveal the way that faster media have penetrated more deeply unconscious process. If art appears clumsy or raw and ungainly, it nevertheless expresses some-

thing that artists have expressed since prehistory about self-integration—and now electronics has become native to our thought processes. Closer attention to art reveals elements of the environment in which artists find themselves and in which some of us are at a greater remove. Judging their art aesthetically, by a "look," is to revert to a former context. They have their own looks and sounds and argot. Their jungle is electronic, pansensory, multipersonalitied, multicolored. Their avatars are not academicians but artists like Acconci and William S. Burroughs. Their world is televisual—long-distanced seeing—and involves out-of-body experiences, for which the body is a pod, a mechanism for generating perceptions and for calculating associations. One computer enthusiast told me that he got feelings from the computer when he used interactive media. Perception widens; the outside goes back inside.

Nor are artists playing an endgame with modernism and originality. Modernism and its manifestations are ancient history. Life is more tribal. Video cameras and computers are to them what pencils, brushes, and chisels were to modernists and postmodernists. Freedom of expression is freedom of style. They piece together a world that is far removed from the "golden decade" and its souvenir decade in the 1980s.

Generally, any transition is a fight for relevance, or self-worth, and perhaps a shaping of identity. Transitions are forms of communication that communicate something about difference. For example, when a person or group secedes from a parent or parent society, the division between the new group and the old marks a differentiation of social viewpoints. The Pilgrims left England because they wanted a different life and more freedom to express themselves. Adolescence is schismatic, too. The parent is the starting point for the adolescent's break from childhood. Yet adolescents carry a message about adulthood in them. And they often want some kind of change in mores, or social viewpoints.[41]

Parents sometimes view this digression as a necessary one. They perceive youth as indulging in a differentiation, and wait for the indulgence to evolve into a cure. Often parents interfere with the process and end up prolonging it.

Today the mass media are full of messages about saving the children and protecting them from adolescents who are a bad influence. Conflicting messages are sent between the behavior of parents and younger people, and the images that the media present of both. In the language of communication, too much noise creates dissonances, information overload, or feedback. Too much noise, call it *noia*, creates paranoia.

Growth and differentiation are also controlled by communications. And every kind of evolution is the addition of information to an already existing context. In today's environment we are still coping with the transition from an industrial world to a postindustrial, elec-

tronic world. This suggests that problems have arisen in the transition itself. The transition from youth to maturity is a primary focus of our society, if for no other reason than that the society itself has not come to terms with what the transition itself is. Yet these are problems of evolution in which the environment is brought into question. And as the context changes so does the differentiation.

Transitions also involve complexities. Human complexities are often exemplified by the behaviors of mystics, schizophrenics, and artists. Differentiations, such as those between childhood and adulthood, involve stresses as well as awakenings. The differentiation is not created by the people, however, but by the context, which includes the larger environments of education, social contracts, money, ritual, and so on.

Businesses, parents, and governing bodies influence this transition. They impose values of every sort upon it. Yet dissonances occur because they represent the parent environment that created the transition in the first place. Businesses treat transitions as avenues of commerce. Parents treat transitions as metaphorical connections between good children and good adults. Governmental entities, including parents and teachers, treat groups as single classes of behavior. The dissonances in the transition are generally treated on the spot, however, without looking at the transition in the larger context.

In school we are taught that the way to define something is by what it is in itself. For example, a noun is the name of a person, place, or thing; a verb is an action word. In general we are taught things, not relations. We are taught dates and names, and we learn to specialize everything. In fact, things like nouns and verbs are bits of relationships that exist in a context, and the context creates the meaning. The context of growing up in an environment that requires a lot of information extends the pattern of growing up. In this extended pattern, dissonances occur. In the past, adolescence was part of adulthood, but it was not a fully modulated adulthood in the modern sense. In a modern world we restrain the passage to adulthood because of the complexities of a technological society. We also enforce childhood, especially in advertising and the entertainment media, which insist on extending childhood.

Since the 1960s art has focused on the media, on youth, or on the transition from industrial to electronic cultures. The entire culture became youth-oriented. Youth were targeted because of their increased economic status and then criticized for their behavior. Beginning in the 1980s artists began to examine the mixed messages coming from the media and from authority figures, and art was consumed en masse. In the late 1980s and early 1990s it became more political, turning toward a kind of affirmative action art, as if art had suddenly become overpurposive (which was perhaps a survival instinct). Now art has

returned to a right-brain activity. It is smaller and more personal, yet just as serious in its endeavor to integrate our unconscious and conscious processes, to make life more enduring, and to salve spiritual wounds. Aesthetics, ultimately, are incidental to underlying expression. Style is a means to attract attention, but sometimes it is a means to elicit memories. The language that describes art often is confusing (artists may have "appropriated" or "sampled" images, but this was not as much an endgame as a communication about their difference). The environment is an artist's agar, however. Art helps us to understand the context of our experiences. An artist's quest for difference, in fact, is the quest for integration. It was never otherwise.

1. *Pictures*, Artists Space, New York, exhibition catalog of works by Troy Branutauch, Jack Goldstein, Sherrie Levine, Robert Longo, and Philip Smith, essay by Douglas Crimp, 24 September–29 October 1977. "To an ever greater extent our experience is governed by pictures. . . . We only experience reality through the picture we make of it" (p. 3). Crimp discusses the "psychologization" of images and a form of representation that he says is "'representation as such.' It is representation freed from the tyranny of the represented" (p. 5). "The picture is thus . . . separable from that which it might be said to picture" (p. 8). He concludes by adding, "The work of the five artists in this exhibition, and that of many other young artists as well, seems to be largely free of references to the conventions of modernist art, and instead to turn to those of other art forms more directly concerned with representation—film and photography, most particularly—and even to the most debased of our cultural conventions—television and picture newspapers, for example" (p. 28).

2. American Federation of the Arts, San Francisco Roundtable Discussion, 1949, panel discussion transcripts. Also in attendance were biologist-anthropologist Gregory Bateson, Kenneth Burke, Susan Langer, and Darius Milhaud, among others.

3. Ibid.

4. American Federation of the Arts, "The Creative Act," 1957, panel discussion transcripts.

5. American Federation of the Arts, 1957.

6. Ibid.

7. Ibid.

8. Gregory Bateson, *Steps to an Ecology of Mind* (New York: Ballantine, 1972), p. 128.

9. Ananda K. Coomaraswamy, *Traditional Art and Symbolism*, The Bollingen Series 89, ed. Roger Lipsey (Princeton N.J.: Princeton University Press, 1977), p. 435.

10. Ibid., pp. 295–97.

11. American Federation of the Arts, 1949.

12. Bateson, *Steps*, p. 132.

13. Ibid. p. 130.

14. Ibid. *Steps,* p. 180.

15. Bill Bryson, *Made in America* (London: Minerva, 1995), pp. 400–402.

16. Stephen Holden, "After the War, the Time of the Teenager," *The New York Times,* 7 May 1995, sec. E, p. 4.

17. Bryson, p. 401.

18. Haynes Johnson, *Sleepwalking Through History* (New York: Anchor Books, 1992), p. 25. In this section's discussion of Reagan, Michael Milken, and "corporate raiders," I have borrowed liberally from Johnson's excellent book on the 1980s.

19. Ibid., p. 400.

20. Coomaraswamy, *Traditional Art*, pp. 296–97.

21. Walter Ong, *Orality and Literacy* (London and New York: Methuen, 1982), p. 75.

22. See R. Murray Schafer, *The Tuning of the World* (New York: Alfred A. Knopf, 1977), et passim, which discusses history through the changing perceptions in "the soundscape."

23. Ong, p. 136.

24. Mark Siegeltuch, from a letter published in a Bateson newsletter, *Continuing the Conversation* (Gravelswitch, Kentucky).

25. Ananda K. Coomaraswamy, *The Transformation of Nature in Art* (New York: Dover, 1956), p. 29.

26. Jeffrey Rian, "Social Science Fiction: An Interview with Richard Prince," *Art in America,* (March 1987), p. 90.

27.　Acconci has spoken about his transition from writer to artist as a change in dimension. He has also said that the difference between the '70s and '80s generations was the change from being against artistic materialism to materialism. See my interview, "I never wanted to be political; I wanted the work to *be* politics," *Flash Art International,* January–February 1994, pp. 84–87. For Acconci the "white cube" of a gallery was an extension of a blank page—a void where this erstwhile writer could perform. Artists of Acconci's generation called galleries "spaces," which suggested that a gallery was more than just walls and floors for presenting *objets d'art.* Galleries became performance rooms, places where artistic events were enacted. Robert Smithson used the term *nonsite* to differentiate between the gallery space and the landscape "site" from which he would cull his installation art.

28.　Witold Rybczynski, *Home* (New York: Penguin, 1987), pp. 5–12, et passim.

29.　These interpretations, and others described below, are simplified to make a point about appropriation art exploring a level of understanding beyond the formal confines of art and the gallery system.

30.　See Ashley Montagu, *Touching* (New York and London: Columbia University Press, 1971); Lawrence K. Frank, "Tactile Communications," *Genetic Psychology Monographs* 56 (1957), pp. 209–55; and J. C. Carothers, "Culture, Psychiatry, and the Written Word," *Psychiatry* 22 (1959), pp. 307–20, from whom some of the ideas on tactility were drawn.

31.　See Dorothy Lee, "Being and Value in a Primitive Culture," in *Freedom and Culture* (Prospect Heights, Ill.: Waveland Press, 1987), pp. 89–104. Lee writes, "Our speech is studded with terms such as better, bigger, inferior, average, compared to, normal, equal, in relation to, etc., showing that we constantly are passing judgment according to a comparative standard. The Trobriander has no such means unless we accept his rarely used words 'it-sames' and 'it-differents' as comparative" (p. 92).

32.　See Edmund Carpenter and Ken Hyman, *They Became What They Beheld* (New York: Ballantine, 1970), et passim; and Ong, *Orality and Literacy,* et passim.

33.　Coomaraswamy, *Traditional Art*, p. 298.

34.　Frank, "Tactile Communications."

35.　Bateson, *Steps*, p. 137.

36.　Ibid., p. 146.

37.　Gregory Bateson, *Angels Fear* (New York: Bantam, 1988), p. 199.

38.　Ibid.

39.　Bateson, *Steps*, p. 156.

40.　Bateson, *Angels Fear*, p. 132.

41.　Bateson, *Steps*, pp. 77–78.

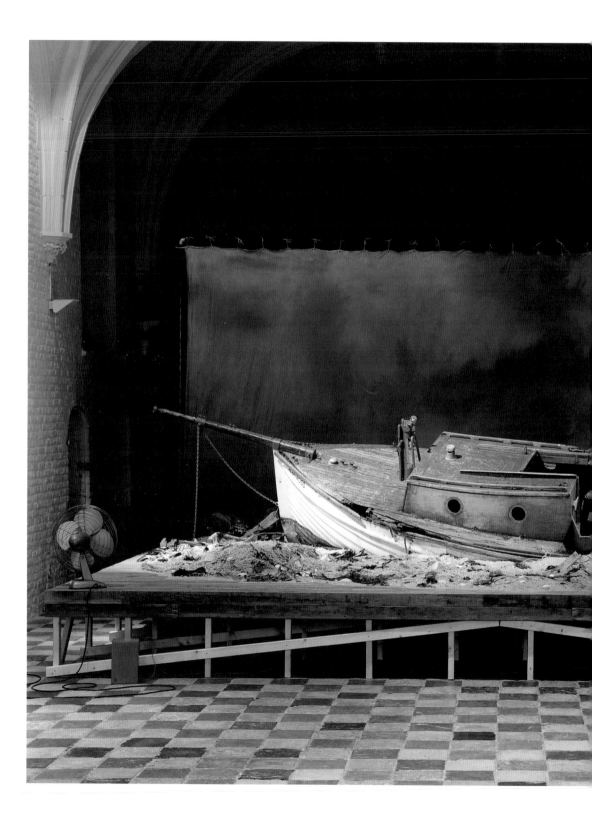

Mark Dion. *Flotsam and Jetsam (The End of the Game).* 1995.

The Meat Factor

Jen Budney

It's strange what can make a person want to travel. This time, it's because I've had my wallet pinched again. I'm also planning to buckle down and get to work on an overdue karmic overhaul, as a suspiciously large number of my wallets have now disappeared this way—yesterday's was the fifth in as many years. I've had my pocket picked at a pub in Stirling, Scotland, at a tavern in Halifax, Nova Scotia, at a lounge in Toronto, yet another in Manhattan, and now on a train in Milan, Italy. Aside from making clear that I'm frittering away my money on drink in more than just one way, this list has led me to finally, sorrowfully conclude that the human race is not, after all, inherently good. The smattering of old hippies left tripping lightly on this ailing planet will be disappointed, I'm sure, but I've been convinced beyond reasonable doubt. It's not that I suddenly think we're all spiteful and nasty at heart, or, like Richard Dawkins of *The Selfish Gene*, that we're programmed just to beat each other down in contest to propagate our DNA. What I believe instead is that the human being is, essentially, all balled up: neither bad nor good, but ungainly, shaken, and rash.

I could barely blubber out my story to the polizia; tears had made my poor Italian virtually unintelligible. I never cried over the other wallets. What made this one so much worse was that I knew the person who had taken it—the woman with whom I'd shared a cabin on the train from Rome to Milan. We had begun to talk with only forty-five minutes left to the six-hour trip, when she blasted on her new Sony radio-cassette player, waking me up. I jumped about a foot from my prone position in the cabin's corner at the first boom-boom-boom. She waited patiently for me rub open my eyes, then asked, absurdly, "Does the music bother you?" My natural reaction was to snap back with something haughty and sarcastic, but I decided to take a Buddhist approach instead. She was playing the music I call Eurodance, a kind of Disco Lite popular throughout Italy, Spain, and France. This genre boasts an infinite number of hit singles, all of which I strongly suspect are produced from the same karaoke

booth at the San Diego Mall for export to non-English–speaking countries: "Hey baby, baby, we're gonna funk it tonight, uh-huh, yeah, yeah," et cetera. She asked me didn't I think the music was *bella*. I said not really.

Amé was twenty-two, from the Ivory Coast. Neither of us spoke fluent Italian, but hers was better than mine. She'd been living in Italy for nearly three years, working in a glove factory just outside of Milan. It was a job she hated, she said. Same thing day in, day out, and her boss was a jerk. I asked her why she stayed. Surely it would be simple enough to find work in France, for instance, and French *was* her "mother tongue." She waved the idea aside. Her sister, who lived in Paris, had told her there were already too many immigrants there competing for work. Besides, she could hardly go job hunting. The immigration visa she had was "special" for Africans and other people "like Africans" (Sri Lankans, Chinese). She was not allowed entry into any other European country for the length of her employment here, not as a tourist nor even for a vacation. If she wanted to leave Italy, her only option was to return to the Ivory Coast. A friend had told her about Amsterdam, which sounded exciting, but she thought she'd never see it. Whereas I, being Canadian, could go anywhere I wanted.

Amé fiddled with her hair and, to my surprise, pulled off a four-inch extension. She held it up for me to see. "It's to make my hair grow," she said. "Just like the women of color in America do it." She explained, "You see how our hair is so coarse and tough. We can wrap these extensions on really tight, and if you do it right they're hard to get off." She demonstrated on the loose extension, which was a few shades lighter than her natural color, by pulling away one thin segment of hair and circling it round the others, making a kind of knot. She gave it a final, professional tug, like an airline stewardess presenting the life preserver. Amé looked carefully at my hair, which was about the length of her extension. I told her that the bleached blond was from a bottle. I'd been trying to grow my hair from stubble for what felt like years, but couldn't stand my natural color, mouse. Dying it was the only way to stop from shaving it off. I'd give anything to have dark, thick hair like hers. She shrugged.

"How many are you?" she asked me, meaning how many siblings were there in my family. I said I had one little brother. He was twenty-two like Amé, three years younger than me, and studying mathematics in the States. She looked disappointed and said, "We are nineteen." That was nothing, I told her—I had a friend from Sudan who "was" forty-one. Her eyes widened. "But we have only five boys," she told me, shaking her head. "Not enough." And then quickly, suspiciously, "Why are you unmarried?" I asked her what she meant. She said that at my age in her hometown I was pushing my eligibility. "Maybe, just maybe, you

Art Club 2000. *Untitled (Wooster St./GAP Vampiring).* 1993.

Art Club 2000. *Untitled (Indüstria Superstudios 1)*. 1993.

can find a husband at twenty-seven. But certainly at twenty-eight you're too old. Nobody wants you when you're twenty-eight." Which meant I should hurry. She added, "But men can get married at ninety if they want." I told her that hardly seemed fair. She said, no, perhaps it wasn't fair, but that's how it was.

I was curious about Amé's blithe acceptance of this double standard. She'd been living in Europe for nearly three years—surely she would have been exposed to some Western ideas that might have changed her perspective on her hometown just a bit? What did she make of her family's nineteen children in relation to the situation in Italy? I asked. (Despite both stereotypes and appearances—there was a couple smooching passionately in the corridor beside us—Italy currently enjoys the lowest birthrate in the whole world.)

"No, I don't want nineteen children," she told me. "Six are enough, but all boys. I want all boys, because women are nothing but trouble. They can't go out and work like men; they're always sick. As my father says, a woman is just a sack of problems. I want six sons."

She offered me a bite of her ham sandwich as we pulled into the station. She said she'd walk with me to the bus stop since we both had to take the same number north. I said okay, and was secretly thrilled. What little I'd heard of Amé's ideas were so contrary to mine and those of nearly every other woman I knew, that I was itching to hear some more from her. I had in mind the rather obvious mixed bag of questions about population control, feminism, colonialism, God—a kind of earnest college student's poll. Amé was all the more fascinating for carrying herself in a manner startlingly up-front, and I told myself this was a trait I didn't see often enough in myself or in other North American or European women, who tend to hide the force of our opinions behind courtesy, ending too many statements in deferential question marks.

I gripped my wallet in my left hand as we shuffled down the corridor to the train's exit. I was proud that I'd managed to keep this one (a Wal-Mart special with a big zipper so that nothing could fall out) for so long. Upon reaching the exit I saw that we had to jump down a few feet to the tracks below, as we were in the last car and the train hadn't pulled in far enough to meet the platform. With visions of belly flopping and shattering my teeth on cold concrete, I reached behind me and shoved my wallet into the top of the loaded cotton shopping bag slung over my shoulder; I wanted at least one hand free. I leapt, staggered forward, and turned, and saw Amé struggling with her own bags at the door. As she landed with a soft thud beside me I realized how tiny she was. Her slimness had made her look tall and lanky in the cabin, but she clearly was not much over five feet. I told her I'd like to zip into the station's 24-hour supermarket to buy some milk on the way to the bus stop. She nodded as if preoccupied, said "Okay, okay. Ciao!" and shot off like a bullet down the platform.

Despite her heavy baggage she moved twice as fast as I could with my one cotton sack of books and underwear.

I was flabbergasted—why hadn't she waited? Had I said something wrong? But already I was feeling that strange headiness that always comes over me just before I realize something's missing. I reached into my bag for my wallet, still staring after Amé's tiny figure scurrying into darkness, "Hey baby, baby, we're gonna funk it tonight, oh yeah." My wallet was not where I'd put it. I peered down at the tracks—I still hadn't budged from where we'd jumped off—but I saw nothing. I checked my bag again—unpacked it, double-checked, repacked, and checked again—and then finally resigned myself to the fact that my wallet, with the equivalent of two hundred dollars, my credit cards, and all my identification, had really, truly vanished. And Amé was nowhere in sight.

The police, of course, were no help at all. After spilling my story to a pair of pimply, uniformed teenage boys who kept urging me, futilely, to stay *tranquilla*, a middle-aged woman asked me to fill out a form in triplicate, all caps, so that the station could file away my story officially. They didn't even want my phone number to call in case they found something. "Come back and check in a month," they said, without a flicker of conviction. But when I told them that, yes, I did see the person who took my wallet, and I described her, their faces lit up. "Ah, an African," they crooned knowingly, smiling at each other. Suddenly they were much more sympathetic toward me. And I understood with some small horror that the only thing I'd accomplished by going to the Stazione Centrale Polizia was to feed the Italian police force's racism. It was already considerable, and it was the last thing anybody needed.

Besides, I liked Amé. I didn't want to see her to get into trouble. All I really wanted was to talk with her some more, go through my list of questions, and then ask her how she came to the decision to make off with all my money (and I did want it back, of course). I dreamed up a half-dozen slow-motion scenarios, spotlit close-ups of her face in a darkened corridor: worried, raised eyebrows or a sly smile revealing just what she was thinking as she slipped the wallet noiselessly out of my open bag. But I really didn't have a clue. It dawned on me that our exchange in the train had meant nearly nothing. In my "eager college student" mode, I'd discovered about Amé merely that which I would have scripted from my own imagination if a creative writing prof had assigned me the short story "Chatting with Amé the African in a Small Train Cabin, Heading North." And obviously, I'd impressed Amé only as someone privileged and invulnerable enough to rip off. I'd been duped, I thought. I'd duped myself. What I'd been taking for communication had turned out to be an empty transfer of information. It's not like we were lying to each other; it's that the words

Above and opposite: **Beat Streuli.** *Glasgow Series.* **1995.**

had left us both untouched. So Amé had an extra two hundred bucks, and I was out a planned new pair of sneakers. So what? I tried to feel betrayed, but instead I felt pathetically empty and depressed.

In 1955 Anna went mad, cutting out the headlines from the daily paper and tacking them to her bedroom walls. Over the weeks, the walls became covered, and Anna sat dumbly cross-legged on the scrubby carpet, staring, overwhelmed by information. Information about which she could do nothing, yet information that made her own life seem meager and pointless. Anna, a character from Doris Lessing's 1962 novel *The Golden Notebook*, was suffering from a thoroughly modern disease, that of information overload. Lessing wrote the novel in a kind of cybertext, twenty-five years before a generation of graphic designers came out with what looked like cybertext but was really just hard to read. To paraphrase her explanatory introduction, the skeleton of Lessing's novel is *Free Women*, a conventional short novel of sixty thousand words, the central character of which is Anna. It is also a kind of summary of the larger novel. But this short novel is split into five sections and interrupted by excerpts from four notebooks, Anna's journals: "Black," "Red," "Yellow," and "Blue." Anna keeps four journals out of fear of the chaos that would come from reconciling all the parts of herself into one. The "Black" notebook contains memories of her past in Africa, with which she cannot come to terms. "Red" details her frequent yet ambivalent relations with the British Communist Party. The "Yellow" book holds the workings of an autobiographical novel called *The Shadow of the Third*, which is in turn a summary of the short novel; and "Blue" is a simple diary, with accounts of her days, love affairs, friends, the world news. *The Golden Notebook* is a compilation of all these journals and the short novel, plus the story of Anna's life outside of them, narrated by Lessing. It is nonchronological, overlapping, incomplete, and radically anti-ideological. Yet at the end it somehow creates a whole out of hundreds of scraps, clips, and bits. Or maybe it just stops, and only feels complete.

The details of the stories within *The Golden Notebook* are specific and pointed. Lessing covers race relations in colonial Africa, the psychology of war, radical politics and the sociology of radical political groups, relations between the sexes, nervous breakdowns, and more—even theories of female orgasm. And though undoubtedly all these topics are important—and individual topics are more or less important depending upon the reader—it is the form of Lessing's novel that most interests me. Her "cybertext" approach was largely either misunderstood or overlooked at the time of the book's publication; most people preferred to focus on her portrayals of male-female relationships. (And as I have been told by

one female friend, who in the late 1960s was intensely involved in New York's radical Left, most men were turned off by these portrayals, finding them far too threatening.) But form, not woman's lib, was the most important consideration for Lessing, too. She says her "major aim was to shape a book which would make its own comment, a wordless statement: to talk through the way it was shaped."[1] *The Golden Notebook* is thus a critique of conventional modes of description. It is about the inadequacy of a conventional novel, a straight story, for expressing the complexity of the truth.

Years later, Trinh T. Minh-ha began exploring the issue of form as conveyor of meaning within film. Martha Rosler has done the same with photography. These are conceptual approaches like Joseph Kosuth's three chairs,[2] but they go one step further by contextualizing themselves in everyday life, or "real life" politics, on top of the basic critique of information systems.

We are hearing an awful lot about the new information technology these days, about how it is revolutionizing our ago-old mores and customs—from cellular phones to home shopping to virtual sex—and my attention span for such subjects is becoming shorter by the minute. The problem is, as we all keep saying, that the issues surrounding these new technologies are never discussed so much as hyped. I used to think my disinterest was disillusionment: I had been promised a revolution for so long, and nothing happened, so I gave up. But recently, flipping through the newspaper *Mute* ("Proud to Be Flesh"), one of the few nonirritating publications of computer culture, I found a name and real reason for what makes me so uneasy: the Californian Ideology.

Richard Barbrook and Andy Cameron have christened this orthodoxy in honor of its birthplace. They define the Californian Ideology as "a mix of cybernetics, free-market economics, and counter-culture libertarianism . . . promulgated by magazines such as *Wired* and *Mondo 2000* and preached in the books of Stewart Brand, Kevin Kelly and others."[3] Naturally, it takes Marshall McLuhan as its patron saint. With ideologues of this technological determinism ranging from hacker nerds to old hippies to hip academics to Newt Gingrich (the far-Right Republican leader of the U.S. House of Representatives), and with a recent European Union report recommending the construction of its own "Infobahn," the global dominance of the Californian Ideology would seem to be a *fait accompli. Wired* is perhaps the best-known journalistic product of this new techno-optimism. Its monthly ravings about the libertarian possibilities of info-tech have included a chipper interview with Gingrich that completely ignores his vicious welfare cutbacks, praising instead his faith that the convergence of media, telecommunications, and computing will lead to "an electronic exchange within which everybody can become a free trader."[4] Once more, Adam Smith can

Pepón Osorio. *Badge of Honor (Detail of Father's Prison Cell).* 1995.

Pepón Osorio. *Badge of Honor (Detail of Son's Bedroom).* 1995.

rest easy in his grave.

Of course, what this theory fails to acknowledge are the vast sums of tax dollars that the government has poured into the telecommunications industry over the decades and its virtual (excuse the pun) dependence on the Department of Defense for the money and go-ahead for new projects. Instead, independent computer geeks and enterprising businessmen are celebrated as pioneers of the industry. The American myth of the lone cowboy is not, after all, easy to dispel. (It is strong enough to lure an artist such as Robert Longo into making the same movie as the likes of Hollywood's Kevin Costner. Think about it: What did the films *Johnny Mnemonic* and *Waterworld* both tell you? Bad guys, whether Japanese or smokers/polluters—"Injuns"—have no souls. And in the future, whether techno-jungle or primitive postapocalypse, all women—Daughters of the American Revolution, damsels in distress—will wear tight mesh T-shirts.) The cowboy is America's history, and thus it is all the world's destiny.

But as Barbrook and Cameron remind us, Thomas Jefferson, one of the men behind this myth and the libertarian behind the United States Declaration of Independence, was also one of the largest slaveholders in the country: "Behind the rhetoric of individual freedom lies the master's fear of the rebellious slave."[5] Much of Gingrich's political success has been based on his mobilization of the white middle class against a supposed threat from "black welfare scroungers, immigrants from Mexico and other uppity minorities."[6] The Californian Ideology threatens to drive an even greater wedge between America's, and the world's, rich and poor (between the slaveholders and the slaves). Barbrook and Cameron explain:

The hi-tech industries are an integral part of this racist Republican coalition. However, the exclusively private and corporate construction of cyberspace can only promote the fragmentation of American society into antagonistic, racially determined classes. Already "red-lined" by profit-hungry telcos, the inhabitants of poor inner city areas can be shut out of the new on-line services through lack of money. In contrast, yuppies and their children can play at being cyberpunks in a virtual world without having to meet any of their impoverished neighbours. Working for hi-tech and new media corporations, many members of the "virtual class" would like to believe that new technology will somehow solve America's social, racial and economic problems without any sacrifices on their part. Alongside the ever-widening social divisions, another apartheid between the "information-rich" and the "information-poor" is being created. Yet calls for the telcos to be forced to provide universal access to the in-

formation superstructure for all citizens are denounced in *Wired* magazine as being inimical to progress. Whose progress?[7]

Lessing's Anna is dealing not with anything like the information superhighway, but with the simple daily paper. Depending on the paper, however, there is an awful lot of info to be found there. Lessing's protagonist was created as a microcosm of her larger society, a person who cannot come to terms with the disparity between herself-as-subject—an artist, a writer trying to mirror the world—and the overwhelming global problems of famine, poverty, war, and the bomb. To write a novel, to make art, while others are trapped in war-torn countries, tortured for their beliefs, victims of land mines and sniper attacks, without enough food to keep themselves alive let alone books or even the ability to read—while it is still a world of slaveholders and slaves—strikes Anna as utterly absurd. At the same time, she feels that the language and logistics of the British Communist Party, into which she has been investing all her revolutionary hopes and energies, is becoming completely obsolete and academic, willfully ignorant of both the horrors of Stalinism and the needs of people like herself—a single, working mother—whom the party purports to serve.

Anna breaks up: she compartmentalizes her life. She breaks down and no longer knows if it is she or her lover who is speaking; she becomes formless. And finally, she breaks through the patterns of her conditioning and past, and begins to finish a novel that has been started by somebody else. Her chronic stutter ("I-I-I-I," "me-me-me-me") disappears when she realizes that "subjectivity" in art, "that shocking business of being preoccupied with the tiny individual,"[8] can be a way of making the personal general and much, much larger. Lessing explains: "Growing up is after all only the understanding that one's unique and incredible experience is what everyone shares. . . . Nothing is personal, in the sense that it is uniquely one's own."[9] It might be added that in retrospect it would seem that this is how subjectivity functions in good art. The recent, ongoing backlash against identity politics on the cultural stage can be blamed in part on threatened and reactionary critics, of course. A backlash follows every strong movement. But some of the blame may also be placed on many of the movement's practitioners, who, quite uselessly and not entirely unintentionally, have alienated their audiences by remaining preoccupied with the tiny individual, prioritizing their own subjective experiences to degrees unfathomable to others. ("And you're upset that I can't read your mind, love," sings Billy Bragg).[10]

The brilliant American poet-diva Sapphire explains the transformational powers of sharing personal information vividly and viscerally in "Are You Ready to Rock?," the introduction to her book *American Dreams*, which is also the best antidote to the "Oprah-ization" of

personal trauma that you will ever find:

> . . . nobody said that what was cannot be changed. This is an adventure in light
> waves & new days tiptoeing across a poisoned land selling flowers to soul survivors.
> We smile for Tina Turner & those fabulous legs that finally carried her to freedom.
> We hear you, honey, walking to freedom with thirty-six cents and a gas credit card.
> *What's Love Got to Do With It* when it leaves you brain damaged, bleeding in the
> snow, blind, limbless, discarded & deserted. Jerry Hall says you can never be sure
> your man is not gonna run off & leave you. That's terrible. I'm not being sarcastic.
> I feel like someone poured acid on my face & is banging in my dreams with tele-
> phone poles.[11]

And now, hypocritically but not surprisingly, the Republicans, like the government of
Germany, are getting all worked up over the contents of the Internet. Among other things
the Germans say they would like to ban is the abundant Nazi and neo-Nazi propaganda cir-
culating over the Net. The Americans, of course, just want to ban the smut. I am sure they
would ban Sapphire's poetry if they had half a chance. But, as with other media, it is not the
information accessible through the new technologies that is the real problem—it is their struc-
tures and systems of distribution. This means that what is *not* available is more important
than what is available. What's smut got to do with it when it leaves millions, or billions, in
China, Africa, India, Peru, and L.A., out—as they say—in the cold?

There is a wonderful ad for a computer distribution company (wonderful for its de-
licious, perverse way of showing just how twisted things really are). The ad for "Origin:
Technology in Business" shows a turbaned, elegantly robed maharaja-type Indian charac-
ter in profile, poised over the mouse of his personal computer, the cable for which is con-
nected to that of a computer belonging to a fur-bundled, obviously chilly but cheerful
Eskimo. It would seem that these two are chatting over the Internet, prompting the
question: How did the Eskimo rig up the modem inside his igloo? There is an ad for IBM,
subtitled "Solutions for a Small Planet," which carries the photo of a Native American chief
in full ceremonial costume. The text reads: "The Great Spirit guides my people, but he can't
advise about video-conferencing. So I'll be checking out the new systems for myself. At
Telecom '95." (This is a heavily promoted, spectacular technology fair held in Geneva.)
These ads reek of Disney it's-a-small-world-after-all-ness, but in the end I suppose they are
essentially fanciful and relatively harmless.

Next I would like to see a seventeen-year-old, illiterate El Salvadorian factory worker,

who produces clothing for, say, the Gap for fifty-six cents an hour, chatting on-line with an underfed twenty-year-old Chinese textile worker, whose hands are permanently stained with the toxic dyes she has been working with all day. Solutions, indeed. Imagine what revelations might be communicated if they were in the position to exchange a little personal information.

It is not that we are excluding the so-called Third World completely from the great information age (and when I say "Third World," I mean the one in Manhattan, too), it is just that the "exchange" is working only one way, like someone spying through a two-way mirror. There is, for instance, the current race between Walt Disney, Viacom, Turner Broadcasting, and Warner Brothers for stakes in the revived multibillion-dollar children's cartoon industry, which has recently opened up in places like China, Thailand, and Latin America, having fully saturated the markets in Europe and the States. (Potential profits include television advertising and toy-licensing fees. Now little girls in Wuhan, China, can not only make those ever-present Pocahontas dolls, they can own one, too!) This is not quite what is known as the Berlusconi Phenomenon; it is more like an update of plain, old-fashioned colonialism. The Berlusconi Phenomenon, however, is similar, and should in itself make the California ideologues stop and think for a minute. Named after Italy's former prime minister Silvio Berlusconi, who during his eight-month reign controlled the state television as well as his own three private stations (basically, everything), it applies as well to the mergers of Disney-ABC, Westinghouse-CBS, and Viacom-Paramount, to all those lobbying for further deregulations of the American telecommunications industry, and to individual media moguls in other countries, such as Leo Kirch in Germany, Johann Rupert in South Africa, and Rupert Murdoch in Australia, Britain, and the United States.

At this point you may well ask: What does any of this have to do with art making, novel writing, and other modes of cultural production? What does this have to do with Doris Lessing? Those of us who have long ago learned how to set the proverbial clock on the VCR, and now surf freely and frequently over the Net, *we* are finding the superhighway quite fun, entertaining, and educational. What should *we* do, stop watching the tube just because there are folks in Bangladesh who can't afford to buy one? Boycott the Internet because it's not hooked up in libraries in the Bronx? Well, of course not. That would be silly. (A television is not a car, after all. If I was asked, on the other hand, "Well, what should I do, stop driving my car just because the industry is criminal and the oil and exhaust are completely destroying our health and planet?" I would say yes. Why not practice for middle age when

it will be far too expensive or impossible to drive one, the sands having been sucked clean of every last drop of unleaded?) The point is that television, the Internet, and countless other information/communication technologies are important, and could be harnessed to create, if not a global village, at least some cultural stuff that in content *and* form would help to bridge some gaps that otherwise will just keep growing. The above examples describe just a few of the many ways our information systems are failing. But any call to arms could be quite useless or even damaging without a better understanding of just how this technology does or can function—because not everyone wants to use it the same way.

One of my heroes is the late Eric Michaels, an American anthropologist who spent five years researching the impact of television on remote Aboriginal communities in Central Australia. He also wrote for *Art & Text* magazine. His essays on art and communications technology, written during his time in the outback, were published together posthumously under the title *Bad Aboriginal Art* .[12] It is essential reading for anyone involved in cultural production, because Michaels provides not only a thorough, invective critique of the art world, entertainment corporations, and the government, showing just how incestuous they are or can be, but also a description of the use of television and video by his "study group," the Walpiri people, which indeed deserves to be called a TV revolution, so different is their approach to the medium from anything we could imagine.

The television produced by the Walpiri in their own studios became a method of bringing together a community that had been drifting apart because of an emerging generation gap. They used the medium to recount the Walpiri "history," one that cannot be written, and can never be known or recounted by one person alone. Their programs, unlike other Australian TV programs, described their people without breaking any of the many taboos that had been for some time making television a bone of contention in Aboriginal communities. (These taboos include that forbidding a person's image to be seen or name to be spoken after he or she is dead, which makes the habitual nationwide airing of twenty-year-old National Geographic–type documentaries about Aboriginal communities by the big Australian TV stations a particular sore spot.) It also became an efficient method of education during a transition period for a community that historically has had a tough time adapting to the Western idea of education (i.e., literacy, the written word). The Walpiri had always been eager, original "readers" of television and film—media that, like them, value the oral over the written—and thus found it empowering to "write" TV as well. Michaels's essay (titled "The Aboriginal Invention of Television") convinces one that the imaginations of most Western artists are painfully limited when handed a Sony camcorder. It also makes clear the importance of restructuring television, both physically, in regard to

access, and conceptually. Despite the hype about the Internet, it remains our most important, and powerful, source of information.

Lessing made a point to commend the generation following her and the largely autobiographical character of Anna, who more than anything could not bear the monstrously isolated, elite position of the artist. Lessing noted that the artists of that generation had changed the situation by creating a culture of their own "in which hundreds of thousands of people make films, assist in making films, make newspapers of all sorts, make music, paint pictures, write books, take photographs." Furthermore, they had "abolished that isolated, creative, sensitive figure—by copying him in hundreds of thousands."[13] But she warned as well of the inevitable backlash to this situation, and she was not wrong. While more and more people began graduating from art and film schools every year, the open, communal youth culture of the late 1960s and early 1970s gradually made way for disco and then yuppies, phenomena that met their matches in art, literature, and film.

Now, in the 1990s, we are postgrunge and back again to shunning the idea of "originality" and its infamous sidekick, "genius." (How many bought Julian Schnabel's CD just for the hilarity of it, for the same reason numerous intelligent, discriminating people spent money to hear William Shatner sing "Mr. Bojangles"?) Many artists now look to the practices of conceptual art from the 1960s and 1970s—body art, performance, and institutional critique—for inspiration (which of course were not dead in the 1980s but merely hidden in the shadows of neo-expressionist painting and other big things). And this is important because these are practices that take as their primary objective the questioning of our habitual and traditional means of communication or information exchange.

Christine Borland, for example, worked with forensic police at an abandoned building in Newcastle, England, used variously as an impromptu homeless shelter and parking lot, to form an absurd taxonomy of irrelevant objects for the event-installation entitled *A Place Where Nothing Has Happened.* She not only points to the unreliability of our systems of classification but also draws attention to those unofficial uses of the building, making the title rather ironic: What would constitute "something" to oppose "nothing"? (More whimsical and beautiful are the bright-pink-and-green smashed watermelons that trail down a flight of gray stone stairs in her photographic series *Stairwell: Running, Falling, Rising.*)

On opening day of the 1995 Venice Biennale, Cai Guo Qiang piloted a real Chinese wooden junk down the Grand Canal. It remained docked in front of the Giustian Lolin Palazzo for the duration of the exhibition, as part of *Bringing to Venice What Marco Polo Forgot.*

Marco Polo had returned from Cai's native region of Quanshou, China, exactly seven hundred years earlier. What he had forgotten to bring back Cai installed indoors in vending machines: herbal medicines based on the five traditional elements of nature and life—water, wood, metal, fire, and earth. The audience was free to purchase these medicines from the machines, and many did.

Liam Gillick wrote and performed a musical in much the same spirit as Dan Graham's *Wild in the Streets* nearly thirty years before, but in a form more like Lessing's *Golden Notebook. Ibuka!* is a musical in three acts, based on Gillick's book *Erasmus Is Late*, which records a metaphysical conversation between Erasmus, Charles Darwin's opium-riddled brother, and a bizarre cast of time-straddling characters—Robert McNamara, the secretary of defense under Kennedy; Maaru Ibuka, cofounder of Sony; Elsie McLuhan, mother of Marshall; and Murry Wilson, father of Brian Wilson of the Beach Boys. The conversation takes place "on the night before the mob are re-defined as workers," when modern destabilization sets in. One of my favorite passages from the book is spoken by Elsie McLuhan: "To have an extended discussion between people over time, something about the very nature of discussion itself will obviously begin to overwhelm the subject any of us might be attending to. So we disagree. And if we have any level of accord it might be because we recognize the power of paradox. Attention to detail is becoming the key mode of behavior. And as this concentration on smaller and smaller elements increases so it will come under attack from a social system that uses the power of contradiction to keep shifting the goal. This will be of some use to Erasmus's free-market relatives."[14]

The art world is opening up to include more countries and cultures. There are now important biennials in Johannesburg and Kwangju, Korea, and the one in Havana, which consciously sets itself in opposition to the New York–centered art world and imperialism everywhere, becomes more acclaimed every year (as, paradoxically, Cuba flounders). Thus we are slowly beginning to include artists from Africa, Latin America, and Asia on equal footing with artists from the Northern Hemisphere. Mysteriously, this trend is often greeted with a rolling of the eyes and a sardonic comment about the unforgivably corrupt and Euro-centered art world trying desperately to redeem itself, but I really think it is something about which we should be optimistic, even if cautiously. Isn't this what we have been wanting all along? "In Korea," recounted the young Cuban artist Kcho, "a European curator asked me to switch my place with Chuck Close. He saw me as this thing on the outside, that could just be shifted anywhere. I said 'No.'"[15] Far more than just being "fair" or "inclusive," the works we are seeing from these places also shed light on traditions that some thought had already been explored (or exploited) to death, just as the Walpiri did with television.

Kcho's take on Tatlin's *Monument to the Third International—A Los Hojos de la Historia* (*To the Eyes of History*)—is one such piece. Built from twigs and reeds and a dripping coffee filter, Kcho finds a new use for a powerful symbol. Originally intended as a monument to the technological utopia envisioned under communism, Tatlin's tower has been transformed into an ode to the Cuban people, who make do with what they can, as well as a lament for the lost idealism of the revolution.

In response to the art world's considerable alienation from the public (which increased steadily in recent years with the infamous *60 Minutes* scoop by Morley Safer as well as aggravating populist attacks by neoconservatives like Jesse Helms, resulting in arts funding cuts), many artists are now focusing on art that speaks to a broader audience. For the Kwangju Biennial, for instance, Rirkrit Tiravanija bicycled to the border of North Korea, videotaping the trip and projecting it back at the biennial site, to a largely Korean audience, next to an orange healing wall. Shirin Neshat's photographic works show texts from religious, feminist, or sensual writings of Iranian people, calligraphied in Arabic script across the faces, hands, and feet of anonymous veiled women. Often these women are holding guns, and the resulting images are disturbing as well as beautiful. They trigger in us fear, sympathy, and awe—fear of the headline-making, sometimes scapegoated, violent Islamic fundamentalists; sympathy for the women of many Islamic cultures who, much more often than outsiders, are the victims of this violence; and awe before the power of their religious beliefs, so much stronger than anything familiar to us in Western society.

And then there are those who, frustrated by the limits of the current conception of art and its ensuing institutions and bureaucracies, are searching to find altogether new job descriptions for artists. Canadian Ben Smith Lea is one of these. In his *Useful Artist Project* he dons a variety of guises. When a new bike lane in the heart of downtown Toronto was consistently ignored by motorists, making cycling dangerous, "Traffic Artist" showed up in orange coveralls and a reflective safety vest, carrying a whistle. He set up orange traffic pylons to delineate the bike lane and remained there as monitor, directing cars away with a whistle, smile, and slow wave. His point was not to police but to produce aesthetic stimuli that would calm the area.

In "The End of the World," the introductory story to her spoken-word album *The Ugly One with the Jewels*, Laurie Anderson tells us: "I've always been interested in trying to define what makes up the late 20th century American ego, and so as an artist I've always thought my main job was to be a spy. To use my eyes and ears to find some of the answers." Anderson is one of many artists who have made a name by working with new technologies, but she, importantly and unlike others, has always approached this technology as a

way to expand communication with her audience, not as an end in itself. Despite the gadgets, the essence of her art is still a sweaty, smelly, pockmarked, and wrinkled *human* thing. Electronic voice manipulations provide vivid descriptions of characters like grouchy customs officers; video projections lend visual contexts or foils to stories. Anderson uses technology largely to problematicize her narratives yet bring us closer to understanding the many-sided subjects on which she is "spying." It is quite fun to imagine that we are arriving at a new, larger generation of artists practicing with some of Anderson's spirit, spying not just on America but everywhere, on conceptual territories for which we do not yet have names. But we also face a new, different set of problems, and sometimes I wonder if they are not the result of this crisis of information, which Anderson, more than most artists, knows how to juggle.

As power becomes more and more concentrated in the hands of the minority elite—whether Berlusconi, Warner Brothers, the government censors, or those with access to the Internet—a general pessimism pervades, at least on the part of the "slave-owners." There is the stench of market-driven *merde* masquerading as art hovering over our heads, over the airwaves, in the galleries and museums. How else can you explain much-heralded bands like Elastica, my own personal pet peeve, who (having recently settled a lawsuit with The Stranglers on one such count) rip off punk classics from twenty-five years ago to make new, if vaguely familiar, pop hits? The idea is that sincerity has been out for a long time, and now even irony has lost its capability to subvert, so we might as well just make what has been made before—only this time make it marketable. Such willful (and cowardly) historical amnesia makes for art and music just one step away from Eurodance, Disco Lite, or its counterpart, the schlock that shocks (e.g., the Chapman brothers, the infamous young British artists who made a porn movie based around a doctored mannequin head that would have been much more interesting if they would have had the nerve to perform in the film themselves, instead of hiring women to do the acting). At times I catch myself thinking that these products are being pushed on an unsuspecting audience that does not understand the advertising language and will not, therefore, complain about the fodder they are being force-fed as culture. But then I realize: we who have studied semiotics and written college papers on Guy Debord are buying these products too, and worse yet, *we* are making them. And then I am stumped. Martha Rosler says:

> To put it simply, I think we have a war between mass culture and fine art. Artists may feel somewhat impotent in relation to mass culture, but mass culture is our culture, it is "people's culture." It is not generated by people, however. People are

in a very real sense the objects or the creatures of mass culture. Which is not to say that people don't also have a culture of everyday life. It's simply that the culture of everyday life is not represented in what we take to be our official culture, which is television and *People* magazine and the *National Enquirer*. I think that the fact that we developed a dandyistic art like pop art has to do with artists feeling an extraordinary impotence in the face of a culture of mass representation, which does not represent the mass, but rather the thing.[16]

We can soon add cyberspace to that list of official culture in which everyday life is not represented, if *Wired* magazine is any indication of its future. This may seem at first a terribly harsh view of "mass culture," which can also occasionally be fun as well as enlightening. But if you shut your eyes and try to imagine for a minute the millions of Kentucky Fried Chicken restaurants odorifically greasing up the planet, or the citizens-of-the-world's combined, glassy-eyed watched hours of *General Hospital* or *Baywatch*, then Rosler has a strong case. Feeling impotent would seem excusable. But none of this is new. The resulting co-option has been happening for decades—the Situationists wrote the textbook on it. The difference is now—as *The Jetsons* is watched by children in the Gobi desert, as the Japanese and Russians flock to McDonald's—that buying and selling threatens to replace communication and understanding on an exponentially larger scale. I have this nightmare that Disney will soon make the animated film *Ken Saro-Wiwa*, in which an athletically built, noble Nigerian boy valiantly but tragically sacrifices himself in the battle between the staid, wise Shell Oil/Abacha government officials (amongst which flutters a doe-eyed white love interest) and his own people, the conniving, cruel Ogoni (among whom he has lived as a kind of Cinderella). The landscape shall be pure, lush Crayola emerald green, nary a dead tree, oil puddle, or puff of smog in sight.

A few years ago this kind of talk was getting everyone all excited, skipping nimbly round a Baudrillardian black hole. But now we know better—like Case in William Gibson's *Neuromancer*, who fought his corporeality all the time, we are still, and always will be, "meat." This places a number of limits on virtuality (or simulacrum), not least of which is that this crisis of information, besides creating an even more vacuous global culture, has and will continue to have very real and serious consequences on the basic standards of living of billions around the world. But in the end, it might be just this meat factor that saves us—it might not make our world any smaller, but it might open something up, so that we will not all become like Anna in her crisis: divided, compartmentalized, shut off. (Another thing: I, for one, don't ever want to be like Winona Ryder and Ethan Hawke in the movie

105

Singles, who bond only by remembering all the lyrics to the *Brady Bunch* theme song. If *this* is liberty . . .)

This morning, in a delirious burst of optimism, I went back to the train station to see if anything had turned up. Milan's Stazione Centrale is a grotesque, dirty white chunk of colossal prefascist architecture, designed for the precise purpose of making an individual feel small. Located far from the city's touristy fashion district, the area surrounding the station is crowded with Moroccan and Senegalese men hawking contraband Marlboros, leather backpacks, and sunglasses. Beside them loiter outrageous Brazilian transvestites, rather more listless female prostitutes from former Yugoslavia, and a number of grungy adolescent junkies looking like they have just stepped off the cover of *The Face*—and of course, there are the railway travelers, rushing by the station's habitual inhabitants as if they did not exist. The Moroccans stop regularly throughout the day for prayer breaks, prostrating themselves over the turd-stained sidewalk, cigarettes shoved momentarily to the side, muttering a low praise to Allah against the backdrop of this former jewel in Mussolini's crown. Today, the Stazione Centrale represents authority, anonymous and omnipresent, trying its best, but failing, to minimize and control the network of exchanges and interactions of the people in a brand-new world of immigration. This station also shows the future of Italy—and the farther you stray from it the more you encounter only white faces, and spaghetti instead of couscous on store shelves. But just last week a new Asian grocery opened up by my house, a good half hour away from the station.

Still, we are all dwarfed by the Stazione Centrale. My Canadian passport, which gets me all the way to Amsterdam, where Amé cannot go, does not get me very far here. The more I wander around the more the station takes on the characteristics of some dystopic novel of the future. More *1984* than *Mona Lisa Cyberpunk,* mind you. In Gibson's books there is some purpose to the mishmash—everyone is a hustler, a slightly skewed on-line American cowboy. They serve a higher purpose: money, a tangible, practical goal. But this station is like Orwell's book. Everyone dutifully does their thing: cops act like cops, tourists act like tourists, immigrants act like immigrants, and nobody seems to know why. I don't see anyone making much money. Whose chaos is this, anyway? (In Italy, the accusations fly: It's the Commies! The Mafia! The Fascists! The Cops! It's TV! The government! The Church! It's much too irresistible to joke that in this country chances are all these factions are run by the same six guys, anyway.)

Of course, nobody had found my wallet. Would I like to buy some cigarettes? No thanks,

I quit, but even if I did I couldn't since I don't have any money. If I like, I can call the international Mastercard hot line from the station, but that would mean filling out a new form and waiting for the chief's approval. The Senegalese squatting behind their handbags shout "Hi, Blondie!" and I remember that many of these men have university degrees—much better educations than the cops who hassle them, who are not doing much to help me out now. The sole lady-cop scribbles down an address and pats me on the hand. The Canadian consulate is just across the street. I can order some new ID there. I slow down for a second on my way out, as a Chinese couple with a new baby demonstrates a genuinely curious hot-pink-and-yellow rubber ball that bounces up and down in place, entirely of its own accord, seemingly forever.

As a prelude to the following story, it should now be mentioned that Canada is, officially, the country with the world's highest standard of living. My home province, Alberta, is the country's richest province, thanks to oil—it is the Texas of the Great White North. Coincidentally, it was in my hometown, the province's capital of Edmonton, that Elsie McLuhan gave birth to Marshall so many years ago. Not at all coincidentally, this service-oriented, sprawling prairie city also gave birth to the World's Largest Shopping Mall (both the concept and the thing itself), in three intense but glorious contractions (or phases) during the equally glorious 1980s. (Not only did we have the world's largest shopping mall but also the Stanley Cup champion hockey team with Wayne Gretzky; we were thus indisputably the center of the universe.) But the city of Calgary is the province's financial capital and base for all the oil companies. This, combined with its lack of both the Mall and Stanley Cup, has naturally rendered it irretrievably crass in the eyes of Edmontonians, a Dallas to Edmonton's Houston. And thus, appropriately, a couple of years ago I heard a news report from "Cow Town" so ludicrous it left me stupid with incredulity for weeks.

A polar bear in the Calgary Zoo, whose name I forget, had begun to act a bit strangely. Instead of frolicking in its fake snow, munching its tuna, and scratching its belly for the hordes of runny-nosed elementary school students dragged there by their teachers, the bear had begun to pace about its pen. Back and forth it paced all day. This behavior was disconcerting for the zoo's visitors; it made them anxious. Moreover, it was not good for business—nobody wants to go to a zoo and watch a melancholy polar bear pace. It is supposed to act like the star.

The polar bear was soon diagnosed by the zoo's vets as depressed, upset, and confused, just like humans get at times. And of course we should ask: Why not? This is an animal that in nature requires hundreds of square miles for hunting and running and mating. It likes

freezing temperatures all year round, silence, and the cleanest air in the world. Granted, it can get pretty darn frigid in Calgary, but there the bear had been, alone for years in a cage the size of your average SoHo loft, fed only dead things by minimum-wage teenagers, crowds ogling all the while, without even a giant treadmill to work off its frustration. The Calgary Zoo, in its wisdom, decided to fix the situation. And what did it do? Do you think it returned the poor animal to nature, where it could live happily in the wild the way it so obviously longed to? No, of course not.

The zoo, treating the case as many doctors now treat their human patients, put the polar bear on Prozac instead. And they were happy to report that as a result of this treatment the bear stopped pacing completely, and now lolls passively in its little cage all day long, just as it was meant to do when it signed the bloody contract in the first place. And I do believe that the vast majority of citizens in this city were content with the result.

I think that people who would put a caged polar bear on Prozac to keep him from pacing must be horribly out of touch with most everything in their lives. Granted, the people of the province of Alberta, the buckle in Canada's bible belt, have often done stupid things (like spray-painting "Eat Beef, Dyke!" on the welcome sign to vegetarian K. D. Lang's hometown). But this one really took the cake. The polar bear's story also seems symbolic, a fable we may pass on to generations to explain the larger human predicament in the period of late capitalism. Not only do we have Prozac, but also home shopping, Game Boy, virtual sex, and the Oscars to dull our senses, close us off, and stop our restless pacing in a world that increasingly denies and frustrates our physical, animal needs.

So, about the Canadian consulate, I will only sum up. The office was cramped and beige, fringed in a red-and-white maple leaf motif, dotted with glossy calendar pics of friendly Mounties and majestic Nature. A pale young man sat opposite me behind what looked like the world's thickest sheet of bulletproof glass. We spoke to each other through fake telephone receivers, like lovers visiting in prison. I told him my situation ("I have nothing"). "It's too soon to say you have nothing," he told me. "You should wait a month before drawing any conclusions." If I insisted on some help today, however, he couldn't exactly help me himself, but he could direct me to the building's basement, where somebody else could. So I went to the basement. And there I found a real telephone covered in a year's worth of dust and grime, hanging from a wood-paneled wall. Empty cardboard boxes and scuffed, mismatched shoes mysteriously littered the hall. I dialed "123," as the pale young man had instructed, and a woman with a thick Italian accent responded. Yes, she said, it really was too early to say for sure that I had nothing. Why don't I come back to this same phone in a month—if nothing has turned up at the police station, she can give me a few numbers to

call in Canada, and I can start to get some ID back. Out of curiosity, I asked her where her office was located. On the third floor of the same building, she told me, in the same office as the pale young man. And like Dorothy in the *Wizard of Oz*, I suddenly felt very home-sick. Or at any rate, I got to thinking of home.

What I thought was this: "*I am so lucky*. I am *such* a fortunate person. Because this—getting the runaround by a bunch of utterly humorless bureaucrats—was generally the worst my country ever threw my way. No wonder white Albertans are such petulant whiners—we are spoiled rotten."[17] I hung up the phone quite happily and decided never to bother the consulate again.

And thus my thoughts returned to Amé. I wondered where she was and what she had decided to do with my wallet: drop it in a trash bin or stash it under her bed? I wondered also what she was going to do with the money. It was enough to buy another of those little Sony radio-cassette players. It could buy a whole lot of Eurodance CDs. Or, if the Unicef commercials or *International Herald Tribune* editorials had any truth to them, it could buy a lot more for her countless siblings back in the Ivory Coast. Would she marry an Italian and have those six sons, or was she planning on heading back home soon? I tried to imagine her there but couldn't come up with any pictures. Washed-out stills from a movie with Meryl Streep and an image I had drawn from Lessing's book both lingered briefly, then faded from my mind. Some grassy plains, a big sky—the Africa I dreamed of could have been Alberta in the summer. I wanted to picture a city, inside a house, to know where Amé came from. But it was simply too far away to dream. I have never been to Africa; I thought: maybe I should finally drag my ol' meat body over there and see what it really looks like.

I stopped begrudging Amé the money she took. It just didn't seem to matter much, strolling back past the station, past the middle-aged man in his Arafat scarf, selling fists full of candy-colored lighters, a buck a piece. Besides, I've had so many wallets stolen now that I've had to teach myself not to get worked up. I think of these disappearances as sacrifices made for the privilege of traveling. And as it turns out, ironically—as it so often does—I'd had the most enriching, stimulating time with my pocket-picker than with anyone else in the last twenty-four hours. Quite simply, there are many things you can't count on in this world, and your wallet is one of them.

Another are the trains in Italy. Tomorrow there will be a strike, and the blankness of the LED arrival/departure signs will make the station all the more desolate and cavernous. Borland's work comes to mind, and I wonder, does "strike" mean that something or nothing is happening? A few frustrated travelers (peevish Germans, mostly) will be found squatting atop their luggage, smoking and flipping through fashion mags. The Italians all

know better, and will treat it as yet another well-earned holiday and stay at home. And even though there won't be any buyers, the Senegalese, the Moroccans, the Chinese, and the Bosnians will be out there as usual. Because the Stazione Centrale is not, and never has been, a mere point of departure or arrival, nor is it simply a market. It could be argued that it is now primarily a social space, a meeting place for the have-nots: a riddle in the opaque, insulating shell of Italian culture, the Italians being the only folks who never actually spend time there. I guess you could call it a kind of analog Internet—a way for people to meet people from around the world if they can't afford to stay at home in front of a computer screen. Could it be the *next* wave of the future?

I wondered what these people might make of my hometown in Alberta, with its wide, empty roads and endless suburbs, designed for the car—designed precisely to "allow" you to never meet anyone at all. As if that were ideal. Still, there were things I liked. I thought, wouldn't it be fun to take Amé there, to show her the gaudy splendor of West Edmonton Mall as well as the soulless burbs, but also, say, Elk Island Park, where if you find the right trails you can wander for days without seeing another person, but in a much different way from the suburbs. In Elk Island Park it's just you and the wood buffalo, coyotes, and moose among the silver birch trees. It's not for everyone, I know. And as I've left no room for irony, I feel like one of those tripping hippies to even bring it up. But there's something to be said for staying alone like that, under a big prairie sky. You become aware of your infinite littleness in the world—that you're just an animal like any other. If you let yourself, what you feel instead of lonely or scared or bored is an incredible richness of soul. "I'm sure there are places like that where Amé's from," I thought. And then: "I bet she's never been anywhere so cold."

1. Doris Lessing, *The Golden Notebook* (London and New York: Flamingo, 1993), p. 13.

2. Joseph Kosuth's *One and Three Chairs* is a seminal conceptual work in which he describes a chair in three "languages," combining in one installation an actual chair, a full-scale photograph of that chair, and a printed dictionary definition of a chair. This juxtaposition makes apparent the inadequacy of any one of these "languages" in communicating the "chair-ness" of a chair.

3. Richard Barbrook and Andy Cameron, "The Californian Ideology," *Mute: Digital Art Critique,* (fall 1995), p. ix.

4. Ibid.

5. Ibid.

6. Ibid.

7. Ibid.

8. Lessing, p. 13.

9. Ibid.

10. From the song "Life with the Lions" from the album *Workers' Playtime.*

11. Sapphire, *American Dreams* (New York and London: High Risk Books, 1994), p. 1.

12. Eric Michaels, *Bad Aboriginal Art: Tradition, Media, and Technological Horizons* (Minneapolis: University of Minnesota Press, 1994).

13. Lessing, p. 12.

14. Liam Gillick, *Erasmus Is Late* (London: Bookworks, 1995), p. 39.

15. Jen Budney, "Kcho: No Place Like Home" (interview), *Flash Art International* 29, no. 188 (May–June 1996), p. 86.

16. Rosler, cited in *Democracy: A Project by Group Material,* ed. Brian Wallis (New York: Dia Art Foundation/Bay Press, 1990), p. 217.

17. A note for all those (Americans) who still believe that Canada is a socialist country: This is as patently untrue as the rumor that we all live in igloos (only a few do). The premier of Alberta, Ralph Klein, proudly calls himself "Newt of the North," and the homegrown federal Reform Party leader, Preston Manning, styles himself jointly after Ross Perot and Mr. Rogers.

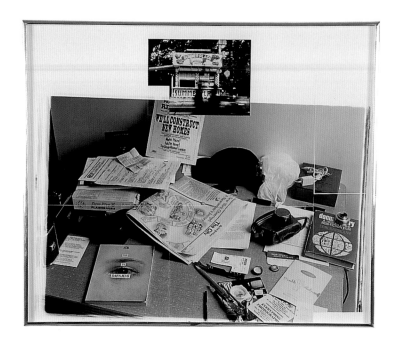

Moyra Davey. *Untitled (The City).* 1996.

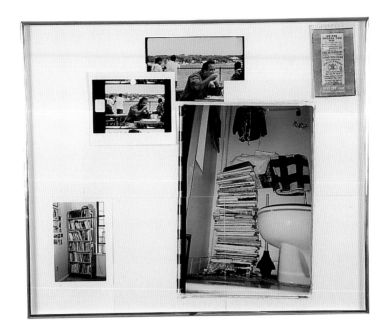

Moyra Davey. *Untitled (No Fee Unless . . .).* **1996.**

Gabriel Orozco. *Turista Maluco (Crazy Tourist)*. 1991.

Opposite and left: **Walter Niedermayr.** *Passo Rolle.* **1992.**

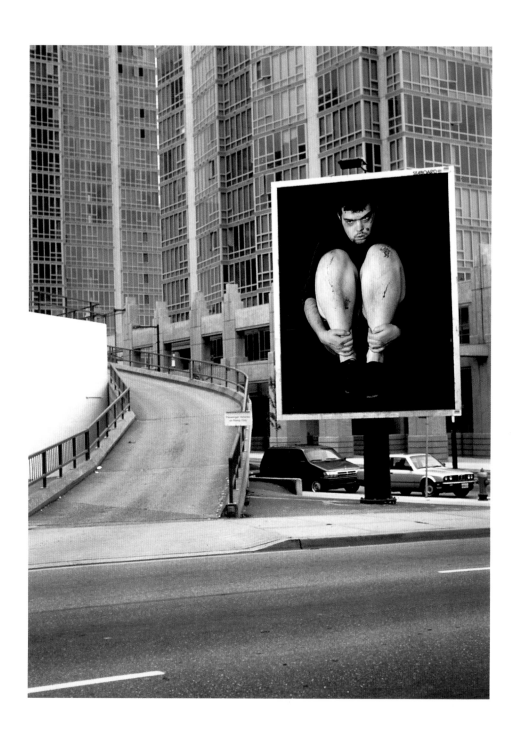

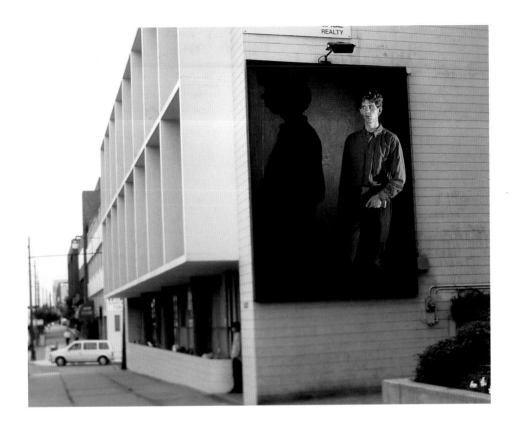

Opposite and above: **Sarah Dobai.** *The Campaign.* **1994–95.**

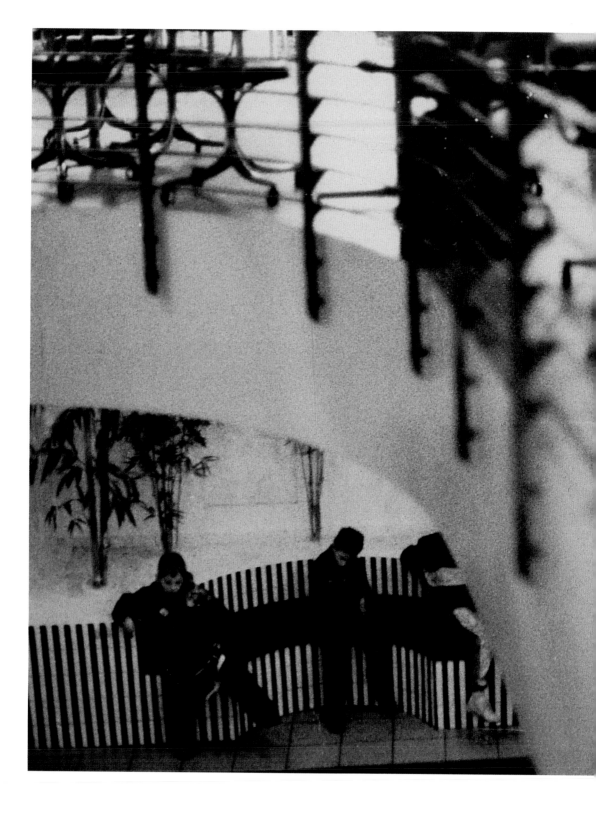

Antje Majewski. *Untitled.* 1994.

Graham Durward. *Untitled (Balloon Video)*. 1994.

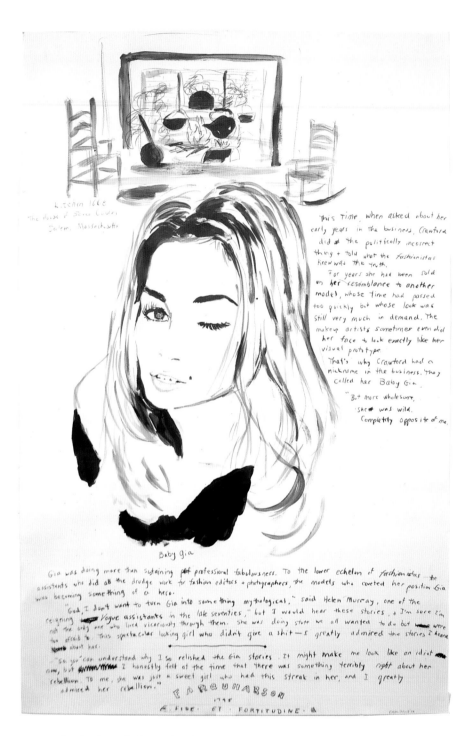

Kitchen 1666
The House of Seven Gables
Salem, Massachusetts

Baby Gia

This time, when asked about her early years in the business, Crawford did the politically incorrect thing + told what the fashionistas knew was the truth.

For years she had been sold on her resemblance to another model, whose time had passed too quickly but whose look was still very much in demand. The makeup artists sometimes even did her face to look exactly like her visual prototype.

That's why Crawford had a nickname in the business. They called her Baby Gia.

"But more wholesome, she was wild. Completely opposite of me."

Gia was doing more than sustaining professional fabulousness. To the lower echelon of fashionistas — the assistants who did all the drudge work for fashion editors + photographers, the models who coveted her position — Gia was becoming something of a hero.

"God, I don't want to turn Gia into something mythological," said Helen Murray, one of the reigning Vogue assistants in the late seventies, "but I would hear these stories, + I'm sure I'm not the only one who lived vicariously through them. She was doing stuff we all wanted to do but were too afraid to. This spectacular looking girl who didn't give a shit — I greatly admired the stories I heard about her.

"So you can understand why I so relished the Gia stories. It might make me look like an idiot now, but I honestly felt at the time that there was something terribly right about her rebellion. To me, she was just a sweet girl who had this streak in her, and I greatly admired her rebellion."

FARQUHARSON
1795
E. FIDE. ET. FORTITUDINE.

Karen Klimnik. *They Called Her Baby Gia.* 1994.

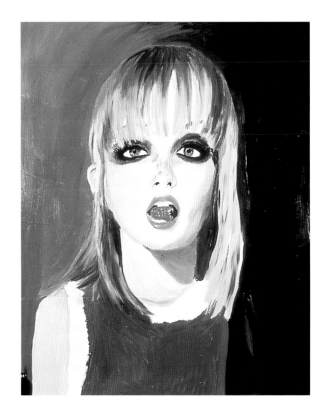

Karen Klimnik. *The Black Plague.* 1995.

Damien Hirst. Detail of *I Love Love.* **1994–95.**

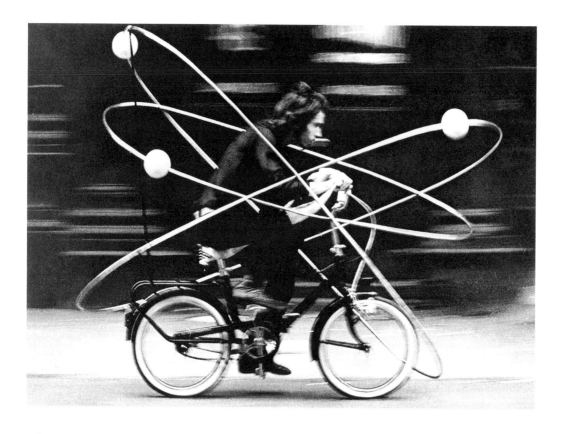

Neke Carson. *Atomic Bicycle.* 1970.

Atomic Bicycle

Keith Seward

"Saturate each atom," Virginia Woolf wrote in her diary.[1] In the postwar age, we know what that means: when the nucleus of a uranium atom is bombarded with neutrons, it results in its fission and in a tremendous conversion of mass into destructive energy. But it is not a matter of whether Woolf lived to see the A-bomb dropped in 1945 or understood anything of the long history of atomic physics, stretching from Democritus and Lucretius to the present day. The artist already works at a molecular level: every text is made of a million microscopic decisions of grammar and style; every painting is made of countless independent commitments to a certain hue, density, or direction in the minutest brush-strokes. Every work of art is caught up in fission and fusion: what does the saturation of *each* atom among congeries of them signify if not a desire to set off chain reactions in language, to trigger a conversion of painting or photography into energy and thereby irradiate the world with art?

Perhaps artists were the first physicists: Lucretius formulated his theory of the declination of atoms in hexameter. "It originates with the atoms," he wrote. "Then those small compound bodies that are least removed from the impetus of the atoms are set in motion by the impact of their invisible blows and in turn cannon against slightly larger bodies. So the movement mounts up from the atoms and gradually emerges to the level of our senses."[2] It is as accurate a description of the creative process as of the physical universe: a brush-stroke here, a brush-stroke there, until the microscopic structure takes on a macroscopic appearance, the colors blend in the eye. But if it originates with the atoms, where does it end? It used to be said that art was that which endured—that art was long and life was short—but now that we can predict with certainty that a given radioactive material will take 1.2 million years to disintegrate, art does not look so long-lived. Artworks may possess half-lives, exhibit periodicity, and create fallout, but in the end they are simply atoms among an

infinity of others in the universe. One of the first problems in the formation of the atom bomb was to separate out U235—the most volatile form of uranium, capable of a chain reaction that spreads like fire—from ordinary uranium; so how do we extract the U235 that is art from the rest of the universe?

universe>art/non-art

It has been said that the *vexata quaestio* of nineteenth-century art was, What is Beauty? How could Courbet dare to paint pictures of peasants on the grand scale normally reserved for the *beau idéal*? For the twentieth century, the question was, What is Art? How could Duchamp dare to sign a urinal and call it art? These are generalizations, of course, yet inevitably they bring to mind the fact that we are at a turning point, at the threshold of the twenty-first century, and it is tempting to try to sum up the art of today—and perhaps that of tomorrow—with a new question: What will replace Beauty and Art in the new inquiry? Truth? Quality? Sublimity?

If art is the sphinx, its riddle has yet to be solved. Obviously, some of the best minds of the century have tried to define art without success, or we could move on to something else. In "The Origin of the Work of Art," Martin Heidegger demonstrated that the concept poses a vicious circle: "What art is can be gathered from a comparative examination of actual artworks. But how are we to be certain that we are indeed basing such an examination on artworks if we do not know beforehand what art is? And the essence of art can no more be arrived at by a derivation from higher concepts than by a collection of characteristics of actual artworks."[3] That Heidegger seeks an "essence" of art betrays the problematical neoplatonic presuppositions underlying his mode of inquiry. That is, the very form of the question "What is . . ." implies an answer that would reduce art to its quintessence: if art is z, then every work of art is $(z–1)$, $(z–2)$, $(z–3)$—an essence or ideal minus the specific imperfections of matter in which the artwork is necessarily ensnared.

While it is not difficult to see why Plato might have sought an ideal behind so many sculptures of athletes and Aphrodites—a vanishing point behind the relatively isomorphic history of Greek art up to the Periclean period—it is not as easy to see why the neoplatonic might seek an essence reconcilable to a tribal mask, a Bronzino painting, a Buddhist stupa, a Greek amphora, and a performance by Paul McCarthy. Given the astonishing number of things that qualify as art, the very category "art" must be overdetermined: it is not reducible to an internal essence, but is rather traversed by a complex of external determinations, differentiations, deformations. Consequently, the very form of the question "What is art?" is

misleading because it preordains a response articulating the ways in which the object is made to fit the category or the essence rather than the ways in which the category is manipulated to fit the object.[4]

How do we phrase the question more accurately? One way is to replace the verb *to be* with *to become*. What becomes art? Restating the problem in terms of becoming rather than being allows a work to be evaluated by criteria that are not absolute in relation to some Art, but are rather relative to historical parameters surrounding the work at any given time. It allows for the work to overshoot its goal, to become art, to pass through art and then become non-art again. The case of Adolphe Bouguereau: he began, like so many others, as a student (i.e., producer of non-art); he won a Prix de Rome and became a popular late-nineteenth-century painter (i.e., producer of art); the advent of modernism made his academic depictions of mythological subjects look ridiculous (i.e., his work became non-art); the development of postmodernism sparked a reconsideration of his position in the history of art, and his paintings now hang in the Musée d'Orsay beside those of peers as disparate as Manet and Meissonier (i.e., they became art again). Did Bouguereau's paintings themselves ever lose or recapture the essence of art? Of course not. It was not the work but the concept of art that changed—and if the very essence of an essence, as every good neoplatonist believes, is that it be unchanging, then art can have none.

Prior to any definition of art's essence, there is thus an operation of selection and separation. Art may detonate an explosion, but just as U235 must be extracted from ordinary uranium before an A-bomb can be constructed, so too must art be extracted from the universe before it can set off a reaction. What causes it to be separated out is a complicated process: the becoming-art of any given object involves a sort of polymerization, in which a multitude of molecules (e.g., personal ambitions, political pressures, global fears, the race to stay ahead of the enemy) are fused into a temporarily stabilized aggregate. But the synthesis of all these becomings-art, taken in their duration, has the effect of splitting the entire universe in two—though certainly not evenly in half—into volatile and stable radioactive materials, into art and non-art. Consequently, any attempt to define art without accounting for *both* art and non-art is comparable to basing a theory of critical mass on U235 alone. In the terms of logic, it begs the question: it assumes what it tries to prove by deriving the essence of art from things already considered art. Heidegger does this by deducing an essence from van Gogh and Greek architecture, both already well seated in the canon. It is like a syllogism of the following form (where the first premise, unspoken, assumes what is to be proved):

(Van Gogh was an artist.)

Artists cut off their ears.

Therefore, van Gogh was an artist.

Of course, Heidegger was well aware that his attempt to discover art's essence was tautological in nature. When he infers from van Gogh's depiction of a pair of peasant boots that the essence of painting as such is the "unconcealment" of truth, he crosswires the ends and means of art and epistemology: "Truth," he admits, "belongs to logic. Beauty, however, is reserved for aesthetics."[5] But if truth, according to Heidegger's reformulation, now pertains to aesthetics, does beauty pertain to philosophy? His philosophy of art is certainly pretty—pretty illogical.

universe>art>power/knowledge

Thomas De Quincey once broached the problem of the approach "What is . . . ?" in regard to literature. What *is* literature? De Quincey was not sure he could answer, and in fact thought that a far more important point was "to be sought not so much in a better definition of literature as in a sharper distinction of the two functions which it fulfills."[6] Taking the fact that there is something called "literature" as a given, De Quincey drew a very useful distinction between two of its primary functions, arguing that there is a Literature of Knowledge and a Literature of Power. "The function of the first is—to *teach;* the function of the second is—to *move.* . . . The first speaks to the *mere* discursive understanding; the second speaks ultimately, it may happen, to the higher understanding or reason, but always *through* affections of pleasure and sympathy." De Quincey adds an example: "What do you learn from *Paradise Lost?* Nothing at all. What do you learn from a cookery-book? Something new, something that you did not know before, in every paragraph. But would you therefore put the wretched cookery-book on a higher level of estimation than the divine poem? What you owe to Milton is not any knowledge . . . what you owe is *power.*"[7]

Once the U235 of art has been extracted from the universe, is it not reasonable to assume that it will unleash a tremendous power? Given the political or even moralizing temper of much contemporary art, it would be tempting to predict that the paradigmatic question regarding the art of the future might be something like "What is just?" or "What is right?" or "What is fair?" However, to call for an art that empowers is like calling for a flower that blooms or a bird that flies. Artists may charge at the unjust windmills erected in society by the powers that be, but art is not opposed to power per se—art *gives* power. And what do you learn about the facts of the AIDS crisis from the work of Felix Gonzalez-Torres?

Nothing at all. You would do better to consult the informative literature of the GMHC. Nevertheless, there is something about Gonzalez-Torres's elegant, eloquent, poignant work—there is something about art itself—that speaks to a "higher understanding" through "pleasure and sympathy," that hits an overtone of mortality more affective than the atonal statistics of death.

The precise nature of such power is not easy to articulate. It is not simply an issue of representation or subject matter, although there certainly are artists overtly concerned with power and force. In the early installments of his *Drawing Restraints* series (1989–93), for instance, Matthew Barney devised a number of pseudo-athletic training procedures that necessitated that, in order to make a drawing, the artist pounce on trampolines, climb ramps while straining at the end of tethers, and push football blocking sleds. The idea, more familiar to athletes than artists, was to see if increased resistance could stimulate an increase of power, just as a muscle atrophies in repose but strengthens against an opposing force such as weight. Although critics have construed the autotelic nature of such training procedures in Barney's work as sublimated autoeroticism (i.e., pumping iron = jerking off, and similar nonsense), really it is not so much a matter of psychoanalysis as thermodynamics: muscular hypertrophy results from the excessive buildup of energy in a closed system (as opposed to a dissipative system, where that energy is expended). Barney's oeuvre is not comprised of idiosyncratic allegories of athletes and satyrs; rather, each element in his iconography is a point of contention for certain forces traversing an entire series of energetic systems. In the recent video *Cremaster 4*, the mad dash and sudden bursts and abrupt halts of the sidecar racers around the Isle of Man are just that: the circulation of forces in a closed system—energy spinning in circles in a force field surrounded by water.[8]

However, though Barney's work may explicitly address the movement of forces and cultivation of powers, it would be wrong to think that the power of his work derives only from this. The power of a work encompasses but transcends mere thematic concerns. Some of the most sublime art in the world—that of Gonzalez-Torres, for example—is incredibly powerful without having any pronounced relation to power as such. And if content alone is not enough to produce power, neither is form. Artists exploring the expanding field of digital hypermedia are encouraged to "empower" users by providing them with nothing more than an increasing number of buttons to click, but as the New York–based digital artists Necro Enema Amalgamated (producers of the CD-ROM *BLAM!*) write, "Giving a user more and more buttons to click is like giving extra links to a dog chain. Sure, you can call three feet of mobility 'freedom' if you want. You can think of *BLAM!* as empowering you, but we know that we're the ones jerking the end of your chain. We've determined what every last little button

accomplishes. Programmers are just that: *programmers.*"⁹ *BLAM!* is an aggressively nonin-teractive CD-ROM, substituting tracking mechanisms and Pavlovian behavioral modification techniques for the simplistic models of user empowerment currently predominant, and yet it delivers more power than any of its peers. In short, it does not wait for you to point and click—it pushes your buttons first.

Nietzsche says that the "effect of works of art is to *excite the state that creates art—intoxication.* . . . Art and nothing but art! It is the great means of making life possible, the great seduction to life, the great stimulant of life."¹⁰ Perhaps it can be said that art itself is not to be grasped but to be taken up or caught, in the same way that surfers catching a wave merely insert themselves into a preexistent flow of energy. Artists often feel as though their creativity originates beyond them, such as in a "muse": it may really be an impulse of some sort that the artist picks up and directs into a work, and passes on to the viewer. "A work of art," writes George Kubler in his brilliant, concise book *The Shape of Time,* "transmits a kind of behavior by the artist, and it also serves, like a relay, as the point of departure for impulses that often attain extraordinary magnitudes in later transmission. Our lines of communication with the past therefore originated as signals which become commotions emitting further signals in an unbroken alternating sequence of event, signal, recreated event, renewed signal, etc."¹¹ It is a matter of potential and kinetic energy: the artwork harbors a certain force, and this force becomes kinetic when it *moves* someone.

universe>art>power>shock/beauty+sublimity

If a treatise were to be composed, in the manner of Edmund Burke or Immanuel Kant, on the affects produced in us by modern works of art, it would no longer focus on the beautiful or the sublime. Its subject would have to be the affect predominant since the nineteenth century; its title would have to be *The Analytic of the Shocking.* The OED cites the first use of the word *shock* to connote "a sudden and disturbing impression on the senses" in 1705, but it is only with the advent of modernism that the word—the *feeling*—has come into its own. Many of the major thinkers of this century have in fact articulated theories of shock. Freud, parallel to the developmental etiology in medicine of traumatic shock, proposed a theory of psychic shock in *Beyond the Pleasure Principle:* the one "regards the essence of the shock as being the direct damage to the molecular structure or even to the histological structure of the elements of the nervous system; whereas what *we* seek to understand are the effects produced on the organ of the mind by the breach in the shield against stimuli."¹² Walter Benjamin, applying Freud's formulation to works of art, wrote

of the "disintegration of aura in the experience of shock."[13] Other thinkers in various disciplines have developed more or less explicit theories, including one of shock's complement and antithesis, the "blasé attitude."[14]

That the primary affect associated with modern works of art is shock implies not only that art has power but that we are able to connect with artworks—plug in, form a circuit, tap into the power of the work. This is fundamentally different from the sublime, which was predicated on distance. Burke argued that the feeling of the sublime was only possible in the face of danger, but a danger kept at bay: "When danger or pain press too nearly, they are incapable of giving any delight, and are simply terrible; but at certain distances, and with certain modifications, they may be, and they are delightful."[15] The sublime is thus always on the other side of the proscenium, as even its etymology—*sub* (under or up to) and *limen* (threshold)—indicates. In shock, however, there is no longer a safety zone between artwork and viewer. "The work," wrote Adorno, "is neither a reflection of the soul nor the embodiment of a Platonic idea. It is not pure Being but rather a 'force field' between subject and object."[16] A force field, a shock corridor, a power line able to pass shock waves from one thing to the next—it is no metaphor to say there is something that connects us to works of art, that enables works of art to transmit their force to us. How else can we be *moved?*

For a work to be shocking, however, entails more than that it form a circuit with us. The work has to have a superior force, something excessive, it has to be able to send a tremendous surge over the power line. If the U235 of art can be not just extracted from the universe but *exploded,* then how do we measure its force? How does it acquire or increase its power? Traditionally this force—or more specifically, the quantity of this force—derives from the degree of difference manifest in a work of art, either in the form of the new (the black square) or the taboo (the slit eyeball). Simmel argues that the blasé attitude is caused by "an indifference toward the distinctions between things."[17] Conversely, the shocking is precisely that which asserts its difference in an aggressive fashion: violence is anathema to society? Buñuel's *Un Chien Andalou* begins with an eyeball being sliced open like a plum. Art has to represent the world: the life of the bourgeoisie? Malevich paints a black square. If the sublime is produced by the deferral of the dangerous, the shocking is created by the danger of the different.

But haven't we seen it all? Is anything shocking anymore? If the blasé attitude appears to reign today, it is because of a paradox: a work can only shock by asserting its difference, and yet art itself has become a differential system. In other words, it was easy for a work to differentiate itself when art was comprised of isomorphic systems—academies, schools, movements. But just as nuclear proliferation has now taken the form of coups d'état, terrorists,

guerrillas, molecular clusters of power rather than the old bilateral stasis of superpowers, so too has art undergone a profound, rapid fission. *Atomization* has become its very operative principle. If the category is traversed and *smashed* by a complex of external determinations, it now allows for every kind of difference: when we speak popularly of artists, we tend to say that an artist reflects society, leads society, attacks society, mocks society, cures society, is suicided by society, and so on. You could draw an equation, *artists x society,* where the variable *x* can stand for reflect, attack, cure—and, today, for throw shit at, puke on, fuck, *anything.*

In short, art has become a differential system in which an astonishing number of aesthetic strategies are able to multiply and combine in pursuit of a dazzling number of effects. It can encompass the most advanced experiments of New York or Berlin and the most indigenous traditions in China or Mexico. It does not level the differences between such disparate incarnations of creative desire, because art is itself comprised of these differences. Consequently, shock may seem dulled because nothing can be different *enough* when difference itself is the norm. But does this mean that art no longer has power? No—*shock* is not a very specific word: after all, there are many different uses for a current—electrocution, electroconvulsive therapy. Art may no longer shock but it can resuscitate hearts, cure schizophrenia, punish criminals.

universe>art>power>shock>atomic bicycle

Traditional aesthetics have always prioritized vision. Nietzsche criticizes Kant for having "unconsciously introduced the 'spectator' into the concept 'beautiful.'"[18] The spectator's aesthetics—contrasted by Nietzsche to those of the creator—assume or perhaps even create a gap between subject and object, a caesura, a *viewing distance.* In the concept of the sublime there is the threshold between subject and object, and even in the museum there is the artificial fabrication of a no-man's-land—PLEASE DO NOT TOUCH—as though artworks were little resurrected Christs murmuring *"Noli me tangere"* to every passerby. In contrast, the art of power presumes that there are points of contact between artworks and viewers, that it is possible to form a circuit between the affective designs of an object and the affective receptors of a subject—as though the artwork is a conductor transmitting impulses from the efferent nerves of the artist to the afferent nerves of the viewer. It is not so far from a Lucretian physics, which is based not on vision but touch. How can a sense be affected by something that does not touch it? asks Lucretius, arguing that in sensation, clusters of atoms literally brush against the eyeball or slip in through the ear.[19]

Art has an essentially atomic structure, which is to say that it exhibits wave-particle

duality, that it is schizophrenic. "But electrons, neutrons, protons and even whole atoms—the stuff our own bodies are made of—also display pathological behavior. . . . The root cause of this pathology is the schizophrenic personality of quantum phenomena, which act like waves one moment and particles the next."[20] Artworks tend to be objects or things, but just as a nuclear reaction transforms matter into energy, so too do artworks become forces. Shock is nothing other than the sudden, excessive transmission of charged electrons from one atom to another. Asked to describe his electroshock therapy, a patient says: "It's like an atomic bomb that runs horizontally through your brain."[21] Powerful art sets off reactions and explosions in the beholder, who is no longer an isolated satellite of bourgeois subjectivity but a circuit board, an affective system able to connect to outside forces. Shock treatment literally exteriorizes Antonin Artaud: "And my whole inward electric body, the whole lie of this inward electric body which for a certain number of centuries has been the burden of every human being, turned inside-out."[22] There is no longer a gap, a viewing distance, between works and viewers—there may no longer even be "works" and "viewers," as the lie of the inward electric body gives way to the communication of force fields, power lines transmitting shock waves of charged electrons from one field to another.

In 1970 the artist Neke Carson developed what he called the *Atomic Bicycle*. A photograph shows him racing through Central Park on a "bicycle modeled after the old-style idea of the atom for people who like to ride around in an obsolete concept of the universe." Lucretius's universe ceased to be obsolete only recently, as developments in physics of the last twenty-five years revived his vision of an infinite number of atoms falling vertically through infinite space. What physicists today appreciate is Lucretius's *clinamen*—a slight swerve in the declination of the atoms without which there would be no creation.[23] "If it were not for this swerve, everything would fall downwards like rain-drops through the abyss of space. No collision would take place and no impact of atom on atom would be created. Thus nature would never have created anything."[24] The clinamen is a slight deviation of that which is at once particle and wave—atom and energy.[25] It is the creative principle. Is every artist not pedaling away in the nucleus of an atomic bicycle, crashing into other atoms, producing the clinamen—the chain reaction that gives off radiation, aura, and shock? Saturate each atom: convert your medium into energy and irradiate the world with art.

1. *The Diary of Virginia Woolf,* ed. Anne Olivier Bell (London: Hogarth Press, 1980), vol. 3, p. 209.

2. Lucretius, *De Rerum Natura,* trans. R. E. Latham (New York: Penguin, 1951), p. 64.

3. Martin Heidegger, "The Origin of the Work of Art," in *Basic Writings,* trans. David Farrell Krell (San Francisco: HarperCollins, 1993), p. 144.

4. Gilles Deleuze articulates a similar problem in Nietzsche's critique of Plato: "Moreover, when we ask the question 'what is it?' we not only fall into the worst metaphysics but in fact we merely ask the question 'which one?' in a blind, unconscious and confused way" (*Nietzsche and Philosophy,* trans. Hugh Tomlinson [New York: Columbia University Press, 1983], pp. 66–67).

5. Heidegger, p. 162 et passim. See, for example, "The essence of art . . . is the setting-itself-into-work of truth," p. 197.

6. Thomas De Quincey, "The Literature of Knowledge and the Literature of Power," in *Selected Writings of Thomas De Quincey* (New York: The Modern Library, 1949), p. 1099.

7. Ibid., pp. 1099–1100.

8. An exposition of Barney's relation to force appears in "Matthew Barney and Beyond," *Parkett* 45 (December 1995), pp. 58–65.

9. *The NEA Agenda* (New York: Necro Enema Amalgamated, 1994), p. 7.

10. Friedrich Nietzsche, *The Will to Power,* trans. Walter Kaufmann (New York: Vintage, 1968), pp. 434, 452.

11. George Kubler, *The Shape of Time* (New Haven, Conn.: Yale University Press, 1962), p. 20.

12. Sigmund Freud, *Beyond the Pleasure Principle,* trans. James Strachey (New York: Norton, 1961), p. 36.

13. Walter Benjamin, "On Some Motifs in Baudelaire," in *Illuminations,* trans. Harry Zohn (New York: Shocken, 1978), p. 194.

14. The "blasé attitude" derives from Georg Simmel, "The Metropolis and Mental Life," in *On Individuality and Social Forms,* trans. Donald Levine (Chicago: University of Chicago Press, 1971), p. 328.

15. Edmund Burke, *A Philosophical Enquiry into the Origin of Our Ideas of the Sublime and Beautiful* (New York: Oxford University Press, 1990), p. 36. See also Kant: "It is impossible to find satisfaction in a terror that is seriously felt," and so on ("Analytic of the Sublime," in *The Critique of Judgment,* trans. J. H. Bernard [New York: Hafner, 1951], p. 100 et passim).

16. Theodor Adorno, "Valéry Proust Museum," in *Prisms,* trans. S. Weber (London: Neville Spearman, 1967), p. 184.

17. Simmel, p. 329.

18. Friedrich Nietzsche, *On the Genealogy of Morals,* trans. Walter Kaufmann (New York: Vintage, 1969), p. 104.

19. See Lucretius, p. 72: "For touch and nothing but touch is the essence of all our bodily sensations, whether we feel something slipping in from outside or are hurt by something born in the body" (also p. 137 ff). In "The Power of Words," Edgar Allan Poe describes the word as an airborne current that literally has a physical force comparable to that of wind: "Did there not cross your mind some thought of the *physical power of words*? Is not every word an impulse on the air?" Words are thus literally able to cause storms, tornadoes, *the maelstrom.* (See Poe, "The Power of Words," in *Poetry and Tales* [New York: Library of America, 1984], p. 825)

20. John Horgan, "Quantum Philosophy," *Scientific American* (July 1992), pp. 100, 96, respectively.

21. John Friedberg, M.D., *Shock Treatment Is Not Good for Your Brain* (San Francisco: Glide, 1976), p. 95.

22. Antonin Artaud, "Electroshock," in *Anthology* (San Francisco: City Lights, 1965), p. 184.

23. See, for example, the book by the Nobel Prize–winning physicist Ilya Prigogine (with Isabelle Stengers), *Order Out of Chaos* (New York: Bantam, 1984), p. 141: "We are not so far from the clinamen of Lucretius!"

24. Lucretius, p. 66.

25. "The atom of the ancients, from Democritus to Lucretius, was always inseparable from a hydraulics, or a generalized theory of swells and flows. The ancient atom is entirely misunderstood if it is overlooked that its essence is to course and flow" (Gilles Deleuze and Félix Guattari, *A Thousand Plateaus*, trans. Brian Massumi [Minneapolis: University of Minnesota Press, 1987], p. 489).

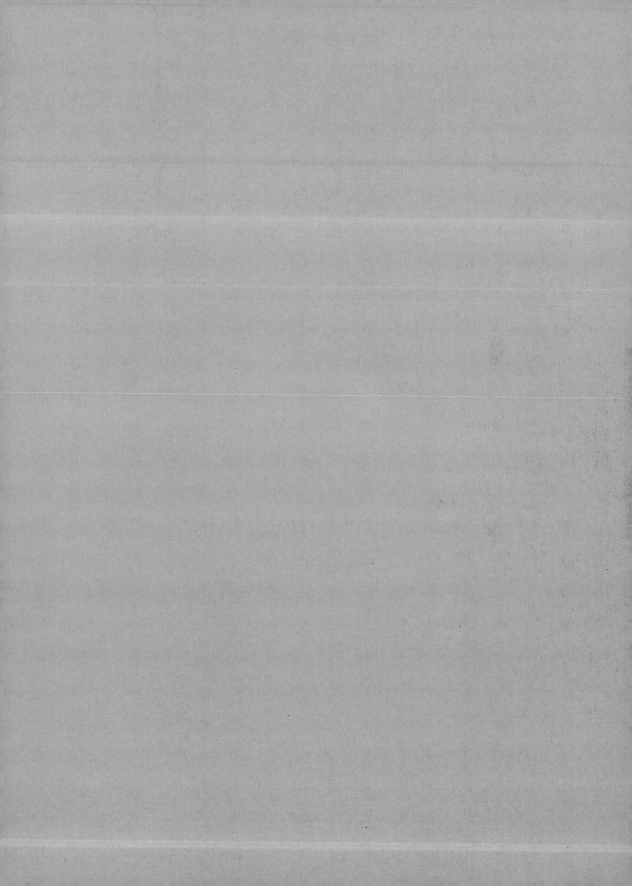

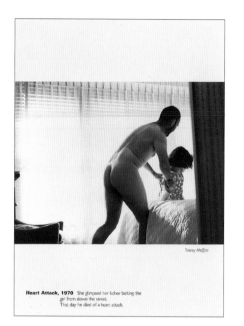

Heart Attack, 1970 She glimpsed her father belting the
girl from down the street.
That day he died of a heart attack.

Tracy Moffatt. *Scarred for Life (Heart Attack, 1970).* 1994.

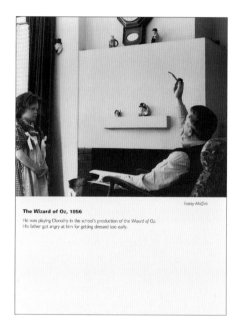

The Wizard of Oz, 1956

He was playing Dorothy in the school's production of the *Wizard of Oz*.
His father got angry at him for getting dressed too early.

Tracy Moffatt. *Scarred for Life (The Wizard of Oz, 1956).* 1994.

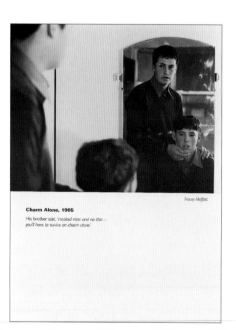

Charm Alone, 1965

His brother said, 'crooked nose and no chin –
you'll have to survive on charm alone'.

Tracy Moffatt. *Scarred for Life (Charm Alone, 1965).* 1994.

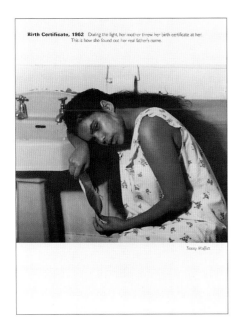

Birth Certificate, 1962 During the fight, her mother threw her birth certificate at her.
This is how she found out her real father's name.

Tracy Moffatt

Tracy Moffatt. *Scarred for Life (Birth Certificate, 1962).* 1994.

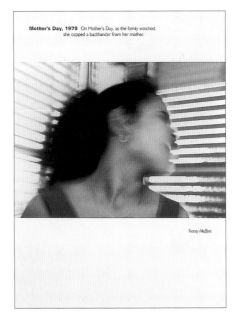

Mother's Day, 1975 On Mother's Day, as the family watched,
she copped a backhander from her mother.

Tracy Moffatt

Tracy Moffatt. *Scarred for Life (Mother's Day, 1970).* 1994.

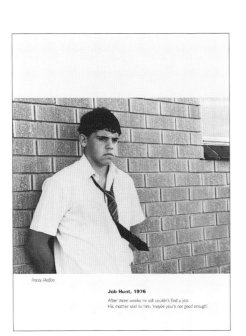

Tracy Moffatt

Job Hunt, 1976

After three weeks he still couldn't find a job.
His mother said to him, 'maybe you're not good enough'.

Tracy Moffatt. *Scarred for Life (Job Hunt, 1976).* 1994.

Jack Pierson. *Begonia and Tim's Shower.* 1995.

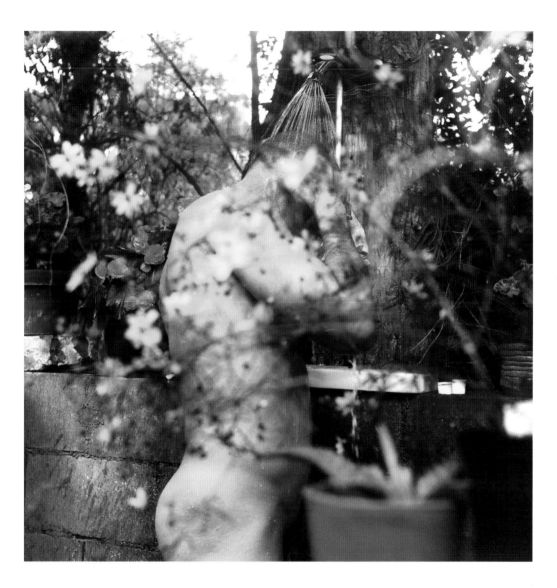

Jack Pierson. *Tim in Outdoor Shower.* 1995.

Miltos Manetas. *Soft Driller.* 1995.

Diana Thater. *Abyss of Light.* 1993.

Matthew Barney. *Cremaster I.* 1995.

Steven Pippin. *Interior.* 1994.

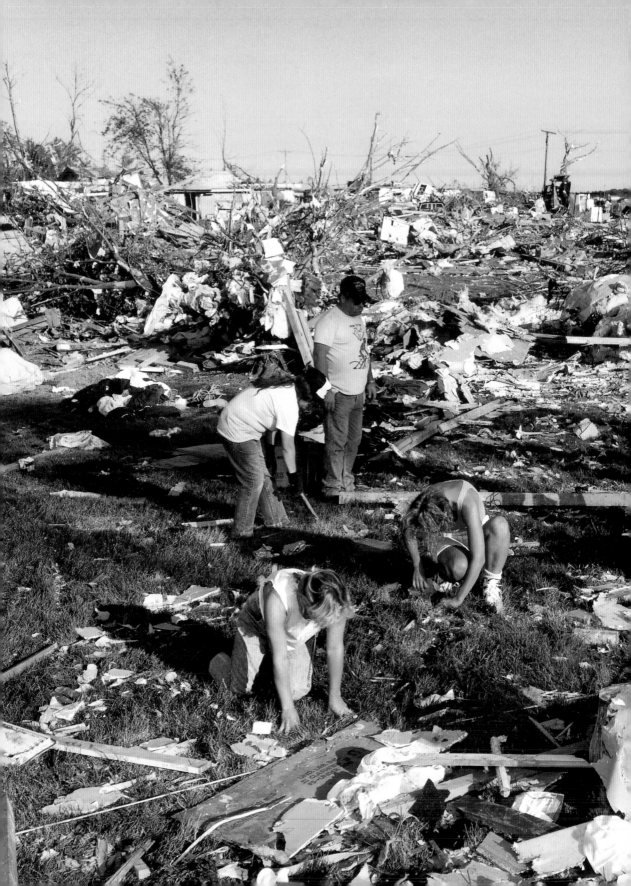

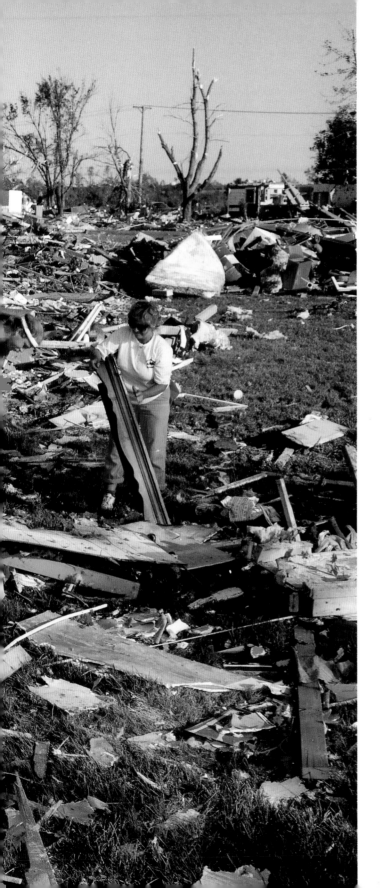

Jay P. Wolke. *Post Tornado, Ill.* 1991.

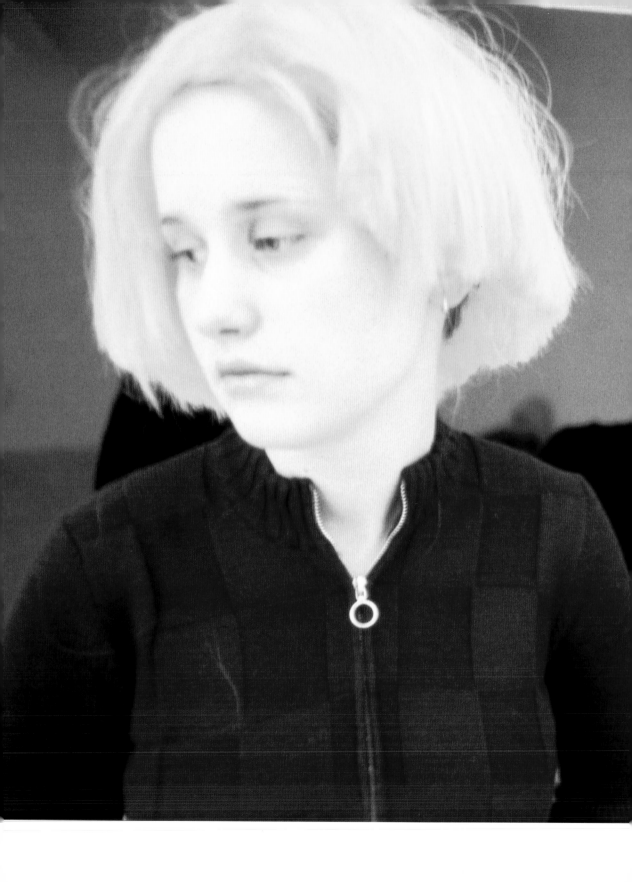

Vanessa Beecroft. *Ein Blonder Traum.* 1994.

Terminal Holding Patterns (Flight 101 Is Indefinitely Delayed)

Neville Wakefield

Whether one consults the annals of the world, or supplements uncertain chronicles with philosophical inquiries, one will not find an origin of human knowledge that corresponds to the idea one would like to hold regarding it. Astronomy was born of superstition; Eloquence of ambition, hatred, flattery, lying; Geometry of avarice; Physics of vain curiosity; all of them, even Ethics of human pride. The sciences and arts thus owe their birth to our vices: We should be less in doubt regarding their advantage if they owed it to our virtues.

— Jean-Jacques Rousseau, part 2 of the *First Discourse*, 1750

Nearly two hundred and fifty years down the unlinear line that passes for history, the doubts leveled by Rousseau regarding the origins of knowledge—its genesis and promulgation within the arts and sciences—remain as pressing now as they did then. Nowhere, perhaps, is such doubt both more in evidence and less proclaimed than on America's TV channel 18, a form of television edification that goes under the name of the Discovery Channel. Spilling from the barium light of the postmodern hearth into the living rooms and living arrangements of those who, like myself, have come to favor the easythetics of passivism over the rigors of travel, "nature television," the TV vérité of the 1990s, has become the *gesamtkunstwerk* from which the annals of our world are laid bare. Responding to the outside world seen in interior light, we find a new form of indoor anthropology, in which both science and art, nature and aesthetics are fused in the particular nonspace that television's focus has claimed as

its own. Within this improbable architecture, the art of distance and the technology of proximity have combined to produce a spatial alloy, the measure perhaps, not just of our times but of the vices out of which such times are born.

The Discovery Channel has during the last ten years entered eighty million homes via the cable network to become a global enterprise, a name as the press release would have it "synonymous with informative television entertainment worldwide." In many ways, what Discovery does on the tube is what *National Geographic* once did in print. As well as catering to a taste for the forbidden—thongless Masai and topless Amazons did for the pipe-and-slippers crowd what nature's tech-war does for the current demographic—it provides a complete cosmology, a world that moves seamlessly from the paleo to the neo, from *The Great White Shark* to *Submarines: Sharks of Steel*, from the ethnology of blowpipes and nose rings in *People of the Rain Forest*, to that of F14s and epaulets in *Carrier: Fortress at Sea*. It has, in other words, become a part of the solid furniture of television life. And for those whose calendars permit, its particular brand of nonfiction infotainment, from which hard-core nature programming is never more than a hour or so away, has become the roughage in a televised diet made macrobiotic by endless afternoons of human plight—incest, child abuse, family meltdown—of Ricki, Maury, or Jenny.[1]

As furnishing for global living rooms, the Discovery Channel has more in common with airport architecture than with its domestic domicile, for it models a nonspace, a duty-free ecology and discounted state of mind. Like the holding patterns between customs and immigration, it devotes itself only to the curious pleasures of detachment and delay. A form of home-flight entertainment, tele-nature is both state without place and place without state. Hitting channel 18 on the remote offers pleasures similar to those of passing through ticket check and immigration. In both cases we check in to relieve ourselves of the encumbrances of baggage and identity. Assigned flight and seat numbers, we can relax, confident that within their combined vectors is held the covenant of travel. Enfolded within this promise of future space, we become sedentary tourists expectant of the mobility of flight but confined to the departure hall, the first-class spaces and satellite lounges of "Admirals," "Connoisseurs," and "Ambassadors": places where status is the mere promise of state, the empty reassurance of the name. Held within their archaic nomenclature, the fear of nonspace finds club comfort in the invocation of the old state(rooms), and social hierarchies now left behind. As the security checks, inspections, and continual surveillance remind us, the nonspace of the airport, like tele-nature, is a no-man's-land where violence, once unstated, becomes pure terror: the omnipresence of threat. Everywhere and nowhere, these are global spaces whose logic, once detached from the spatial landscape of calculation, belongs only to such a figure of excess.

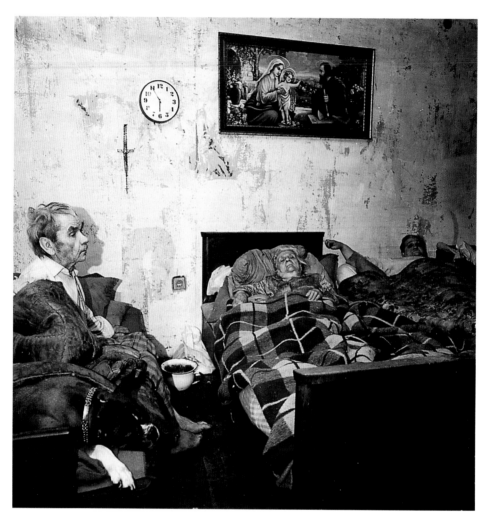

Boris Cvjetanovic. *Mesnicka Street.* 1983.

Boris Cvjetanovic. *From the Summer Holidays.* 1995.

Pages 170–71: Angela Bulloch.
From the Chink to Panorama Island. 1995.

In common with ethnology and the human sciences, of which "interest" programs provide an accurate if none too rarefied barometer, nature television also predisposes its audience as direct witness to present actuality. Nature, which like human behavior is beyond the reach of normal life, eludes everything but television's long-armed grasp. But the elsewhere that it describes—the wide open plains, untamed savannas, submarine landscapes, and other cruel spaces—has joined the specular might of an equatorial culture devoid of meridians, an arena not unlike the talk-show floor or airport lounge, where actuality is without time or place. Like the underdeveloped colonial territories once favored by ethnological and anthropological research, this is a space from which we harvest not a sense of distance but of the civilized near. And to the swelling audience of recumbent travelers, Discovery's nature programming preys upon a delicious and cataplexic fear. With no place to run and no place to hide, our paralysis would appear no different from that of the victims of nature's mortal indifference. Transfixed by nature's pixilated enactment of its own death, we rehearse its bit parts like speechless extras whose cues have been long since missed. For here nature itself has achieved the status of nonplace, a place of memory and wordless communication. Sheathed only in the uncertain pleasures of our own solitude it has become a place of anthropological silence.

Formally, these hour-long armchair missions into a dark Other—where Africa is still the "Cradle of Legends," the Nile still "River of the Gods"—pay homage to the nineteenth-century belief in the explorative character of travel, to an era tuned to the metaphorical resonance of the remote. This was a time when nature and culture were still divided over the unknown of passage. Unbounded by the guardians of travel, the old parentheses of excursion and return, our journeys of discovery never leave nature's departure lounge. Like latter-day Marlows, we strain upriver, searching for the equivalent of Kurtz's Inner Station, the remnants of some colonial "mission," a heart of darkness beating perhaps to the rhythm of the Other and suspected to be absent from the postmodernized soul. But the savagery that for Conrad, writing at the beginning of an era, came in the breath of existential epiphany—"The horror! The horror!"—is now, at the end of that era, delivered simply as horror. Where Marlow's journey of realization fills the jungle with the cadenced but relentless crescendo of the pounding drums, and is echoed in the throb of language propelling novel and protagonist toward the figure of Kurtz, ours takes place in the narrative silence of pure scopic revelation. The flower of European civilization ("all Europe contributed to the making of Kurtz"), exemplar of enlightenment, the figure of benign colonialism, like that of disinterested science, has abandoned himself to . . . certain practices.

Today we trade not in the ivory of animals but of vision. Colonized and harvested in the name of science it is nonetheless distributed in the name of something else—something

less to do with the epic confrontation of civilization with its unlawful or repressed desires than with the sheer thrill of vicarious and uncommitted travel. And so we find that against nature's magnificent backdrop our televised journey leads from serenity to sanguinity. Violence flares like our match in the dark. Illuminating nothing more than a fascination with an aestheticized and indifferent terror, nature television broadens the narrow thread of Conrad's mythic river into leisureways opening no longer onto the Africa of the soul but into Floridas of the mind.

Other elements of a fundamentally nineteenth-century vision, seemingly at odds with postmodernity's amphitheater of the wild, also survive in entropic form. Nature, according to the nineteenth-century romantics, offered the sublime reassurance of a monotheism, evoked in the work of artists such as Caspar David Friedrich, not as object but as subject of our contemplation. Soaked in allegory, the natural world merely provided the backdrop against which the imagination tested its loneliness and ultimately found reassurance in the existence of presences larger than itself. In this sense the camera that lingers on the dried-up water holes of the Serengeti is little different from the gaze that fixes Friedrich's architectural ruins—albeit that one is cast as a necropolis to natural ruination, the other to the demise of civilization. An emblematic painting from c. 1818 entitled *Wanderer above the Sea of Fog* depicts a man perched on a craggy pinnacle, his torso twisted, a wild mop of red hair confronting the viewer. Although his body faces us we see only the back of his head; an exaggerated *contrapposto* forces our gaze to follow his, into the interior space that is his mind and our image. Staring at this enigmatic character swathed in mist, we wait for him to turn around, to reveal in his features those of the landscape beyond. But the autonomy of the pictorial space is never broken; our gaze never met. The solitary figure addresses nature as if it were nonplace, a space of suspended identity where travel deprived of movement becomes a region into which the gaze can pass but the body can never follow. Like the figure, the image itself becomes a description of this suspension between interior and exterior spaces, the thrust of the body and the turn of the mind. The proscenial membrane that divides the seen from the being seen is never punctured. In Friedrich's remarkable painting, the spectator (perhaps for the first time) is cast as nothing other than his own spectacle. Confronted by the forces of nature he strikes a pose, and in doing so derives from his awareness of this a rare and sometimes melancholic pleasure.

Whether attached directly to its chothonic powers or indirectly to a philosophy of nature—from which God, the infinite, appeared as the vast diffuse presence behind the screen of natural facts—the romantic conception of the universe still hovers around the fringes of our understanding, framed as it is between the polarities of nature and culture, of seeing and being seen. But the nature that was once asked to model God must now do the same thing

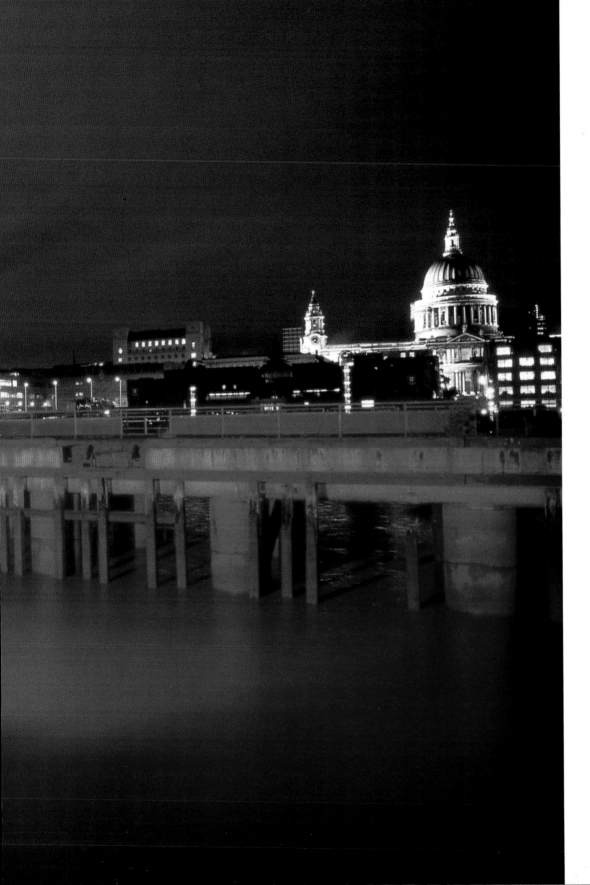

for science. And in part, the attraction of such programming belongs precisely to the fact that what we are watching is not the revelation of the Other but of a technological deity that pours distance into proximity, and in doing so transforms space into nonspace, travel into aesthetics. Hitchcock, master of the psychoplastic landscape, once made the claim that movies are first of all armchairs, with spectators inside. Now nature models the same dictum, as it has become composed around the recumbent gaze. The real estate of the moving image, once called the cinema, now answers to the name of the natural world. And just as Friedrich's romantic version of the sublime, or Conrad's horror, suggested in different ways the inescapable and omnipresent powers of forces beyond our control, so our distant close-up of the wild reinvests in nature a content betrayed by its domesticated setting and contemporized form. Like those of Friedrich's wanderer, our own travels are designed never to break the proscenial divide separating the here from the elsewhere, the acculturated vision from its raw otherness. The question lying at the heart of television's Oedipal triangle—the familial alliance of science, art, and technology—as to whether we represent the construction or construct the representation is thus conjured only in spectacular muteness. For nature itself has become a "surd area," a fringe or backwater region where logic has been suspended. A psychic space like that of the airport waiting lounge, it demands only that we focus upon our detachment from purpose, suspended as if in contemplative quarantine.

It should perhaps come as no surprise that the compass of the natural world, beamed as it is from satellites and nature banks, is not dissimilar from that of the shopping mall, the cineplex, the transit lounge—those spaces that Marc Augé identifies as characteristic of supermodernity.[2] Framed within the handsome and hardworking velour of the aircraft passenger seat, the Discovery Channel has joined its pool of video liquidity, to become literally incorporated in the seat of travel. Here the experience of tourism is played out in parallel time. The promise of destination withheld, it is delivered as a metaspace, which like roads in America, the twinned towns in Europe, and the celestial bodies of outer space is now given meaning only through adoption. (Bruce Willis's potholed section of the Long Island Expressway, it might be noted, compares less favorably with Dolly Parton's section of the same highway, which in turn looks bleak when compared with my goddaughter's adopted star.) Orphaned within a sky without horizons, we adopt nature and the science that promises its delivery not in order to celebrate and understand, but to make of it a celebrity: to transform us as road users, star gazers, and vicarious travelers into pioneers of scarcity. Like the luxury goods of the duty-free halls, the travails of nature are offered as the exotic fruit of the traveler's suspended identity. For airport-style nonspace is no longer the reserve of waiting room, the space-time of infinitely protracted delay—its very architecture is now at one with the soft-furnishing of our immobility.

Fangs, a thirteen-part series of natural predatory dramas played out in anthropomorphized form, does for nature what *The Good, the Bad and the Ugly* did for Clint Eastwood and Westerns. The titles—"Forest of Fear," "Nature's Gangsters," "Teeth of Death," "Silent Savage"—titillate with the possibility of gore and phobic association. A bright shaft of sunlight illuminates a tarantula as it sidles in for the kill. Close-ups of impossible detail linger in the repulsive landscape of its arachnoid otherness while a voice of sonorous authority (always a man's voice because the ego-ideal of these programs is invariably masculine) prepares us as witnesses to a convulsive, poisonous death with soothing talk of natural systems and eco-hierarchies. In another episode we might find ourselves face-to-face with a lion as it strains at the pulmonaries of an unfortunate wildebeest, still alive and kicking. It is not exactly the stuff of the *Lion King*. But then again it's not exactly not. For animal fables permeate Discovery's natural soaps as much as they do the saccharine landscapes of its computer-animated cousins. As Jerry Seinfeld has unwittingly noted, human nature as much as the laws of nature is inevitably the issue at stake: "I always love how one animal is star each week. And you want him to kill whatever he is trying to kill because you're on his side. If it's the lion, you want him to get that boar. The next week it's about boars. Now you're hoping that the boar gets away from the lion. Your loyalty is always so fickle."[3] Survival in the gladiatorial world of snuff-nature is thus a fight less for life than for the capriciousness of our attention. The commentary, by continually invoking foundation narratives of war and flight, naturalizes the bloodfest with appeals to crude Darwinism as the final arbiter of territorial claim. But the theaters of aggression owe less to the evolutionary descent of man, or for that matter the primitivizing grandeur of Rousseau's noble savagery, than to a concept far more contemporary in its realization: that of total (ratings) war.

"There is a bloody, brave little animal in Africa called the honey badger," entices the introduction to "Meanest Animal in the World?" "It kills for malice and sport. It does not go for the jugular, it goes for the groin." Teasing us with the promise of hard-core badger porn, the narration backtracks into the decorum and furry atmosphere of a family channel, with the hastily added proviso that these are the words of an American naturalist whose behavioral assessments belonged to an era before the long lens of tele-objectivity. The program focuses on the the strange and apparently one-sided relationship between the honey badger and the goshawk. The bird, an opportunist scavenger, hangs out watching and waiting for those rare moments when its unwitting partner, the "four-legged digging and killing machine" fails to capture its prey—usually small mice, citizen soldiers of the savanna living under the constant administration of its fear. In many ways our own relationship to the shortsighted badger is similar to that of the hawkeyed hawk. The camera tracks the badger as if from the

point of view of the hawk—from high overhead, swooping in at the first sign of action. It is the ideal vantage point, not only because it combines the effects of movement and distance but because it recognizes that just as the tele-journey has taken over from the grand tour so the zoom has taken over from the walk, the establishing pan from the panorama. The goshawk young observes the badger "without really knowing why," since it has yet to learn of the "special relationship between bird and beast." And like it, we fixate on nonfiction badger entertainment and the amphitheater of the wild from a similarly Kantian perch. For disinterested interest is precisely the attention that these programs demand—transforming as they do the science of understanding into the aesthetics of proximity.

The facts of badger life, or their appearance within narratives of change and evolution, would once (when gathered together and refined in sufficient number) have taken the observer, via a sort of brute-force inductivism, to grand theories capable of unifying and explaining the natural world. But the very attraction of this type of programming belongs largely to the fact that it tells us nothing of nature. The ultimate tale of progress, the motor of scientific advance, may have been empirical discovery, but the hyperstasis of pseudoscience is just pure Discovery. We swim, burrow, and fly as if in a delirium of technology, our own impassivity ensnared by the simultaneous thrill of proximity and the promise of distance. Our desires actualized in visual pleasure—in the hallucination of detail and voyeurism of exactitude—we see less of the natural world than of the perceptual possibilities that it is asked to model. The play of appearances that once sustained the narratives of scientific and behavioral understanding are thus all but dissolved in the revelation of the technical apparatus. Stalking the planet with the technologies of enhanced vision, Discovery returns from its long, distant probes taking hostages of the natural world, at once acculturated by the technology that brings them into being and "naturalized" by the distance that separates us from them. It asks us not that we return to the scientific tenancy of the Enlightenment and narrate the order of things in the noise of knowledge but in the silent and familiar cocoon of recognition.

The nature of space and the space of nature have, since the nineteenth century and before, formed the two sides of a Möbian strip known as pictorial practice. We follow one side—perhaps the nature of the space of travel and the architecture of its holding patterns—only to find that it has become the other and vice versa. Watching television may not have been what Rousseau had in mind when he spoke of our "consultation with the annals of the world," but in it can be found an aesthetics of space as deeply indebted to our vices as it has been presumed to have been born of (pseudoscientific) virtue. Superstition, hatred, flattery, avarice, vain curiosity, and human pride are now perhaps the real players in that placeless space in which the illusion of the far away has been reinvented through the medium of

nature's merciless travails. But while a social anthropologist might attempt to claim that nature constituted as infotainment brings with it the suggestion of weakness in our own society's capacity for symbolization—a weakness that finds its compensation in the TV veldt of violent struggle enacted over symbolic dominion, rules of alliance, lineage, and inheritance—such claims suggest precisely the correspondence between the origin of knowledge and the ideas one would like to hold regarding it against which we have been duly warned. Approaching the end of the twentieth century, we might add to Rousseau's litany a further proposition: that nature is born of aesthetics—an aesthetics of proximity from which distance has beaten a retreat to the call of the wild.

The mere description of a vanishing land, like that of the endangered species, might seem sufficient to evoke the sedentary naturalist straining to see it. But in this hypothetical distance, into which technology's trespass leads our gaze, we find only our own anticipated image, a headspace from which we retrieve a partial identity at the flick of the button, the stab of the remote control. Subjected to this gentle form of possession, we surrender ourselves with more or less talent and conviction to the passive joys of identity loss, a moment of romanticized solitude not dissimilar to that of Friedrich's wanderer or Nietzsche's last man, the narcoleptic moment when we face the mirror of our own endangerment: the spatial extinction of a world forever at home but always in flight.

1. Ricki Lake, Maury Povich, and Jenny Jones are the hosts of eponymous talk shows.

2. Marc Augé, *Non-places: Introduction to an Anthropology of Supermodernity* (London: Verso, 1995).

3. Jerry Seinfeld is the creator and star of *Seinfeld,* one of the most popular sitcoms on American television in recent years. He is quoted here from a press release provided by the Discovery Channel.

The original version of this article, Nature's Mosh Pit: Fear and Proximity in the Discovery Channel, *was published in* Parkett *45 (December 1995), in collaboration with Matthew Barney, Sarah Lucas, and Roman Signer.*

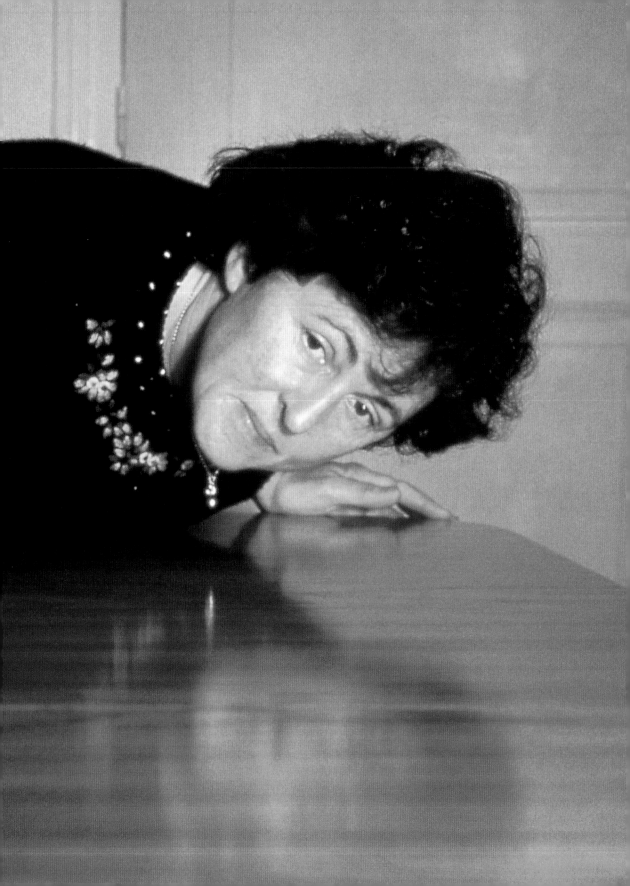

Inez van Lamsweerde and Vinoodh Matadin. *Floortje: Kick Ass.* 1993.

Olafur Eliasson.
Untitled (Iceland Series). 1995.

Tobias Rehberger. *Michel Majerus.* 1995.

Tobias Rehberger. *Jorge Pardo.* 1995.

Tobias Rehberger. *Thaddeus Strode.* 1995.

Tobias Rehberger. *Sharon Lockhart.* 1995.

Mario Airó. *Da Guardare da Vicino (To Be Looked at Close-up)* . . . 1991.

Sarah Lucas. *Fucked (Two Fried Eggs & Hot Dog in a Split Bun with Herpes)*. 1995.

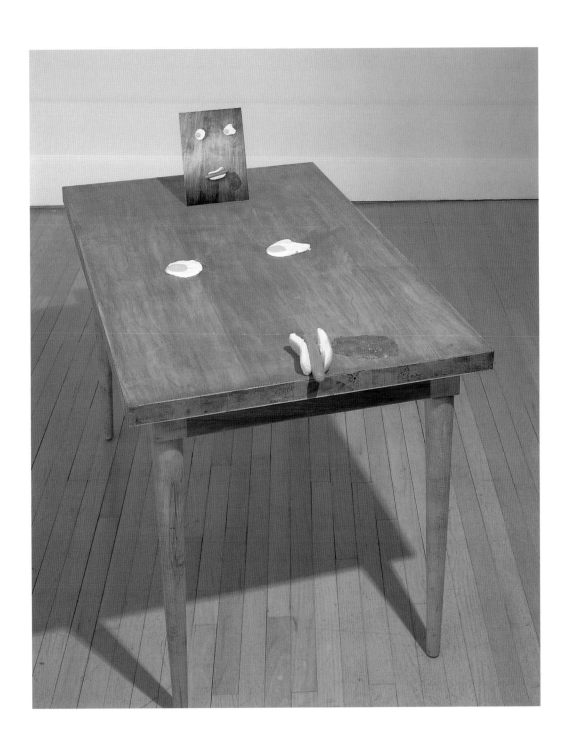

Rudolf Stingel. *Untitled.* 1995.

Keith Cottingham. *Untitled (Double)*. 1993.

David Hammons. *Esquire*. 1990.

Daniel Oates. *Happy Workers (Tom the Postman) II.* 1992.

Above and opposite: **Sam Taylor-Wood.** *Travesty of a Mockery.* **1995.**

Vedova Mazzei. *Untitled.* 1995.

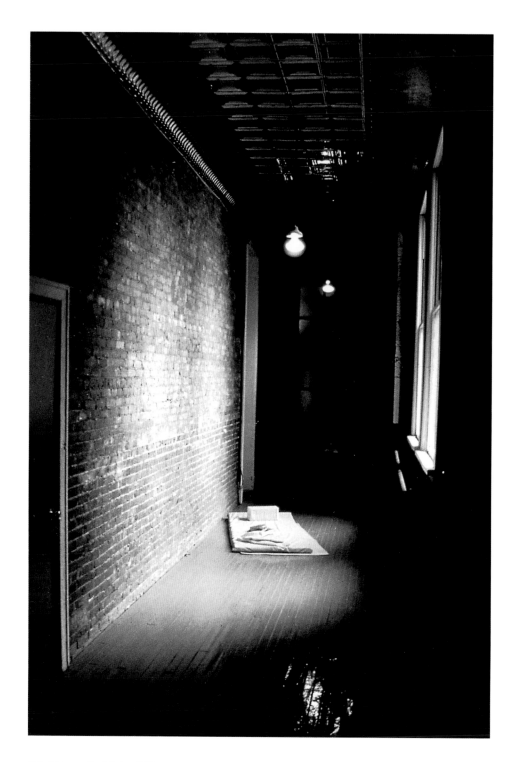

Rirkrit Tiravanija. *Winter.* 1993.

Top and above: **Rirkrit Tiravanija. Snapshots from a journey. 1995.**

Above and opposite: **Giuseppe Gabellone.** *Vulcano.* **1995.**

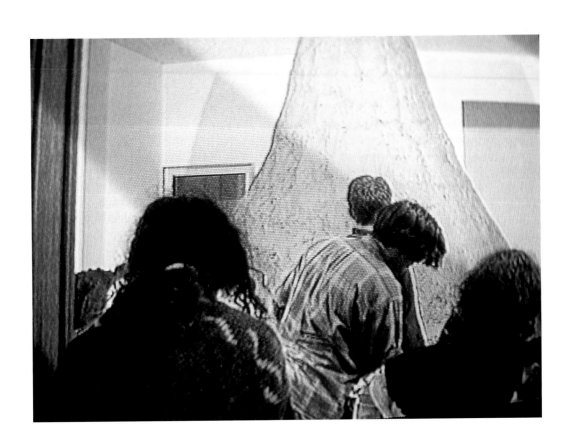

Andrea Zittel. *A to Z Travel Trailer Unit Customized by Andrea Zittel.* 1995.

Jane and Louise Wilson. *Cabin.* **1994.**

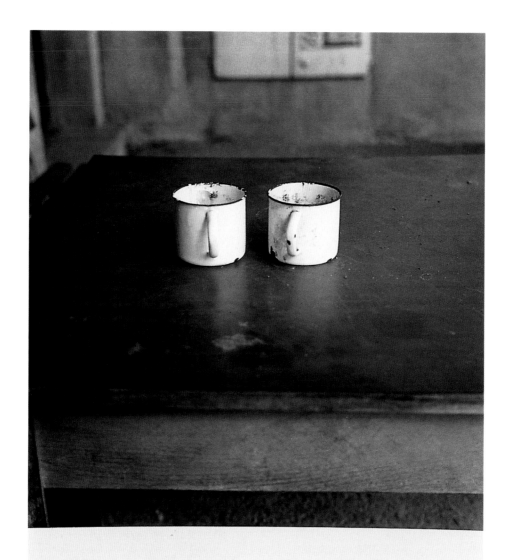

Hrnečky vařte.

Lukas Jasansky and Martin Polak. *Hrnecky Varte (Please, Little Pots, Try to Cook).* 1993.

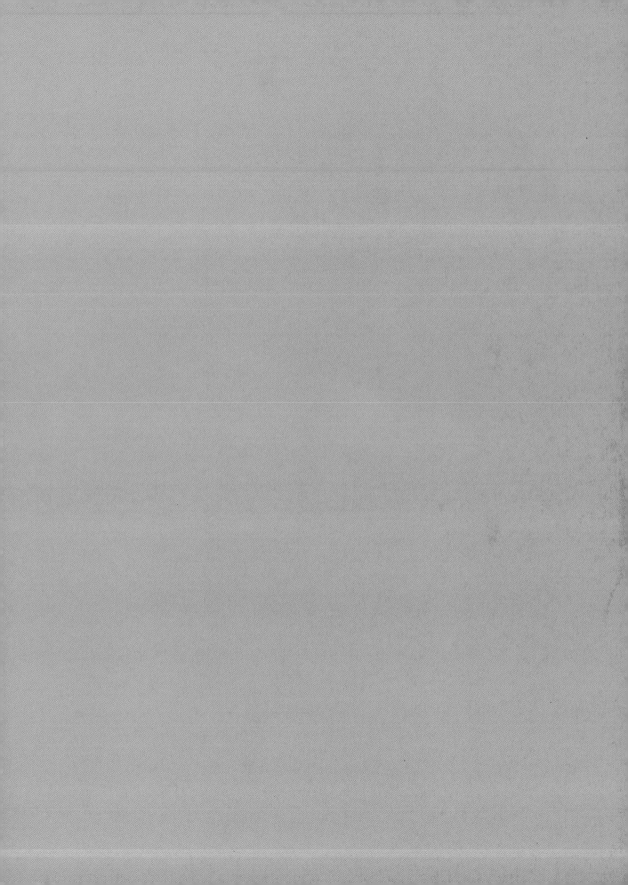

A Short History of the Coming Apocalypse

Mark Van de Walle

Trust no one . . .

More than anything else, this is the spirit that informs the present-day millenarian moment: the sense that there is a secret, and it is about to be revealed—the sense that there is a hidden next move in our current endgame, even if "the rest of us" are not yet ready to know what it is. This millenarian knowledge covers over the facts of daily life like a veil—every event takes on an apocalyptic character, oversignified, meaning too much and not enough at once, nothing escapes its force. In the religious realm, world political events are simply the fulfillment of biblical prophecy: Gorbachev's birthmark was the Mark of the Beast, Ronald Wilson Reagan's name was the number of the Beast. At least until it seemed as though that really was not true, and everyone realized that the universal bar code was the true Sign of the Beast: the coming One World Government would tattoo one on the back of each person's hand, the better to control us in the End Times. Natural events are foretold, too: earthquakes, hurricanes, cold winters and hot summers are all part of the beginning of the end, signs of Revelation's Rapture to come. On the far Right and far Left, the signs are the same: they too signify the end of the world as we know it, it is just that God is not necessarily the one running the show. Instead, it is the military-industrial complex, the Trilateral Commission, the UN, the money/political elite.

You could call it a movement, give it a name, a slogan—the Popular Paranoid Front (PPF), Politics For a New Millennium. Everyone who belonged would share the inside in-

formation on the secret, share the belief that they would survive, even if no one else did: either God would rapture them up, just for believing, or they would shoot their way free, up in the hills. (Or both, since the PPF would not need to keep politics and religion separate.) The rallying cry would be, *Remember Waco! Remember Ruby Ridge! NAFTA No! Apocalypse Now!* They already had a test candidate—Ross Perot, billionaire paranoid—and now they have another candidate, Pat Buchanan, the populist paranoid who won three states in the '96 primaries, witnessing against the New World Order.

Of course, these are only trial runs for the PPF: the true believers would point out that Perot was one of the money elite, and Buchanan is still a Republican (and a former Nixon man, to boot), after all. Eventually the PPF could run on its own, with its own handpicked candidates. They could give speeches tailored to the various paranoid interest groups. The speeches would all start out the same: "We live in the age of the secret, now, as always. It is everywhere and nowhere at once, this secret, this." Then the message could change, customized for the audience's particular flavor of paranoia. For working-class paranoids and fans of Freemason conspiracy: "The plot is run by a small cabal of men working in hidden rooms, giving secret signs, working toward known—but undoubtedly unthinkable—ends. They work through their enormous corporations, shaking the earth with their power and its handmaiden, money; they control governments, who act wittingly or unwittingly as pawns in a larger game; they control armies, information, culture; they run everything behind the masks of business and carefully crafted corporate logos." For Right and Left paranoids: "The plot is run by the government, by shadow governments at work within a vast bureaucracy; they know everything, have files on everyone; they give with one hand so that they may take away with the other, in the classic fashion of kings; they maintain the appearance of incompetence, of glacial immobility, so that they may keep the force of their control hidden away from those who might suspect." Or, for the otherworldly paranoids: "The plot is run by space aliens, who have cut deals with those in power, who watch from above, waiting for the right moment—the moment that has always, according to those who know this secret, been foretold—to come and change the world. They make the world tremble as a sign, as a way of preparing the way for their return."

In the past, the approaching millennium operated according to something much like these twin structures—paranoia and the secret—and it is no different today. The Apocalypse is the Apocalypse, nothing much is changed, but nothing is the same. It presents the same kind of crisis of representation, creates the same kind of meeting place between the sublime and the everyday: a conjunction of what cannot be represented and what is represented everywhere, all the time.

William Kentridge. *Trophy*. 1995.

On a small island . . .

On a small island, you can see the Apocalypse coming from a long way off—the horizon
stretches out toward forever, and the eye follows. On a small island, there is just nothing,
nothing at all, and it is all hurtling toward you at the speed of light, tracing the infinite curve
of the horizon. So you can see the End when it is coming: there is nothing to block your view
of the signs, nothing to keep you from seeing the storm clouds, rolling in from across the
sea, the sky going red then black, the sun snuffed out—and then the moon as well. As with
John at Patmos, all those years ago: exiled by the fading emperor of a fading empire, and left
on this rock, this island; madly hallucinating either madness or truth, waiting calmly for the
moment when the end in all its terrible glory is finally revealed, for his impossible encounter
with the Real Thing, the Thing-In-Itself; calmly waiting for the Revelation's impossible limit
point, the place where reason breaks down and all the secrets are revealed, for "the revela-
tion of Jesus Christ which God gave him to show to his servants what must soon take place.
. . . Blessed are those who hear . . . for the time is near."[1]

"The time is near." Well, of course: the sublime, the limit-experience, is always ap-
proaching, always closing fast (it is the nature of the Thing), but is never all the way there,
not in this life at least (which is its nature, too).

Kant, who would be the first modern philosopher of the end, would lay out the
groundwork for this particular Apocalypse, years after the fact. In his Third Critique, he wrote,
simply: "That is sublime in comparison with which everything else is small."[2] Of course, you
can never actually see such a thing—our senses are always reeling, back and forth, no mat-
ter how big something is you can always imagine larger, and vice versa—so that our experi-
ence of the sublime is precisely our apparently eternal failure, the living end. "Our imagination
strives to progress towards infinity, while our reason demands absolute totality as a real idea,
so the imagination . . . is inadequate to that idea."[3] But that is exactly it: your own inability
to understand, to unravel what must be the last mystery, is all the experience of it that you
will ever get, right up to the last; this inadequacy is the only way you will ever know that there
is something behind the veil, your one proof of any connection to the final Revelation. Like
John's own Revelations—purportedly about the end of everything, they are ultimately all about
the revelation of a failure and a gift at once universal and personal. They are about the im-
possibility of imparting what it is like to stand in the face of the Thing-In-Itself, about the
collapse of reason in the face of a certain beyond. They are about what it is like to arrive at
the point where language, and everything else, comes apart. And in the end, they represent
the best he—or anyone—can think to do: a possible response to an impossible situation.

It is a situation that lends itself to extremes (it is the Apocalypse we are talking about, after all), and both men, Austrian philosopher and Gospel writer alike, responded with a language pushed to its extremity. On the one hand, Kant built his gleaming, prolix edifice of words, a system almost more like a flowchart or a computer diagram in its intricacies than prose, driven by the necessity that the system hang together, that everything mesh and that the system encompass everything, even its own breaking point. Which may be why he stops just short of the place where John starts out: "We must point to the sublime . . . only insofar as it carries with it no charm nor any emotion aroused by actual danger."[4] John, abandoned to his rock, wracked by visions, wrote a sublime encounter composed of pure charm and personal danger, and, like Kant, he failed—there is no touching the Real Thing.[5] Not that it prevented him from trying, piling up images and words as though he hoped or believed that it would somehow close the gap between word and Thing Itself. So: he describes the opening of the seven seals, the woes that will befall the living when the kingdom arrives. He gives us ranks of angels: "And I heard around the throne and the living creatures and the elders the voice of many angels, numbering myriads and thousands of thousands," and seven more holding seven trumpets, blowing up the Apocalypse.[6] He describes a wild array of fantastic beasts: "I saw a lamb . . . with seven horns and seven eyes" and "the four living creatures, each of them with six wings, are full of eyes all round and within," the great Beast himself, the whore of Babylon, the destroying angels, and on and on.[7]

And at the last—after endless, intricate detail, descriptions of events and things past imagining, after all the numbers and symbols and portents—we are left with this: "Surely, I am coming soon."[8] Nothing more. Words fail, and two thousand years later, we are still waiting to understand what it all meant, still waiting for our own experience of what waits beyond the end. Years later, Kant pointed out that the strength of this failure remains the only proof, the only almost-contact that we can have: "This inadequacy itself is the the arousal in us of the feeling that we have within us a supersensible power."[9] Until the End, at least.

And on the eve of . . .

And on the eve of a new millennium, nearly nine hundred years after John's Revelation, the Christian world was still waiting for the return of its divinity. Jules Michelet, in his *History of France*, describes at least part of the thinking: "It was a universal belief in the Middle Ages that [the] world would end with the year 1000 from the Nativity . . . the Etruscans had fixed the term of their civilization at ten centuries . . . Christianity, a transient on earth, an exile

Massimo Bartolini. *Untitled (Propaggine)*.
1995.

from Heaven, was to adopt the Etruscan term."[10] Of course, it was more than a matter of mere numbers—however seductive the rhythm of counting may be, however right the idea of ten centuries as the limit for a worldly empire may have felt.

In fact, after nearly nine hundred years of the same experience of failure, the Christian world had reached the point of its extremity once again and felt itself poised on the edge of the other side—on the edge of an experience of absence that felt like nothing so much as the fulfillment of a sublime prophecy. "This world saw in itself nothing but chaos; it longed for order and hoped to find it in death . . . in those times of miracles and legends, where everything appeared in bizarre colors . . . people could doubt whether this visible reality were anything other than a dream"[11] It was known, finally, that this was at last the moment when all the numbers could be made to work out right; all the Beasts could be found, walking their rounds, performing their preordained parts, all the conditions for the End met. You can hear the voices of the faithful, a distant murmur, totting up congruences of name and deed, adding up the years, the decades, of heresy, infamy, misrule: "Yes, yes, Charlemagne's empire lasted so long, and when you add those years . . . and clearly, this city is Babylon. . . . It is well known that so-called Pope has the numbers 666 inscribed in red on his . . . " Most importantly, in the year 999, the people wanted to believe—if for no other reason than the fact that then the turmoil of the times could point to the possibility of another kind of order.

Because God—the numinous presence at the end of the sublime's caesural pulse—had gone missing for ten centuries; and then, as always, this absence served as the guarantor for His presence. After all, "it could well be that what we call life was really death, and that by ending, the world . . . began to live, and ceased to die."[12] Blaise Pascal, years later, in a time far removed from any millennium, gave a name to this God of the millennium. Or, more precisely, to a way of *thinking* this millenarian God: *Deus Absconditus*, God who hides. What realization, what thought, could be more apocalyptic than this? After all, the entire history of the Apocalypse could come down to nothing more and nothing less than this same search—the search for an endlessly elusive Thing, the long wait for the infinite gap between man and Revelation to be filled.

Maurice Blanchot points out that in the Lafuma edition of the *Pensées*, the *Deus Absconditus* comes first, as the perfect departure point for Pascal's thought. Perfect because there is no response that does not prove him right: any denial merely affirms the sublime failure, serves to affirm the fact of His invisibility, His essential hiddenness. At the same time, it also places everyone, doubter and true believer alike, in the endless twilight of the Apocalypse, both shrouded in the same darkness, both waiting for clarity and light. The hidden God "is doubtless . . . a point of departure by which nothing begins." But still, some-

thing has, in fact, begun: "This obscurity is the difficult point that . . . puts us . . . in touch with the fact that in the world there is no true light, that man nonetheless wants light, wants it totally and wants it to be total."[13]

Which is not to say that Pascal was himself a prophet of the once and future Apocalypse, or even necessarily a believer in it and its urgency. Far from it. In 999 there was a flurry of charity, as the affluent hastened to divest themselves of their worldly goods, a rush to embrace the life of the spirit before the day when it would become the only life; Pascal, in 1660, gave up his studies, and returned to such worldly matters as the running of a public carriage company. Still, he understood, better than almost any thinker since then, the extremity of the position that people occupied at such a moment (Blanchot, fittingly, calls him "tragic man"). For Pascal, the "present-absence" of God, His simultaneous obscurity and awful nearness, merely served to point up the necessity of learning how to live in the world "without taking part in it and without acquiring a taste for it": the necessity of living as though every day were the eve of the coming Apocalypse.

They echoed one another across six hundred years, these two moments of extremity: the one with the certainty that the world was about to end, the other either too early or too late for that, left instead to chart the endless moments of uncertainty and waiting. Both looked across a history set in shadows, hoping for the same impossible thing. So that when Pascal wrote, about Revelations and otherwise, that "God established in the Church sensible signs by which those who seek Him in sincerity should know Him, at the same time He so hid them that He can only be perceived by those who seek Him with all their hearts. . . . There is light enough to enlighten the elect, and darkness enough to humble them,"[14] this simultaneous certitude and uncertainty had found its mirror years before. Michelet takes us back to that moment: "This end of such a sad world was at one and the same time the hope and the horror of the Middle Ages. . . . The Roman Empire had gone, that of Charlemagne also . . . and suffering continued. Misfortune on misfortune, ruin on ruin. There must be something else to come."[15]

"There must be something else to come": even if, as before, as with all the other moments before the Apocalypse, it would be nothing more than another non-encounter with a still-hidden sublime. Another failure, a miss just close enough to keep us waiting: for another ten centuries. For the Truth.

The truth is out there . . .

William S. Burroughs said it: "Sometimes being paranoid is just a matter of having the facts."

Of knowing, finally, the contents of the long closed and hidden box, and having the strength to acknowledge them as the Truth. This last is especially important. Because in the paranoid order of things, there is one structure that really counts: Us and Them. On the one side is everyone who knows the Truth, everyone who wishes to expose it for the good of all; on the other, everyone who knows the truth, everyone who does not want it exposed, for their own ends, whatever they may be.

At once endlessly simple and endlessly complex, the paranoid polarity is seemingly capable of encompassing everything: all intricately intertwined, They are a rich and varied group. Their names include: the CIA (keepers of too many secrets to even begin to list here); the Nazis, with their secret links to the CIA, the occult, and alien technology; the Freemasons, with their links to the occult, governments throughout history (including the United States), the Nazis, the CIA; Wackenhut Enterprises, a private security firm working for the CIA, National Security Administration, and the Pentagon, keeping the secrets for the secret keepers; the office of the President; any of the moneyed elite (but especially, as paranoid politician Pat Buchanan keeps pointing out, the Jews). Other conspirators and secret keepers will also include: the Greys, the alien abductors who cut deals with the Nazis, the Pentagon, the U.S. Government, the One World Government; the Vatican; the Mafia; the Skull and Bones Society; the Tri-Lateral Commission; the Big Drug Companies, and on and on and on. At the end of the millennium, They are everywhere, and They control everything.

Consequently, in the paranoid discourse the truth about things is never in *The New York Times,* and it is not on CNN, either: mainstream information is all smoke and mirrors, a trick of misdirection at the Grand Prestidigitator's hand. The Powers That Be say: "Pay no attention to the man behind the screen." Every paranoid knows that: "*They* show him to us occasionally. All the better to keep Us happy, keep Us feeling like We know what's going on. But *We* know better—just because you're paranoid, it doesn't mean they're not out to get you. It's like monte: the red queen's never where it's supposed to be, the card marked Truth never is."

Because the paranoid knows that the actual facts, the true contents of the secret box, will always be too much to be believed—too strange, too far-fetched: too threatening to the ordinary order of things, which, again, They will do anything to maintain. (Ultimately though, it does not really matter what the contents of the particular secret are: its importance is defined strictly by the fact that They control it, and through it, Us. Just as They are defined simply by their control of the secret and by their opposition to Us. If this seems circular, it's because it is. The form of the circle—at once infinite, closed, and ever expanding—is also the form of the paranoid secret. For both Us and Them.) Of course, things still get

out, otherwise there would be no secret at all. As Deleuze and Guattari have pointed out, "something must ooze from the box, something will be perceived through the box, or in the half-opened box . . . the secret . . . is a social notion."[16]

So if you are one of the paranoid Us, the millennium means that you can read almost all about almost all the secrets in magazines like *Paranoia, Flatland, Conspiracy Update.* Or even the *Weekly World News,* where the secrets are right there in the banner headlines: ALIENS MEET WITH ROSS PEROT, ALIENS MEET WITH BUSH, and at the end of the elections, ALIENS MEET WITH CLINTON. More recently, as the millennium draws closer: NEW STAR OVER BETHLEHEM SIGNALS END OF WORLD! And: SECRET PROPHECIES FROM THE VATICAN'S HIDDEN VAULTS! FIND OUT THE EXACT DATE THE WORLD WILL END—JUST ONE YEAR FROM NOW! Of course, no one in their right mind ever believes what is written there.

But the paranoid knows otherwise: hide in plain sight, it is the oldest dodge in the book. From the paranoid perspective, it seems perfectly reasonable that everything you read in the *Weekly World News* could be true. Why not? Stranger things happen all the time. The Iran-Contra conspiracy was true: there really was a shadow government inside the government, running foreign policy, dealing drugs, sending key-shaped cakes to the Ayatollah; there really were secret CIA mind-control experiments, LSD testing on innocent civilians and not-so-innocent military men. Why not the headlines in *Weekly World News*? Of course, the truth could be there, hidden in plain sight in places like the *White-Trash Nation News.* If the box has to open, what better place? Who would believe anything they saw there? Again: no one, that's who (no one except Us, that is).

So now the secret is everywhere, known to everyone and no one at once; the answers are everywhere, hidden in plain sight. The only question, to the initiate, is how the rest of us can ignore it, how we can fail to see the signs that so clearly appear, written on every wall, on every TV screen, in every headline, hidden behind every locked door. There is only one secret, here at the end of the millennium. Same as it ever was, even if its names are legion. And the secret is this: the End is here. Or almost here, at any rate; it amounts to the same thing, in the End.

1. Revelations 1:3.
2. Immanuel Kant, *The Critique of Judgment,* trans. Werner S. Pulhar (Indianapolis, Ind.: Hackett Publishing Co., 1987), p. 105.
3. Ibid., p. 106.
4. Ibid., p. 109.
5. Compare Slavoj Zizek's reading of Kant through Lacan in *The Sublime Object of Ideology* (New York: Verso Books, 1989), especially pp. 202–7.
6. Revelations 5:11.
7. Revelations 5:6 and 4:6.
8. Revelations 22:20.
9. Kant, p. 106.
10. Cited in Conor Cruise O'Brien, *On the Eve of the Millennium* (New York: The Free Press, 1995), p. 6.
11. Ibid., p. 7.
12. Ibid.
13. Maurice Blanchot, *The Infinite Conversation,* trans. Susan Hanson (Minneapolis: University of Minnesota Press, 1992), pp. 99–100.
14. Blaise Pascal, *Pensées,* trans. H. F. Stewart (New York: Pantheon, 1965), Fragment 309.
15. O'Brien, pp. 7–8.
16. Gilles Deleuze and Félix Guattari, *A Thousand Plateaus,* trans. Brian Massumi (Minneapolis: University of Minnesota Press, 1987), p. 287.

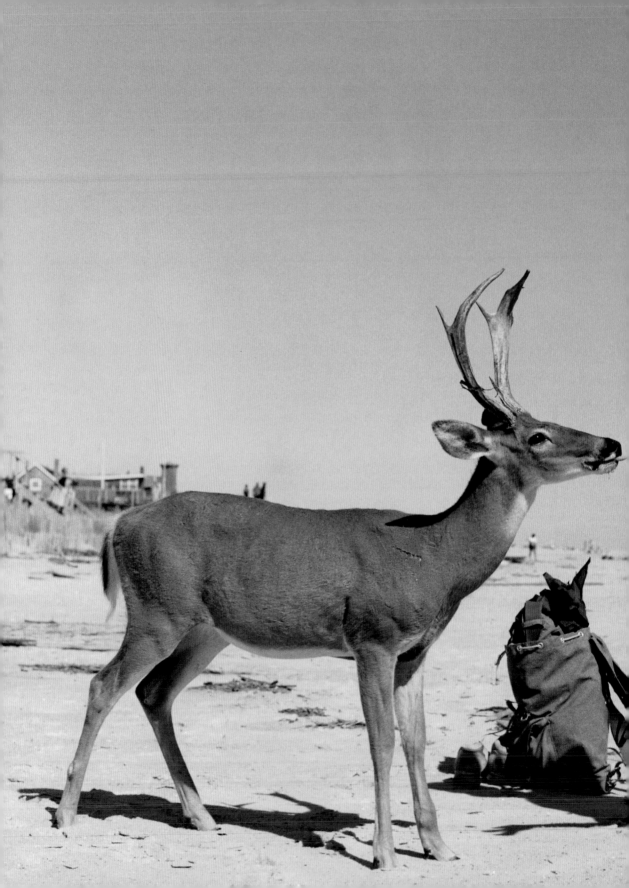

Wolfgang Tillmans. *Deer Hirsh*. 1995.

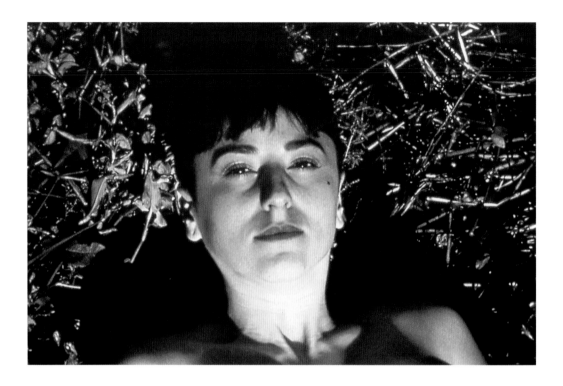

Collier Schorr. *Monika Sofia Condrea.* 1995.

Collier Schorr. *A Chance to Travel.* 1994.

Pascale Marthine Tayou. *Totem Feminin*. 1994.

Pascale Marthine Tayou. *Hyper LoooBHY*. 1995.

Michael Joo. Detail of *Princess (with Double Chrome Pea)*. 1996.

Michael Joo. *TRNSFM (Infinity Cycle).* **1995.**

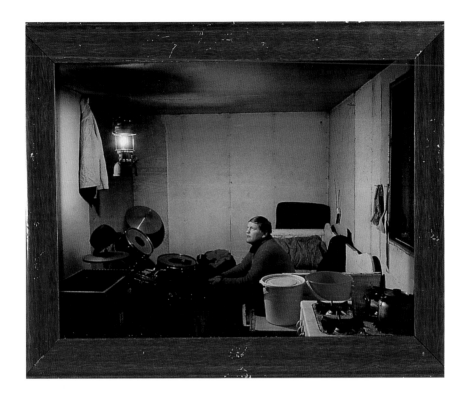

Esko Manniko. *Kuivaniemi.* 1991.

Stefano Arienti. *Untitled (Self-Portrait).* 1996.

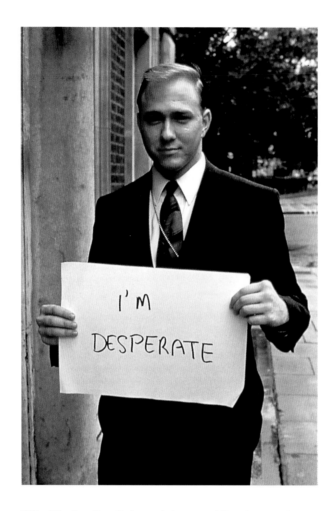

Gillian Wearing. *Signs that say what you want them to say and not signs that say what someone else wants you to say.* 1992–93.

Kcho. *A los Ojos de la Historia (In the Eyes of History).* 1995.

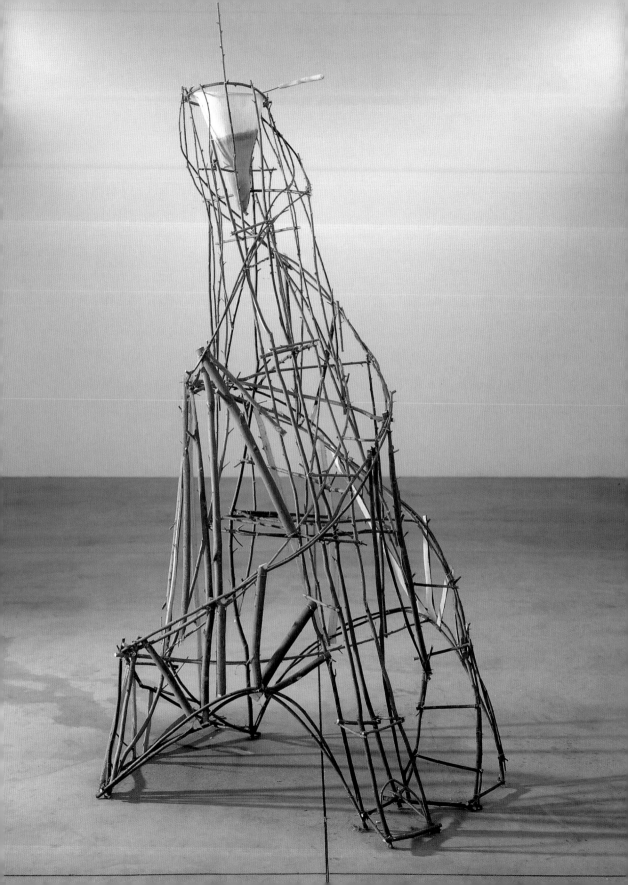

Dinos and Jake Chapman. *Ubermensch (Superman).* 1995.

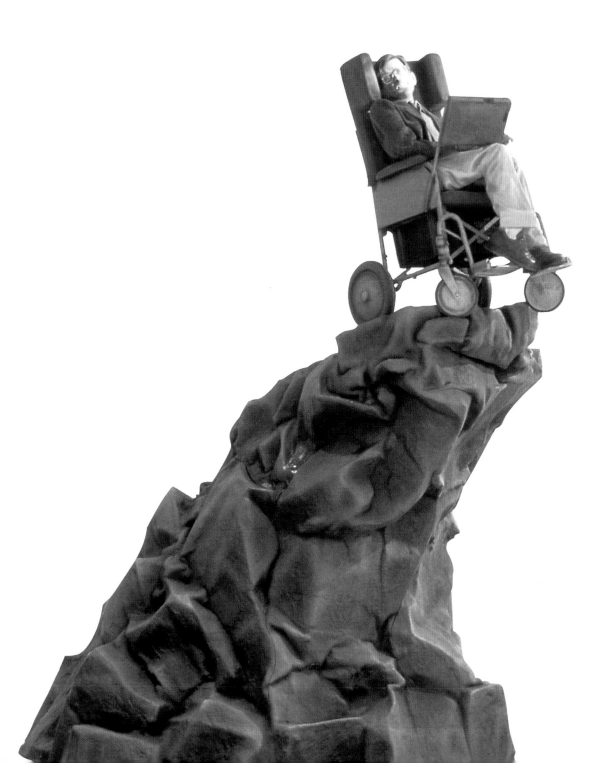

Maurizio Cattelan. *Bidibodibooo*. 1996.

Maurizio Cattelan. *Warning enter at your own risk, do not touch, do not feed, no smoking, no photographs, no dogs. Thank you.* 1994.

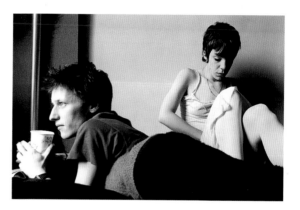

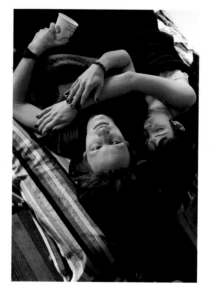

Lina Bertucci. *Untitled Monologues.* 1996.

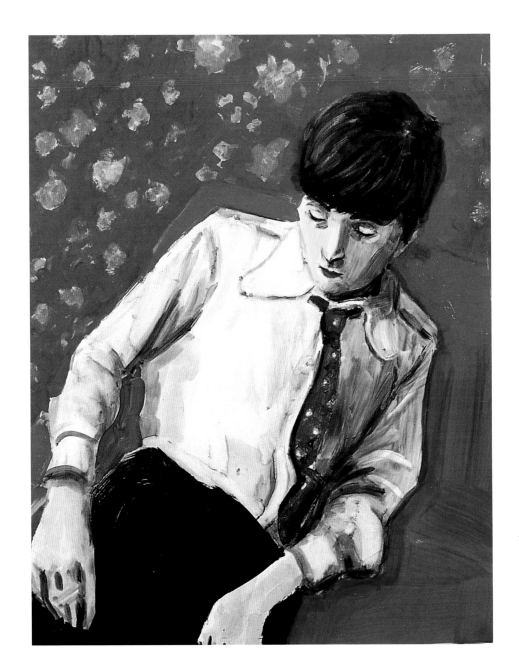

Elisabeth Peyton. *Hotel.* **1996.**

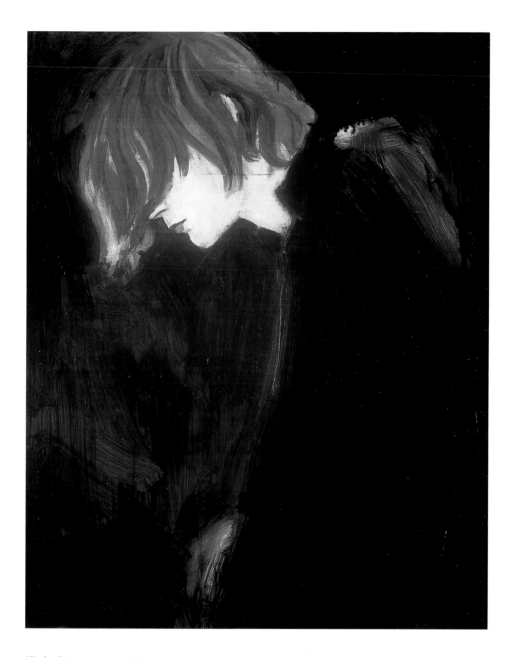

Elisabeth Peyton. *Kurt.* 1995.

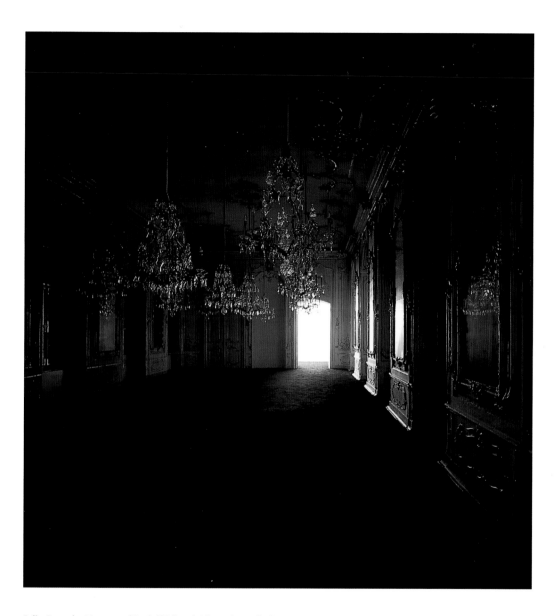

Felix Gonzalez-Torres and Rudolf Stingel. View of Installation. 1994.

Contributors

The Artists

Mario Airó, born 1961, Pavia, Italy. Lives in Milan.

Stefano Arienti, born 1961, Asola, Italy. Lives in Milan.

Art Club 2000 is a group of artists formed in 1992 in New York by Colin De Land. The members are Patterson Beckwith, Gillian Haratani, Daniel McDonald, Shannon Pultz, Will Rollins, and Craig Wadlin.

Matthew Barney, born 1967, San Francisco. Lives in New York.

Massimo Bartolini, born 1962, Cecina, Italy. Lives in Cecina.

Vanessa Beecroft, born 1969. Lives in Milan.

Lina Bertucci, born 1958, Milwaukee, Wisconsin. Lives in New York.

Angela Bulloch, born 1966, Ontario, Canada. Lives in London.

Neke Carson, born 1946, Dallas, Texas. Lives in New York.

James Casebere, born in Lansing, Michigan. Lives in New York.

Maurizio Cattelan, born 1960, Padova, Italy. Lives in Milan and New York.

Dinos Chapman, born 1962, London. Lives in London.

Jake Chapman, born 1966, Cheltenham, England. Lives in London.

Keith Cottingham, born 1965, Los Angeles. Lives in San Francisco.

John Currin, born 1962, Boulder, Colorado. Lives in New York.

Boris Cvjetanovic, born 1953, Zagreb. Lives in Zagreb.

Moyra Davey, born 1958, Montreal. Lives in New York.

Thomas Demand, born 1964, Munich. Lives in Berlin and New York.

Mark Dion, born 1961, Bedford, Massachusetts. Lives in New York.

Sarah Dobai, born 1965, London. Lives in London.

Graham Durward, born 1956, Aberdeen, Scotland. Lives in New York.

Olafur Eliasson, born 1967, Iceland. Lives in Cologne, Germany.

Giuseppe Gabellone, born 1973, Brindisi, Italy. Lives in Brindisi and Milan.

Felix Gonzalez-Torres, born 1957, Guáimaro, Cuba. Lived in New York. Died in Miami in 1996.

Michael J. Grey, born 1961, Los Angeles. Lives in New York.

David Hammons, born 1943. Lives in New York.

Noritoshi Hirakawa, born 1960, Fukuoka, Japan. Lives in Tokyo and New York.

Damien Hirst, born 1965, Bristol, England. Lives in London.

Lukas Jasansky, born 1965, Prague. Lives in Prague. Has worked in collaboration with Martin Polak since 1985.

Michael Joo, born 1966, Ithaca, New York. Lives in New York.

Kcho (Alexis Leiva Machado), born 1970, Nueva Gerona, Cuba. Lives in Havana.

William Kentridge, born 1955, Johannesburg. Lives in Johannesburg.

Karen Klimnik, born 1962, Philadelphia. Lives in Philadelphia and New York.

Inez van Lamsweerde, born 1963, Amsterdam. Lives in Amsterdam.

Sharon Lockhart, born 1964. Lives in Los Angeles.

Sarah Lucas, born 1962, London. Lives in London.

Antje Majewski, born 1968, Marl, Germany. Lives in Berlin.

Miltos Manetas, born 1964, Athens, Greece. Lives in Milan.

Esko Manniko, born 1959, Pudasjärvi, Finland. Lives in Oulu, Finland.

Eva Marisaldi, born 1966, Bologna, Italy. Lives in Bologna.

Vinoodh Matadin, born 1961, Amsterdam. Lives in Amsterdam and New York.

Vedova Mazzei: Simeone Crispino, and Maristella Scala have collaborated since 1990. They live in Milan.

Tracy Moffatt, born 1960, Brisbane, Australia. Lives in Sydney.

Shirin Neshat, born 1957, Qazvin, Iran. Lives in New York.

Walter Niedermayr, born 1952, Bolzano, Italy. Lives in Bolzano.

Daniel Oates, born 1964, Lucerne, Switzerland. Lives in New York.

Catherine Opie, born 1961, Sandusky, Ohio. Lives in Los Angeles.

Gabriel Orozco, born 1962, Jalapa, Mexico. Lives in New York and Mexico City.

Pepón Osorio, born 1955, Santurce, Puerto Rico. Lives in New York.

Florence Paradeis, born 1964, Antony, France. Lives in Paris.

Philippe Parreno, born 1964, Oran, Algeria. Lives in Paris and New York.

Elisabeth Peyton, born 1965, Danbury, Connecticut. Lives in New York.

Jack Pierson, born 1960, Plymouth, Massachusetts. Lives in New York.

Steven Pippin, born 1960, Redhill, England. Lives in London.

Martin Polak, born 1966, Prague. Lives in Prague. Has worked in collaboration with Lukas Jasansky since 1985.

Tobias Rehberger, born 1961, Esslingen, Germany. Lives in Frankfurt.

Collier Schorr, born 1963, New York. Lives in Brooklyn, New York.

Rudolf Stingel, born 1956, Merano, Italy. Lives in New York.

Beat Streuli, born 1957, Altdorf, Switzerland. Lives in Düsseldorf.

Sam Taylor-Wood, born 1967, London. Lives in New York.

Pascale Marthine Tayou, born 1966, Yaoundé, Cameroon. Lives in Yaoundé.

Diana Thater, born 1962, San Francisco. Lives in Los Angeles.

Wolfgang Tillmans, born 1968, Remscheid, Germany. Lives in Brooklyn, New York.

Rirkrit Tiravanija, born 1961, Buenos Aires. Lives in New York.

Gillian Wearing, born 1963, Birmingham, England. Lives in London.

Jane Wilson, born 1967, Newcastle, England. Lives in London.

Louise Wilson, born 1967, Newcastle, England. Lives in London.

Jay P. Wolke, born 1954, Chicago. Lives in Chicago.

Andrea Zittel, born 1965, Escondido, California. Lives in Brooklyn, New York.

Heimo Zobernig, born 1958, Mauthen, Austria. Lives in Vienna.

The Writers

Francesco Bonami was born in 1955 in Florence. He is the U.S. editor of *Flash Art International* and is a curator. He lives in New York.

Jen Budney was born in 1970 in Saskatoon, Saskatchewan. She is an editor at *Flash Art International* and lives in Milan.

Jeffrey Rian was born in Yokohama, Japan. He is a regular contributor to *Flash Art International*, *frieze*, *Purple Rose*, and *Poker World* magazines. He lives in Paris.

Keith Seward, like the Doppler effect, is produced by a certain velocity and motion obtaining between an observer and himself. However, rather than grow quieter as he moves farther away, he grows louder.

Neville Wakefield was born in the Isles of Scilly. He is a writer based in New York.

Mark Van de Walle is a writer based in New York.

List of Illustrations

122–23: Antje Majewski. *Untitled*. 1994. Cibachrome, dimensions variable. Courtesy of the artist.

124–25: Graham Durward. *Untitled (Balloon Video)*. 1994. Video projection. Courtesy Patrick Callery, New York.

126: Karen Klimnik. *They Called Her Baby Gia*. 1994. Crayon and acrylic on paper, 40 x 26". Courtesy 303 Gallery, New York.

127: Karen Klimnik. *The Black Plague*. 1995. Oil on canvas, 20 x 16". Courtesy 303 Gallery, New York.

128: Damien Hirst. Detail of *I Love Love*. 1994–95. Gloss household paint and butterflies on canvas , 84 x 84". Courtesy White Cube, London.

132: Neke Carson. *Atomic Bicycle*. 1970. Courtesy of the artist. Photograph by Pierre Volez/John Paul Goude.

146–47: Tracy Moffatt. *Scarred for Life Series*. 1994. Offset prints on eggshell, 31½ x 23½"each. Courtesy of the artist.

148–49: Jack Pierson. *Begonia and Tim's Shower*. 1995. C-print, 11 x 14". Courtesy of the artist.

149: Jack Pierson. *Tim in Outdoor Shower*. 1995. C-print, 11 x 14". Courtesy of the artist.

150–51: Miltos Manetas. *Soft Driller*. 1995. Video projection, 20 minutes. Courtesy of the artist and Armin Linke. Photograph by Armin Linke.

152: Diana Thater. *Abyss of Light*. 1993. Video installation with videotapes, projectors, film gels, and existing architecture. Courtesy David Zwirner Gallery, New York.

153: Matthew Barney. *Cremaster I*. 1995. Production still from video. Courtesy Barbara Gladstone Gallery, New York. Photograph by Michael James O'Brien.

155: Sharon Lockhart. *Ruby*. 1995. Ektacolor print mounted on gator board, 66 x 44". Edition of 6. Courtesy Friedrich Petzel Gallery.

156–57: Steven Pippin. *Interior*. 1994. Negative photographic images mounted on board, 7 x 39'. Courtesy Regen Projects, Los Angeles.

158–59: Jay P. Wolke. *Post Tornado, Ill* 1991. C-print, 20 x 24". Courtesy of the artist.

162–63: Vanessa Beecroft. *Ein Blonder Traum*. 1994. C-print, 12 x 15¾". Courtesy Robert Prime, London; and Shipper +Krome, Cologne.

166: Boris Cvjetanovic. *Mesnicka Street*. 1983. Gelatin-silver print, 15 x 15". Courtesy Dante Marino Cettina, Umag.

167: Boris Cvjetanovic. *From the Summer Holidays*. 1995. Gelatin-silver print, 15 x 15". Courtesy Dante Marino Cettina, Umag.

170–71: Angela Bulloch. *From the Chink to Panorama Island*. 1995. Projection of the new name for this former loading bay for Bankside Power Station, southside Thames, London: "It involves many different things; primarily was a walk from the raising roadways on Tower Bridge (I call the "gap" where the road don't meet, the chink) along the river to this funny island which is now derelict. I gave the island a new name and had an event mark the end of my residency—where I lit the whole island red and projected the new name onto it" (excerpt from the artist's notes). Courtesy of the artist.

178–79: Florence Paradeis. *Untitled*. 1992. C-print mounted on aluminum, 39⅓ x 49½". Courtesy of the artist.

181: Inez van Lamsweerde and Vinoodh Matadin. *Floortje: Kick Ass*. 1993. C-print, 31½ x 31½". Edition of 8. Courtesy of the artists.

182–83: Olafur Eliasson. *Untitled (Iceland Series)*. 1995. C-print, 23½ x 35½". Courtesy of the artist.

184: Tobias Rehberger. *Michel Majerus.* 1995. Ceramic, 23 x 15⅛". Courtesy neugerriemschneider, Berlin; and Galerie Bärbel Grässlin, Frankfurt.

185: Tobias Rehberger. *Jorge Pardo.* 1995. Plastic, 21¼ x 8". Courtesy neugerriemschneider, Berlin; and Galerie Bärbel Grässlin, Frankfurt.

185: Tobias Rehberger. *Thaddeus Strode.* 1995. Wood, 24 x 9 x 21". Courtesy neugerriemschneider, Berlin; and Galerie Bärbel Grässlin, Frankfurt.

185: Tobias Rehberger. *Sharon Lockhart.* 1995. Ceramic, 18¾ x 12½". Courtesy neugerriemschneider, Berlin; and Galerie Bärbel Grässlin, Frankfurt.

186–87: Mario Airó. *Da Guardare da Vicino (To Be Looked at Close-up)* . . . 1991. Net, rubber, cobblestone, and Plexiglas, 78¾ x 65¼ x 126". Courtesy Massimo De Carlo, Milan.

189: Sarah Lucas. *Fucked (Two Fried Eggs & Hot Dog in a Split Bun with Herpes).* 1995. Table, eggs, hot dog and bun, plastic, photograph, vegetable oil, frying pan, and a spatula. Table: 40 x 30 x 55"; stone: 9½ x 30 x 16". Courtesy Barbara Gladstone Gallery, New York.

190–91: Rudolf Stingel. *Untitled.* 1995. View of installation at Kunsthalle Zurich. Yellow wall-to-wall carpeting, dimensions variable according to site. Courtesy Paula Cooper Gallery, New York.

192: David Hammons. *Esquire.* 1990. Hair, stone, railroad tie, shoe polish, and tin, 45 x 9 x 5". Courtesy Rubell Family Collection, Miami.

193: Keith Cottingham. *Untitled (Double).* 1993. Digitally constructed photograph, 61½ x 53¼". Edition of 12. Courtesy of the artist and Ronald Feldman Gallery, New York.

195: Daniel Oates. *Happy Workers (Tom the Postman) II.* 1992. Polyurethane and acrylic, 18 x 8 x 5". Courtesy 303 Gallery, New York.

196–97: Sam Taylor-Wood. *Travesty of a Mockery.* 1995. Color projection with sound, 10 minutes. Courtesy White Cube, London. Photograph by Stephen White.

198–99: Vedova Mazzei. *Untitled.* 1995. C-print, 20½ x 31½". Courtesy Studio Guenzani, Milan.

200: Rirkrit Tiravanija. *Winter.* 1993. Installation view. Courtesy of the artist.

201: Rirkrit Tiravanija. Snapshots from a journey. 1995. Courtesy of the artist.

202–3: Giuseppe Gabellone. *Vulcano.* 1995. Video, 5 hours. Courtesy of the artist.

204–5: Andrea Zittel. *A to Z Travel Trailer Unit Customized by Andrea Zittel.* 1995. Steel, wood, glass, carpet, aluminum, and object. Courtesy Andrea Rosen Gallery, New York.

206–7: Jane and Louise Wilson. *Cabin.* 1994. C-print mounted on board, 30 x 40". Courtesy of the artists.

208: Lukas Jasansky and Martin Polak. *Hrnecky Varte (Please, Little Pots, Try to Cook).* 1993. Gelatin-silver print, 36 x 48". Courtesy of the artists.

214–15: William Kentridge. *Trophy.* 1995. Animation project for theater production *Faustus in Africa,* charcoal on paper. Courtesy of the artist.

218–19: Massimo Bartolini. *Untitled (Propaggine).* 1995. Cibachromes, 39⅛ x 39⅛" each. Courtesy of the artist.

228–29: Wolfgang Tillmans. *Deer Hirsh.* 1995. C-print, 16 x 12". Edition of 10. Courtesy Andrea Rosen Gallery, New York.

230: Collier Schorr. *Monika Sofia Condrea.* 1995. C-print, 22½ x 32¾". Edition of 3. Courtesy 303 Gallery, New York.

231: Collier Schorr. *A Chance to Travel.* 1994. C-print, 22½ x 32¾". Edition of 3. Courtesy 303 Gallery, New York.

232: Pascale Marthine Tayou. *Totem Feminin.* 1994. Mixed media. Courtesy of the artist.

233: Pascale Marthine Tayou. *Hyper LoooBHY.* 1995. Mixed media. Courtesy of the artist.

234: Michael Joo. Detail of *Princess (with Double Chrome Pea).* 1996. Installation with mirror, expansion rods, MSG, metal balls, variable dimensions. Courtesy Thomas Nordanstad, New York.

235: Michael Joo. *TRNSFM (Infinity Cycle).* 1995. Medical fiberglass, pigmented polyester resin, nylon, polyethylene, stainless steel, and rice wine, 33 x 37¼". Edition of 10. Courtesy Patrick Painter Editions, Vancouver.

236: Stefano Arienti. *Untitled (Self-Portrait).* 1996. C-print mounted on canvas, 40 x 60". Courtesy Studio Guenzani, Milan.

237: Esko Manniko. *Kuivaniemi.* 1991. C-print with original frame, 15 x 19¾". Courtesy Galerie Nordenhake, Stockholm.

238: Gillian Wearing. *Signs that say what you want them to say and not signs that say what someone else wants you to say.* 1992–93. C-print mounted on aluminum, 16 x 12". Courtesy of the artist and Interim Art, London.

239: Kcho. *A los Ojos de la Historia* (*In the Eyes of History*). 1995. Branches, metal wire, cloth, and coffee. Courtesy Fondazione Sandretto Re Rebaudengo per l'Arte, Turin, Italy.

241: Dinos and Jake Chapman. *Ubermensch* (*Superman*). 1995. Fiberglass, paint, mixed media, and fog, dimensions variable. Courtesy Victoria Miro Gallery, London.

242: Maurizio Cattelan. *Bidibodibooo.* 1996. Squirrel, plastic, glass, and metal, dimensions variable. Courtesy of the artist and Laurie Gennilard, London. Collection Re Rebaudengo, Turin, Italy.

243: Maurizio Cattelan. *Warning enter at your own risk, do not touch, do not feed, no smoking, no photographs, no dogs. Thank you.* 1994. Donkey, crystal chandelier, and straw. Courtesy Daniel Newburg. Photograph by Lina Bertucci.

244–45: Lina Bertucci. *Untitled Monologues.* 1996. C-prints, 16 x 20" each. Edition of 10. Courtesy of the artist.

246: Elisabeth Peyton. *Hotel.* 1996. Oil on Masonite, 24 x 20". Courtesy Gavin Brown Enterprise.

247: Elisabeth Peyton. *Kurt.* 1995. Oil on Masonite, 17 x 14". Courtesy Gavin Brown Enterprise.

249: Felix Gonzalez-Torres and Rudolf Stingel. View of installation at Neue Galerie Graz. 1994. Two pearl curtains: 18 x 25' and 18 x 24'; black Capri wall-to-wall carpeting: 787' square. Courtesy Neue Galerie Graz, Austria.